A Child
A Case Study in the Life of a Photo

For Marilyn

A Child at Gunpoint

A Case Study in the Life of a Photo

Richard Raskin

 Aarhus University Press

A Child at Gunpoint. A Case Study in the Life of a Photo
Copyright: The author and Aarhus University Press 2004
Cover design: Lotte Bruun Rasmussen
Cover Photo:

The cover photograph, as well as almost all other images from the SS document generally called the *Stroop Report*, were provided by the Institute of National Remembrance, Commission for the Prosecution of Crimes against the Polish Nation, Office for the Preservation and Dissemination of Archival Records – Instytut Pamięci Narodowej, Komisji ścigania Zbrodni przeciwko Narodowi Polskiemu, Biuro Udostępniania i Archiwizacji Dokumentów.

Printed by: Narayana Press, Gylling, Denmark

ISBN 87 7934 099 7

The publication of this book was made possible by grants from the Aarhus University Research Foundation and the Danish Research Council for the Humanities.

AARHUS UNIVERSITY PRESS
Langelandsgade 177
8200 Aarhus N
Denmark

Fax (+45) 8942 5380
www.unipress.dk

73 Lime Walk
Headington, Oxford OX3 7AD
United Kingdom
Fax (+44) 1865 750 079

Box 511
Oakville, Conn. 06779
USA
Fax (+1) 860 945 9468

PREFACE

This may well be the first book devoted to a single photograph. And surely no photo is more deserving of a comprehensive study than is this one, widely considered the most striking and unforgettable image we have of the Holocaust.[1]

Yet despite its importance, surprisingly little has been written about the picture. Most commentators who have described it in their books – including Elie Wiesel (1970), Lucy S. Dawidowicz (1975) and Susan Sontag (1977)[2]– have offered valuable insights but rarely devoted more than a few sentences to the photo. Even a new book and TV documentary by Heribert Schwan and Helgard Heindrichs (2003) on the principal SS man in the photograph, devote only fleeting attention to the picture itself.[3]

The only more sustained discussions of the photograph to date are a documentary film by Matti-Juhani Karila (1990),[4] several pages in a novel by Jaroslaw Rymkiewicz (1988),[5] one chapter in a philosophical study by Herman Rapaport,[6] and portions of two articles by Marianne Hirsch (1999, 2002).[7] Each of these contributions will be drawn upon in the course of this book.

The present study is intended both for the general reader and also for students, teachers, researchers, archivists and librarians working in such fields as Holocaust studies, history, Judaïca, media studies and photography. Whether the reader's motivation for knowing more about the photograph is a purely personal interest or a professional concern as well, he or she will find here a solid basis for exploring the stories behind the picture in addition to those it tells. For the sake of the general reader, documentation likely to be of interest only to specialists is confined to footnotes.

The opening chapter of the book provides a close look at the photograph itself and describes some of the properties that may account for its unique status. Chapter 2 is a presentation of the document in which the picture first appeared: a report made by SS Major General Jürgen Stroop on his operation to crush the Warsaw ghetto uprising of April 19 to May 16, 1943. This so-called *Stroop Report* was intended primarily for Heinrich Himmler and boastfully proclaimed *The Jewish Quarter in Warsaw Is No More!* This chapter, on the making, contents and

functions of that document, will introduce the reader to the original context in which the photo first appeared. Chapter 3 will be an attempt to understand what the photograph meant for the SS men who took it and chose it for inclusion in the *Stroop Report*; this discussion will be based largely on statements made by SS officials that shed light on the ways in which they experienced their genocidal project. The fourth chapter will be devoted to claims as to the identity of the little boy and of other captives in the photo, as well as the confirmed identity of the SS man with the submachine gun. In Chapter 5, we will examine the role played by the photograph in a number of works of art: the BBC television series, *The Glittering Prizes* (1976), written by Frederic Raphael and starring Tom Conti; the prize-winning short film *With Raised Hands* (1985) by Mitko Panov; Yala Korwin's poem "The Little Boy With His Hands Up" (1982); and a series of paintings by Samuel Bak (1995-present). This chapter will consist of interviews with Frederic Raphael, Tom Conti, Mitko Panov, Yala Korwin and Samuel Bak, as well as a presentation of the works in which the photograph plays a central role. In a final and undoubtedly controversial chapter, I will examine ways in which the photograph has been used in the past 20 years by critics of Israeli policy who suggest that there are Palestinian parallels to the image of the Jewish boy in the Warsaw ghetto. A special effort has been made to deal with this sensitive issue in a way that would alienate neither Israelis nor Palestinians. If I have not succeeded in this difficult and probably impossible task, it was not for want of trying.

Though written with a passion for uncovering the story of the photograph and for exploring its meanings, the tone of this book is deliberately dispassionate, avoiding as much as possible the pathos and indignation that could so easily detract from an objective presentation of evidence, claims and interpretive material.

Readers wishing to view the photograph while reading any portions of this book will find a fold-out copy of the picture on the inside of the back cover flap.

Richard Raskin
Aarhus, Denmark
March 2004

NOTES

1. In a recent article, Marianne Hirsch described the photo in these words: *If you had to name one picture that signals and evokes the Holocaust in the contemporary cultural imaginary it might well be the picture of the little boy in the Warsaw ghetto with his hands raised. The pervasive role this photograph has come to play is indeed astounding: it is not an exaggeration to say that, assuming an archetypal role of Jewish (and universal) victimization, the boy in the Warsaw ghetto has become the poster-child of the Holocaust. In Lawrence Langer's terms "the most famous photograph to emerge from the Holocaust," it has appeared in Holocaust films, novels and poems, and, almost obsessively, on the covers of advertising brochures for Holocaust histories, teaching aids, and popular books...* "Nazi Photographs in Post-Holocaust Art: Gender as an Idiom of Memorialization," in *Crimes of War: Guilt and Denial,* eds. Omer Bartov, Atina Grossmann, Molly Noble (New York: The New Press, 2002), pp. 100-101.

2. Elie Wiesel, *One Generation After* (New York: Schocken, 1982; orig. pub. 1970), pp. 49-50; Lucy S. Dawidowicz, *The War Against the Jews*: 1933-1945 (London: Penguin, 1990, orig. pub. 1975), pp 210-211; Susan Sontag, *On Photography* (London: Penguin, 1977), p. 109.

3. *Der SS-Mann. Josef Blösche – Leben und Sterben eines Mörders* (Munich: Droemer Knaur, 2003); and a 45-minute documentary with the same title, first broadcast on German TV in 2003.

4. *Tsvi Nussbaum, a boy from Warsaw*, a co-production of MTV Finland and Gamma TV France, first broadcast in 1990. Produced and written by Matti-Juhani Karila, directed and edited by Ilkka Ahjopalo.

5. The novel by Jaroslaw Rymkiewicz was originally published in Poland in 1988 under the title, *Umschlagplatz*, a word referring to the transfer center to which the Jews of Warsaw were first marched and from which they were sent on to their deaths in freight cars bound for Treblinka and other death camps. The novel appeared in English as *The Final Station: Umschlagplatz* (New York: Farrar Strauss Giroux, 1994), transl. Nina Taylor, and the photograph is described on pp. 324-326.

6. Herman Rapaport, "The Eye and the Law" in *Is There Truth in Art?* (Ithaca: Cornell University Press, 1997), pp.196-217.

7. "Projected Memory: Holocaust Photographs in Personal and Public Fantasy," in *Acts of Memory*, eds. Mieke Bal, Jonathan Crewe, Leo Spitzer (Hanover: University Press of New England, 1999), pp. 3-23; and the article cited in footnote 1.

CONTENTS

PREFACE .. 5

Chapter One
 A CLOSE LOOK AT THE PHOTOGRAPH 11

 Introductory note 11
 Preliminary observations 12
 Five properties of the photograph 17

Chapter Two
 THE ORIGINS OF THE PHOTO: THE *STROOP REPORT* 25

 Introductory note 25
 The making of the *Stroop Report* 25
 Stroop's fate .. 27
 What became of the originals 28
 The photographer 31
 The first public mention of the *Stroop Report* and photo ... 32
 The textual sections of the *Stroop Report* 34
 The photographic section of the *Stroop Report* 39
 Intended and unintended functions of the *Stroop Report* 51
 Appendix I. The Warsaw Ghetto: A Chronological Overview 58
 Appendix II. OCC Staff Evidence Analysis 61

Chapter Three
 THE PHOTOGRAPH IN CONTEXT 71

 Introductory note 71
 Possible meanings and functions of the photo for Stroop, Krüger and Himmler ... 72

Chapter Four
 IDENTITIES .. 81

 Introductory note 81
 The boy in the photo: four possible identities 82
 Other captives 93
 The SS trooper: Josef Blösche 94

Chapter Five
THE ROLE OF THE PHOTOGRAPH IN SELECTED
WORKS OF ART ... 105

 Introductory note ... 105
 Frederic Raphael, *The Glittering Prizes* (BBC, 1976) 107
 Yala Korwin, *The Little Boy With His Hands Up* (1982) 115
 Mitko Panov, *With Raised Hands* (1985) 119
 Samuel Bak, A series of paintings (1995-present) 130

Chapter Six
PALESTINIAN PARALLELS? USES OF THE PHOTO
IN A WAR OF IMAGES .. 157

 Introductory note ... 157
 A political cartoon and its background 162
 Hanoch Levine's *The Patriot* 164
 A Palestinian child ... 166
 Mohammed al-Dura ... 169

A CONCLUDING NOTE ... 177

BIBLIOGRAPHY .. 179

PICTURE AND OTHER CREDITS .. 185

ACKNOWLEDGMENTS ... 187

INDEX ... 191

Chapter One
A CLOSE LOOK AT THE PHOTOGRAPH

Introductory note

An important first step toward understanding this picture involves looking at it closely, so that our subsequent discussion can be grounded in what is actually there, rather than in what we might assume to be there or think we see.

A case in point is Peter Fischl's poem, "To the little Polish boy with his arms up,"[1] based on a memory of the photo, not written with the picture in view. In this poem, Fischl refers to a Star of David on the boy's coat, when in fact there is no such star – nor could there be, since in the Warsaw ghetto, Jews aged 12 and older were required to wear armbands on their right coat-sleeves, rather than stars sewn onto the front of their coats as was the case in other occupied territories. (Some years ago, the poem was nevertheless accompanied on a website by an altered version of the photograph, on which a star had been added to the boy's coat – making the photograph consistent in that respect with what the poet thought he had seen.[2] A more obvious solution would have been to correct the poem.) Fischl also refers in his poem to "many Nazi machine guns" aimed at the child, when in fact one submachine gun is pointed in the boy's direction, which of course is more than enough to constitute an outrage.

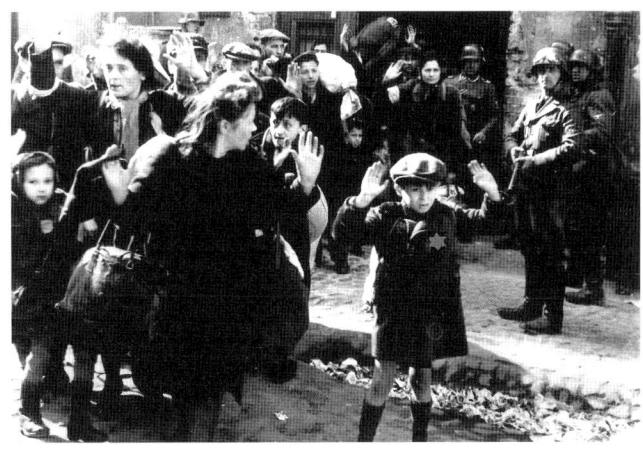

My reconstruction of a manipulated version of the photograph, with a star added to the boy's coat.

A CLOSE LOOK AT THE PHOTOGRAPH 11

On an entirely different level, and in a manner which in no way reflects negatively on the authors of these descriptions, others have also somewhat overshot the mark in commenting on the photograph. For example, in a speech made to the *Bundestag* in Berlin on January 27, 2000, Elie Wiesel referred to the photo, stating:

> There is a picture that shows laughing German soldiers surrounding a Jewish boy in a ghetto, I think probably in the Warsaw ghetto. I look at it often. What was it about that sad and frightened Jewish child with his hands up in the air, that amused the German soldiers so? Why was tormenting him so funny?[3]

And James E. Young also described the boy in the photograph as "surrounded by laughing German soldiers."[4] There may well be a smirk on the face of the SS trooper holding the submachine gun, but to speak of "laughing German soldiers" tormenting the boy, goes beyond what we actually see.

Even so straightforward a question as the number of German soldiers in the picture has been subject to imprecise observation. Jaroslaw Rymkiewicz described the photo in some detail in his novel, *The Final Station: Umschlagplatz*, pointing out that he has "pored over the photo" for decades. Yet of the twenty-three people he counts in this photo, he sees "nineteen Jews and four Germans,"[5] when in fact there are five German soldiers clearly visible, the one Rymkiewicz probably missed appearing in the background, at the upper edge of the picture, toward our left.

While allowances should certainly be made for poetic license in all of these cases, it is important that the present study take its point of departure in a careful examination of what the picture actually shows. And in order to refer to specific persons in the photo with some precision, I have taken the liberty of assigning a number to each, cited in squared brackets in the description that follows.

Preliminary observations

Appearing in the photograph are twenty civilians, largely women and children who are visible to varying degrees, and five German soldiers. There may well be more people present beyond the boundaries of the picture or within the shadows of the archway but we will confine our discussion to those we can discern. All of the civilians whose hands we can see hold either one or both of them in the air, signaling surrender.

Though all five soldiers are presumably armed, only one weapon is plainly visible in the picture: a submachine gun held by the most prominent SS trooper [2] just behind and to the right of the boy in the foreground [1]. And although that trooper is clearly wielding his weapon, it would not be entirely accurate to say that the gun is aimed directly at the little boy. A straight line drawn along

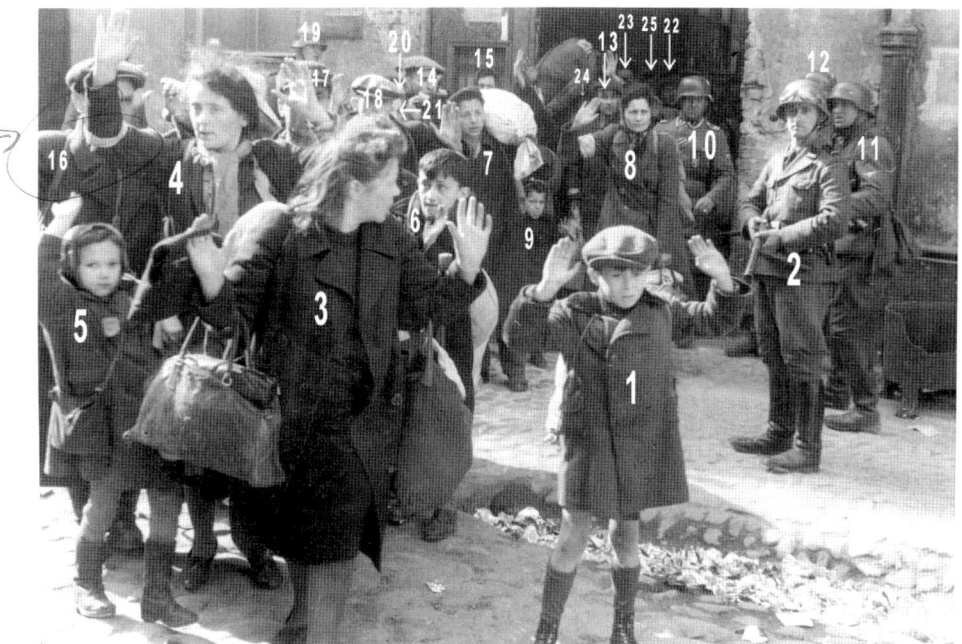

the barrel of the gun and extended in the boy's direction would pass through the outer edge of his left coat sleeve and through the lower left corner of his coat, ending in the gutter, just beside the boy's left foot. Still, the gun is threateningly aimed in the general direction of the boy. What is undoubtedly the muzzle of another gun, not aimed at anyone in the picture, is visible just behind the more prominent trooper's left elbow, and held by a soldier [11] who for the moment is uninterested in the little boy.

Three of the soldiers [2, 11, 12] are grouped on the right side of the photo; a fourth [10] stands in the archway and appears to be looking directly at the boy, leaning slightly to his left to get a better look, while a barely noticeable fifth [19] is at the upper edge of the photo, toward our left, and probably can't see the boy from where he is standing.

The main trooper [2] stands out in relation to the four other soldiers in that:
a) nothing blocks our view of his entire person, while all the others are at least partially eclipsed;
b) he is both closer to the camera and better illuminated than the others, the sunlight highlighting a number of the contours and surfaces of his face, helmet and torso, with the result that we can clearly see his features and expression as well as his body-language;

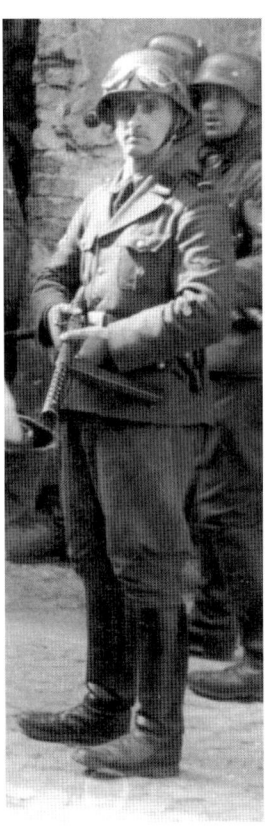
c) he is the only one who appears to be looking at the camera and even posing for the picture, while the others seem to be caught off-guard and unaware that they are being photographed;

d) the woman in the left foreground [3] appears to be turning her head in order to look at him, and the woman in the archway [8] also appears to be looking at him – making him an object of other people's gaze within the photo;

e) his smirking composure, surveillance stance and weapon-wielding all suggest that he is in command, that it is for his sake that the prisoners hold their hands up and that he, more than anyone else we can see, is the arbiter of their fate.

Of the twenty prisoners, four are children: three boys [1, 6, 9] and a girl [5]. There is one teenage male [7] carrying a white sack over his shoulder in the central background of the picture. Seven of the prisoners are women, three of whom [3, 4, 8] we can see with relatively little obstruction while we can just make out a tiny portion of the faces of four others [15, 20, 21, 23]. The remaining eight prisoners whose faces we can see at all [13, 14, 16, 17, 18, 22, 24, 25] are men wearing caps; they might be in their 40s or 50s, though this is guessing since their faces are largely obstructed.

The woman whose face we can see most clearly [4] does not look particularly worried, nor does the little girl [5] standing beside her and who is presumably her daughter. The woman's hands are both raised and on her right arm, a white armband is visible.

At least one other person – the woman [8] standing before the gateway – also wears a white armband. While all the other captives over the age of 12 are presumably wearing similar armbands, they are not visible in the photo. And the little boy with his hands raised, who is probably about 8 years old, wears neither armband nor any other emblem marking him as Jewish. (On some copies of the photograph, there is a small, lighter patch under his collar, not to be mistaken for a yellow star.)

The boy stands out from the other prisoners in the picture in that

a) he is positioned in the middle of a space immediately before the camera, just to the right of the central foreground, and with the other prisoners and soldiers forming a kind of semi-circular frame around him, with the result that he appears to be standing alone in empty space;
b) sunlight illuminates his oversized cap (turned slightly askew), some contours of his face, outgrown coat, bare legs and shoulder bag;
c) the bareness of his knees also catches our attention, signaling both childhood (he does not yet wear long pants) and the vulnerability of exposed skin;
d) our view of him is not obstructed by any other person in the photograph;

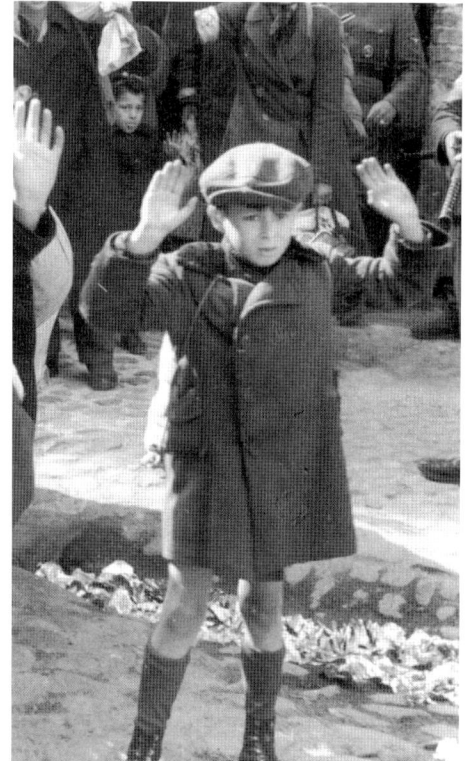

e) his posture, with hands symmetrically raised and angled, framing his face, and our clear and nearly frontal view of the look of terror in his face – he is the only captive to appear terrified – make him the primary focus of attention in the photo.

These are some of the reasons why it is standard practice to refer to this picture as the photograph of the little boy in the Warsaw ghetto with his hands raised, though that child is only one of 25 people appearing in the picture.

With respect to the boy's special status in the photo, Herman Rapaport commented incisively both on the incongruity of a gesture of surrender enacted by a child, and also on the boy's isolation from the other captives in the photo. Rapaport wrote:

> It is curious that the child's gesture and expression are peculiarly unchildlike, as if the child were acknowledging that he fits the role of someone who could be a threat to the Third Reich. In part, this is underscored by the photograph's composition, in which the child is seen as isolated from the group, an isolation or unprotectedness

that suggests that he is being singled out for punishment. Indeed, whereas the other persecuted figures are standing near one another for support – some children peer at the camera from behind the adults – the composition of the photograph suggests that the child with raised hands in the foreground is incongruously taking on the brunt of something he cannot possibly understand (p. 200).

And in a subsequent passage, Rapaport described "the boy's standing apart from the other hostages as if he alone were answerable" (*ibid.*, p. 205).

The frightened little boy is apparently looking at something or someone off-camera, to our right – according to Rapaport, "what must be (they are off camera) weapons directly pointed at him" (*ibid.*, p. 196). Another slightly taller boy [6], whose face is just to the right of the woman's in the foreground [3], is looking – anxiously perhaps – at something or someone off-camera to our left, while the little girl [5], and possibly the woman beside her [4], appear to be looking at the photographer, as does the main SS trooper [2] as already mentioned.

At least several of the prisoners [3, 7, 8] are holding bags of various kinds, and the boy himself [1] seems to have some kind of pack on his back, suggesting that they have had a chance to assemble some belongings in preparation either for a failed escape attempt or for their captivity. They may now be on their way to "resettlement."

However, at the moment the picture was taken, the prisoners and soldiers appear to be standing in place, with their feet firmly planted on the ground, though one or two shoes may be partially lifted (in the lower left corner of the picture). It is conceivable that this scene was prolonged momentarily for the sake of the photo. The picture is captioned: "Pulled from the bunkers by force" (*Mit Gewalt aus Bunkern hervorgeholt*). That the caption is arbitrary in this case is fairly obvious. Other photos, such as the two below which were not included in the *Stroop Report*, show people literally being pulled from an underground bunker.

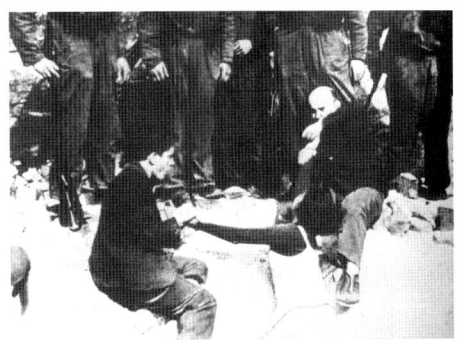
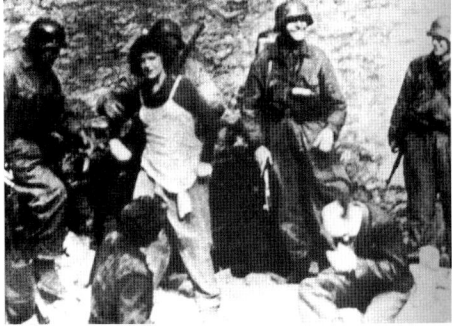

Photos used with permission of the Institute of National Remembrance – Commission for the Prosecution of Crimes against the Polish Nation, Office for the Preservation and Dissemination of Archival Records.

There is no sign of any kind – such as disheveled or dust-covered clothing – to indicate that the captives in the photo of the boy with his hands raised were "pulled by force" from anything that might rightfully be called a "bunker."

Five properties of the photograph

The reader is asked to bear in mind that all allusions to "the viewer" in this section refer to post-war spectators of the photo, whose sympathy lies with the victims, and that the relationship of the SS to the photograph they took and the special meanings it had for them alone, will be treated elsewhere in this book (on pp. 71-80 below).

<p align="center">(1)</p>

Many of the pictures Margaret Bourke-White took at Buchenwald in 1945 showed scenes that were difficult for her to look at and for the viewers of her photos to bear. As she herself stated:[6]

> I saw and photographed the piles of naked, lifeless bodies, the human skeletons in furnaces, the living skeletons who would die the next day... and tattooed skin for lampshades. Using the camera was almost a relief. It interposed a slight barrier between myself and the horror in front of me.

But in contrast to those painful glimpses of horror, the picture she took at Buchenwald that has become what many consider a photographic icon, is one that does not require that we brace ourselves in order to look at it: it is her photograph of survivors behind barbed wire, taken at Buchenwald on April 28, 1945, and appearing in *Life Magazine* on May 7, 1945:

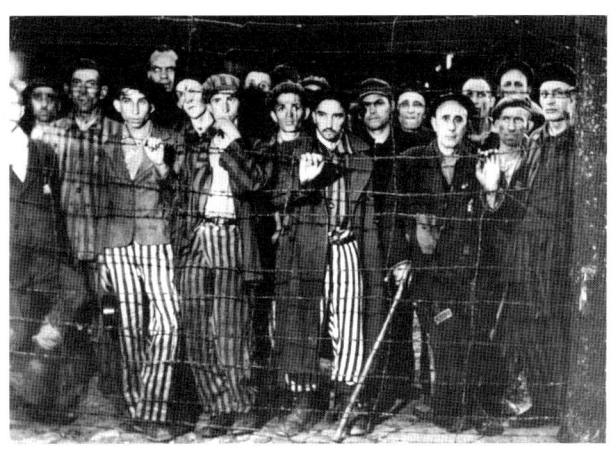

MARGARET
BOURKE-WHITE/Time Life
Pictures/Getty Images

A CLOSE LOOK AT THE PHOTOGRAPH 17

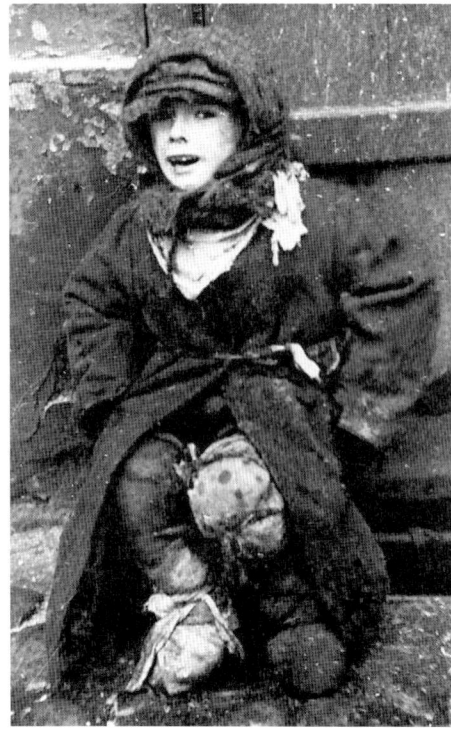
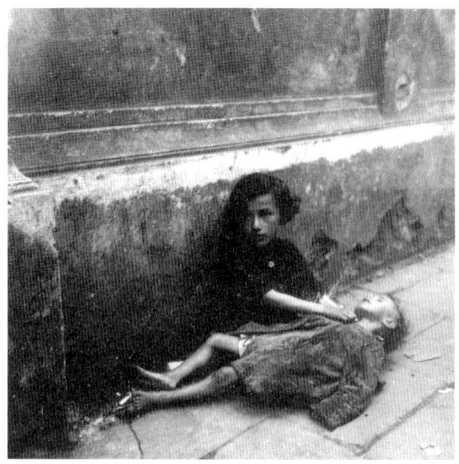

ABOVE: Photo by Heinrich Jöst © Günther Schwarberg, Hamburg.[9] The caption reads: "Most probably these were sisters. I can't say whether the younger one was already dead. She never moved."
LEFT: Photo of a ghetto child © Krakow Photographic Society.

Vicki Goldberg wrote that "for many people, particularly younger people, this is the image that springs to mind when they think of the camps." And in considering why this particular image has become such an important one, Vicki Goldberg suggested that

> Bourke-White's photograph may have become iconic partly because it suggests more horror than it depicts. She took many pictures of piles of dead bodies, many of men more skeletal, more obviously at death's door, more shocking than these. I suspect that this photograph has become a historical marker partly because it presents a level of pain that is just within the range of tolerance.[7]

Similarly, Marianne Hirsch contrasted "images of children who are not visibly wounded or in pain," such as that of the boy from Warsaw, with "other images of emaciated, dirty, visibly suffering children taken in the Warsaw ghetto – images that have never achieved the same kind of visual prominence as the little boy with his hands up."[8]

Marianne Hirsch was most concerned with the drawbacks of these less unbearable images of child victims, suggesting that such images impede a "working-through" of the traumatic past and encourage instead a process of "obsessive

Photo by Joe Heydecker.[10] *Das Warschauer Ghetto* © *1983, 1999 Deutscher Taschenbuch Verlag, München.*

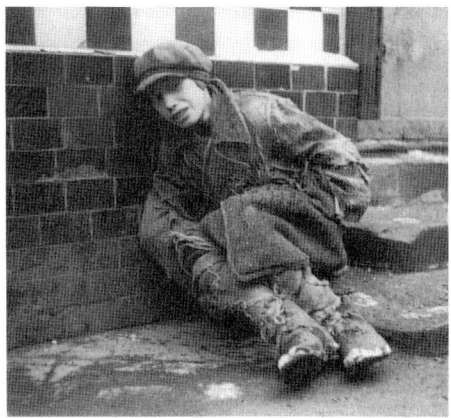

repetition" or "acting-out," as well as "appropriative identification" – a form of *over*identification of the spectator with the victim, due to a lack of distancing devices.

One of the dangers she saw in this kind of relationship to Holocaust images is a "blurring of important areas of difference and alterity: context, specificity, responsibility, history."[11]

This is doubtless an important issue for those whose interest lies in developing theoretical models that deal with photographs in relation to memory and the overcoming of past traumas. In the present context, however, our focus is not on theorization of that kind, but rather on the power of that photograph to capture and hold the viewer's attention. And in this perspective, the fact that the picture is not so terribly painful to look at, is an important asset.

What we have then is a photograph that does not cause us to recoil because looking at it is too distressing. On the contrary, it draws us in and holds us spellbound. But at the same time, although our eyes meet no faces distorted by starvation, or skeletal limbs showing through filthy rags, there is an implicit mortal threat hanging over the captives in the picture, and we can understand that their appearance of physical well-being, recorded at the moment the picture was taken, might well have been a thing of the past in a matter of days, hours or even minutes after the shutter was snapped.

(2)

A second property is so obvious that it could easily be overlooked: the *outrageousness* of the scene.

In this photo, a seven or eight year old boy is forced to assume a posture of sur-

render that belongs to the world of soldiers. All boundaries between military and civilian, adult and child, have been abolished. The protective instinct grown-ups are presumed to experience in relation to children, has been replaced in the figure of the SS man by the threat of imminent execution. The child, like all the other captives in the picture, is nothing more than prey in his eyes.

(3)

Among the compositional values of the photograph is one that concerns the boy's placement in the picture with respect to the Golden Section.

If a line were drawn vertically through the center of the boy, it would bisect the picture along its horizontal axis in such a way that 5/8 and 3/8 of the photo lie on either side of the line. This approximates the Golden Section, defining a visually privileged position within the picture. Similarly, if along the photo's vertical axis, a line were drawn dividing the picture at the 3/8 and 5/8 point, that line would traverse the boy's cap, so that the intersection of the two perpendicular lines – indicating a focal point "to which the spectator's eye is immediately attracted"[12] – lies very close to the boy's face, optimally situated in terms of purely visual logic.

The boy also occupies a space that is his alone, framed by a semi-circle formed

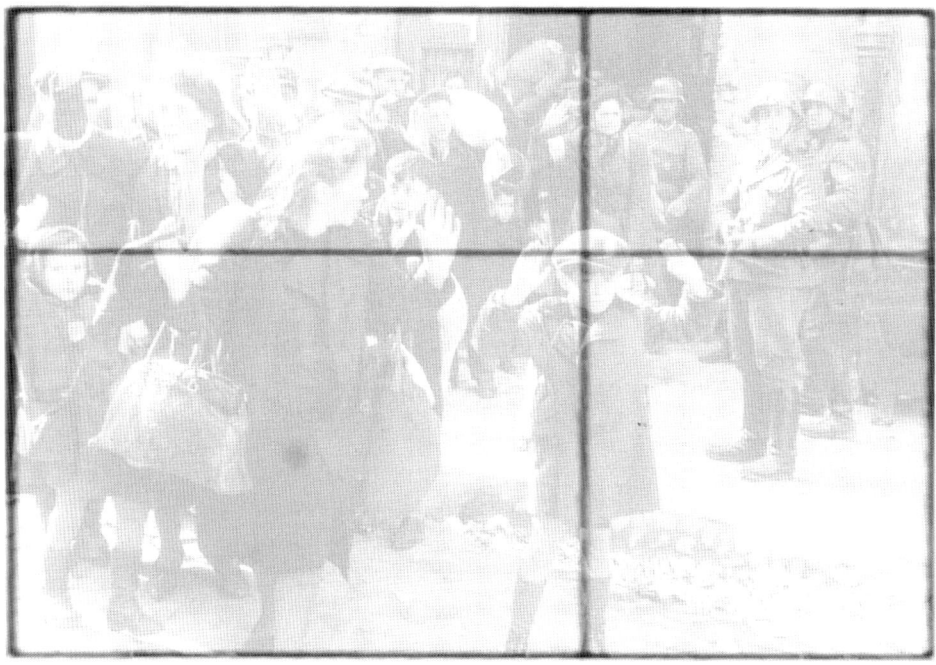

by other captives and soldiers; for this and other reasons already mentioned (p. 15 above), he is clearly defined as the central figure in the photograph.

Yet despite the fact that the picture is routinely described as the photo of the boy with his hands raised, there are also multiple centers of interest in the picture, so that the viewer's eyes can settle on virtually any one of the figures and consider the story it has to tell, momentarily giving it his or her full attention. This variety of faces and stances the viewer can ponder, gives the image an inexhaustible quality, and makes the photograph at one and the same time both a picture of the boy and a portrait of a group with at least fifteen or twenty centers of interest for the viewer to explore.

(4)

It would be difficult to imagine a photograph in which more polar opposites were in play than in the picture at hand: SS vs. Jews, perpetrators vs. victims, military vs. civilians, power vs. helplessness, threatening hands on weapons vs. empty hands raised in surrender, steel helmets vs. bare-headedness or soft caps, smugness vs. fear, security vs. doom, men vs. women and children. These and other interwoven polarities are all part of the same fundamental opposition which structures the visual field and contributes to our experience of it as being multi-facetted and richly textured in its unity.

(5)

Vicki Goldberg described the iconic quality of certain photographs in the following way:

> The Greek word *eikon* originally meant a portrait or representation, sometimes carrying a memorial connotation. In Christianity it became a sacred painting or sculpture. Today the word extends to secular images with so strong a hold on the emotions or the imagination that they have come to serve as archetypes. I take secular icons to be representations that inspire some degree of awe – perhaps mixed with dread, compassion, or aspiration – and that stand for an epoch or a system of beliefs. […] the images I think of as icons almost instantly acquired symbolic overtones and larger frames of reference that endowed them with national or even worldwide significance. They concentrate the hopes and fears of millions and provide an instant and effortless connection to some deeply meaningful moment in history. They seem to summarize such complex phenomena as the powers of the human spirit or of universal destruction (*op. cit.*, p. 135).[13]

Certainly the photograph of the boy with his hands raised has all of these qualities: exerting a strong hold on the emotions and imagination of the spectator, it is awe-inspiring and offers an effortless connection to the historical moment when the Nazis carried out their genocidal project with industrial efficiency.

The photograph makes the meaning and shape of that event a visually accessible reality for us and in a way that enables us to see it up close and as it was reflected in the eyes of its victims and perpetrators. It is as representative of that event as any photograph could be, and this is precisely why those who deny any genocidal intent on the part of the Nazis have taken so great an interest in undermining the meaning of this photo, as will be seen repeatedly in the course of this book.

*
* *

Without presuming to explain with any certainty why this photograph stands out as it does from other Holocaust images, I believe that the five properties mentioned above – the relative intactness of the victims, the outrageousness of the central image, specific compositional values, a network of interwoven polarities (including the presence of both perpetrators and victims within the image), and the degree to which it offers us a close, awe-inspiring and effortless connection to the period – are among those factors that contribute to the unique status of the picture.

NOTES TO CHAPTER ONE

1 Peter Fischl's poem, written in 1965 and published in 1994, is currently accessible at http://Holocaust-trc.org/FischlPoem.htm Teachers using "To Be or Not To Be," the "Lesson Plan Written for Peter L. Fischl's Poster/Poem, 'To the little Polish Boy Standing with His Arms Up'" (available on paper and also at http://www.holocaust-trc.org/pboy_lp.htm), should be cautioned that the booklet contains factual errors about the photograph. On page 2 of the booklet, written by Judy Luehm Junecko but based on an outline by Peter Fischl, it is stated that the photograph of the little boy with his hands raised "was taken by the Jurgen Stroop photographers for Hitler's birthday as a gift, by publishing the photo in the 'Stroop Report' Newsletter in 1943." The *Stroop Report* was anything but a newsletter, as will be clear to anyone who reads Chapter 2 below. And there is no evidence whatsoever to link the taking of this photograph, or the making of the *Stroop Report* (in May 1943) with a present for Hitler on his birthday (April 20), though it is commonly claimed that the SS operation that began on April 19, 1943 to clear the Warsaw ghetto of its remaining inhabitants was timed by Himmler

as a birthday present for the Führer. (See for example http://www.britannica.com/original?content_id=1474.)
2. The altered photograph can still be seen on another website, http://www.voorhees.k12.nj.us/middle/Holocaust/child_of_warsaw.htm, where it was placed in good faith by a teacher who was unaware at the time that the photo had been altered.
3. Elie Wiesel's speech, on the occasion of The Day of Remembrance for the Victims of the Holocaust can be found in its entirety at http://www.gainfo.org/SFPT/Amnesia/German_Parliament_President_Holocaust_Remembrance_Day_Speech_27Jan2001.htm
4. *Writing and Rewriting the Holocaust* (Indiana University Press, 1988), p. 140.
5. Op. cit., p. 325.
6. http://www.uiowa.edu/~policult/politicalphotos/holocaust2.html
7. Vicki Goldberg, *The Power of Photography. How Photographs Changed Our Lives* (New York: Abbeville Press, 1991), p. 37.
8. "Projected Memory: Holocaust Photographs in Personal and Public Fantasy," in *Acts of Memory. Cultural Recall in the Present*, eds. Mieke Bal, Jonathan Crewe, Leo Spitzer. (Hanover: University Press of New England, 1999), p. 17. Hirsch also describes the boy in the Warsaw photo as "not visibly hurt or harmed or suffering" in "Nazi Photographs in Post-Holocaust Art: Gender as an Idiom of Memorialization" (*op. cit.*).
9. Günther Schwarberg, *In the Ghetto of Warsaw. Heinrich Jöst's Photographs* (Göttingen: Steidl Verlag, 2001), photo No. 57. Heinrich Jöst was a Wehrmacht sergeant and amateur photographer stationed in a Warsaw suburb. He entered the Warsaw ghetto on September 19, 1941, and took 137 pictures on that one day. The photos remained locked in Jöst's desk until 1982.
10. A laboratory assistant in PK 689 (a propaganda unit or *Propaganda Kompanie* active in the Warsaw ghetto from the start), the anti-Nazi Joe Heydecker, who wasn't even authorized to enter the ghetto, did so at considerable risk, illegally photographing within the ghetto walls on three separate occasions in February and March of 1941. These photos from the spring of 1941, along with a final photograph taken in 1944 after the ghetto had been destroyed, were published many years later in book form. Joe J. Heydecker, *The Warsaw Ghetto. A Photographic Record 1941-1944.* Foreword by Heinrich Böll (London: I.B. Tauris, 1990), previously. pub. in São Paulo Brazil in 1981 and Munich in 1983.
11. Marianne Hirsch, "Nazi Photographs in Post-Holocaust Art: Gender as an Idiom of Memorialization" (*op. cit.*).
12. J. K. Popham, *Pictorial Composition* (London: Pitman, 1954), pp. 32-33. See also my own *Elements of Picture Composition* (Aarhus: Aarhus University Press, 1986), p. 35.
13. Readers interested in considering other iconic photos might wish to see Huynh Cong (Nick) Ut's "Children Fleeing a Napalm Strike," taken on June 8, 1972, and currently accessible at: http://www.1stcavmedic.com/napalm_girl.htm Equally interesting in this perspective is Joe Rosenthal's photograph taken at Iwo Jima on February 23, 1945 and entitled: "Old Glory goes up on Mt. Suribachi" – an image that can now be accessed at: www.yale.edu/yale300/democracy/may1text/images/Rosenthal.jpg

Chapter Two

THE ORIGINS OF THE PHOTO: THE *STROOP REPORT*

Introductory note

The story of the Warsaw ghetto has been told many times and in considerable depth. Such works as Emmanuel Ringelblum's eye-witness account, *Notes from the Warsaw Ghetto*, and Yisrael Gutman's comprehensive study, *The Jews of Warsaw, 1939-1943. Ghetto, Underground, Revolt*, are readily available at any well-stocked library. It would be pointless to devote a substantial portion of the present book to what has already been masterfully treated elsewhere. A brief chronological overview is however provided as an appendix to this chapter, for the convenience of the reader wishing to have at hand a bare outline of the facts.

If the history of the Warsaw ghetto has often been told, the story of the *Stroop Report* remains relatively uncharted territory and will be the main focus of this chapter. On this subject, there is a scarcity of source material, though a facsimile edition of the document itself has been published in book form (now unfortunately out of print)[1] and every page of the *Stroop Report* can be easily accessed on the Web.[2] What is lacking is a *presentation* of the document in such a way that the photograph of the boy with his hands raised can be understood more fully in the light of its original context.

Readers interested in doing just that will find in this chapter a useful resource. Scattered, fragmentary and sometimes inconsistent data on the history of the report will be pieced together, and both the textual and the photographic contents of the document will be closely examined. Small reproductions of all 53 photographs contained in the specimen of the report now in Warsaw will also be provided. This presentation of the history, content and structure of the *Stroop Report* will enable the reader to see how the photograph of the boy with raised hands fits into the album in which it originally appeared.

The making of the *Stroop Report*

In mid April 1943, SS Chief Heinrich Himmler ordered that the Warsaw ghetto be cleared of the approximately 60,000 Jews still living there. His plan was for them

to meet the same fate as the more than 300,000 who had been gassed at Treblinka or murdered in other ways during the previous year. With the exception of a few phone calls that the SS Chief made directly to Jürgen Stroop, the man he had chosen to lead the so-called *Großaktion*, communication between Himmler and Stroop went through the Higher SS and Police Leader East, Friedrich Wilhelm Krüger, based in Krakow.

These three SS men – Himmler (in Berlin), Krüger (in Krakow) and Stroop (in Warsaw) – were the parties most responsible for the murder of the last 60,000 Jews of the Warsaw ghetto. In order to keep his superiors informed as to the daily progress of this murder expedition, which soon turned into something very different from what they had initially bargained for, Stroop had daily dispatches teletyped to Krüger, who in turn sent them on to Himmler.

Captured by U.S. forces in May 1945 and extradited to Poland in 1948 to stand trial for the war crimes he had committed in Warsaw, Stroop gave testimony during pre-trial hearings on the full range of his activities as leader of the *Großaktion*, including the making of what would come to be known as the *Stroop Report*:

> Since Himmler and Krüger were very interested in the progress of this operation, I had to send daily reports to Krüger, who forwarded them to Himmler. At the conclusion of the operation, in compliance with Krüger's wish, three bound books were made of these reports, one of which was for him, the second was to be sent on to Himmler via Krüger, and the third was for me. As far as I remember, an unbound file copy of the report (*das Konzept*) remained in the headquarters of the SS and Police Leader in Warsaw, in the care of Chief of Staff Jesuiter.[3]

Just as it was Krüger's idea to collect the daily reports in this way, it was also his suggestion that photographic records be kept of the operation. In a conversation while in prison in 1949, Stroop told of a meeting he had with Krüger on May 2, 1943, in which Krüger

> ...was particularly anxious that our accomplishments be preserved on film. During our final conference, held in my headquarters, he declared: 'Photographs of the Grand Operation will serve as invaluable tools for future historians of the Third Reich – for the Führer, for Heinrich Himmler, for our nationalist poets and writers, as SS training materials and above all, as proof of the burdens and sacrifices endured by the Nordic races and Germany in their attempt to rid Europe and the world of the Jews.'[4]

Though the idea for assembling the communiqués and for making a photo album was Krüger's, Stroop nevertheless wrote in his dispatch to Krüger on May 13, 1943:

> Unless ordered otherwise, I am going to submit to the conference of SS and Police Leaders a detailed report of the operation, including an appendix containing photos.[5]

This same intention is mentioned once again in the dispatch of May 16, 1943, indicating May 18, 1943 as the date of the forthcoming meeting at which Stroop would present his final report.

Knowing that the communiqués were being sent on to Himmler, Stroop may have felt it opportune to forewarn the SS Chief of his intention to submit the report at that meeting, not presuming to spring a surprise of any kind on so formidable a chief.

In any event, it should be emphasized that according to Stroop, a total of four copies were made of the report, three bound in leather and one unbound file copy. Intended for a very small circle of SS elite, the *Stroop Report* was by no means designed for propaganda purposes. (And to characterize the *Stroop Report* as a "newsletter" – see Chapter 1, footnote 1 – is ludicrous.)

Stroop entitled his report *The Jewish Quarter of Warsaw Is No More!* (*Es gibt keinen jüdischen Wohnbezirk in Warschau mehr!*), slightly altering a sentence he had written in the dispatch of May 16, 1943: "The former Jewish quarter of Warsaw is no longer in existence" ("*Das ehemalige jüdische Wohnviertel Warschau besteht nicht mehr*"). In order to avoid a title as clumsy as it is offensive, most commentators refer to the document simply as the *Stroop Report (Stroop-Bericht)*.

Stroop's fate

After leading the "grand operation" in Warsaw, Stroop was assigned to Athens in September 1943 to head the fight against the partisan movement in Greece. But he managed to antagonize fellow officers to such a degree that he was reassigned in November 1943 to Wiesbaden as Higher SS and Police Leader of Rhein-Westmark, where he remained until the end of the war.[6]

In early May 1945, he was captured by American forces in the town of Rottau in Bavaria, wearing the uniform of an infantry officer and bearing false discharge papers made out to a Captain of Reserve Josef Straup. For nearly two months, he stuck to the story that he was a *Wehrmacht* captain, then finally admitted to being Jürgen Stroop on July 2, 1945. Though it is sometimes claimed that a copy of the *Stroop Report* found on a bookshelf in his villa gave him away,[7] the Seventh Army Interrogation Center "Preliminary Interrogation Report" makes no mention of any such discovery.[8] Nor did Stroop have any idea as to how or where the Americans had obtained a copy of his report.[9]

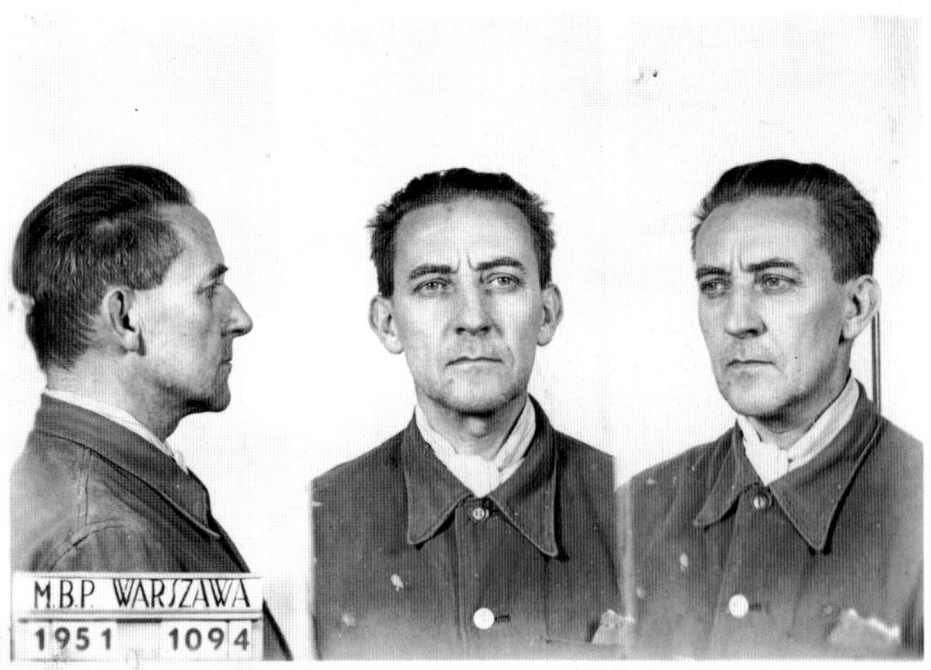

Jürgen Stroop in prison uniform. Photos provided by the Institute of National Remembrance – Commission for the Prosecution of Crimes against the Polish Nation, Office for the Preservation and Dissemination of Archival Records.

In January 1947, Stroop was tried by a U.S. military court in Dachau and sentenced to death for the shooting of American fliers captured in Rhein-Westmark. But at the request of the Polish authorities, the U.S. court agreed to forego carrying out the sentence, and instead to extradite the prisoner to Warsaw to stand trial for the crimes he had committed in Poland.

Stroop was tried in Warsaw in July 1951, found guilty and sentenced to death once again. He was hanged on March 6, 1952, utterly unrepentant.

What became of the originals

Two specimens of the *Stroop Report* were exhibited at the International Military Tribunals in Nuremberg in November 1945, sharing the document number 1061-PS, and when subsequently entered as evidence in December 1945, they shared the title "US Exhibit 275." According to the "Staff Evidence Analysis" prepared by the Office of the U.S. Chief of Counsel (OCC), the sources of these originals were listed as the Seventh Army Intelligence Center (SAIC) for the one, and the Military

 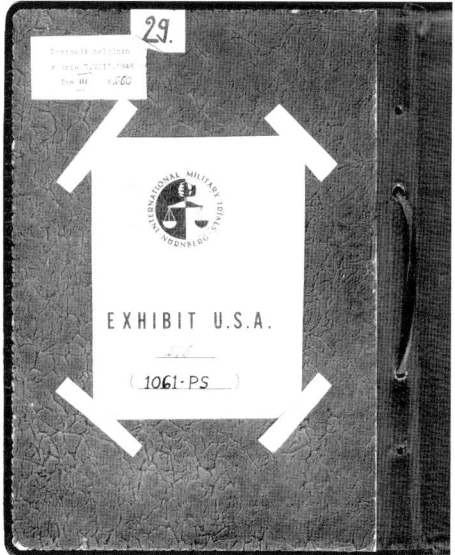

The rough leather binding (left) and inner front cover (right) of the Warsaw specimen of the Stroop Report. Visible on the inner cover are the Nuremberg labels of November and December 1945. The external measurements of the entire album are 30.5 x 23 x 3 cm. Photos provided by the Institute of National Remembrance – Commission for the Prosecution of Crimes against the Polish Nation, Office for the Preservation and Dissemination of Archival Records.

Intelligence Research Section (MIRS) in London for the other. (See Appendix II, pp. 61-62 below.)

One of those specimens, the one supplied by SAIC, was a leather-bound original. Having served its purpose in Nuremberg, it was sent to Warsaw by the OCC in 1948 on the request of the Polish authorities preparing their case against Stroop. It is still there today, in the care of the Institute of National Remembrance, and is the only leather-bound original whose whereabouts are now known.

The MIRS specimen is unbound, and is presumably the file copy which – according to Stroop – was kept at SS headquarters in Warsaw, though how it found its way to MIRS in London (if in fact it did) is a mystery. In any event, the MIRS copy is now at the National Archives and Records Administration (NARA) in Washington, D.C. That it is the file copy rather than one of the bound originals, is suggested not only by the absence of a leather binding, but also by the fact that Stroop's signature is missing from the final page of the introduction and that none of the 32 dispatches is signed by Stroop nor counter-signed by his chief of staff, Jesuiter. (All of these signatures are found in the leather-bound Warsaw specimen.)

LEFT. Title page of the leather-bound Warsaw specimen of the Stroop Report, *bearing the imprint of the International Military Tribunal in Nuremberg and of the Polish authorities in Warsaw. Photo provided by the Institute of National Remembrance – Commission for the Prosecution of Crimes against the Polish Nation, Office for the Preservation and Dissemination of Archival Records. RIGHT. Title page of the unbound NARA specimen, stamped by the MIRS (Military Intelligence Research Section) Library, the Document Section of SHAEF (Supreme Headquarters Allied Expeditionary Force) and the International Military Tribunal in Nuremberg.*

Widely circulated claims that all three leather-bound originals were recovered after the war and are currently located at NARA in Washington, the *Bundesarchiv* in Koblenz and the Chief War Crimes Commission in Warsaw, are simply incorrect.[10] The *Bundesarchiv* possesses no specimen of the document,[11] and the NARA copy – as already mentioned – is unbound and devoid of the signatures that were undoubtedly present in all three of the leather-bound specimens of the report.

It is therefore clear that two of the three leather-bound originals are now missing. One of them may be Stroop's which according to his adjutant, Karl Kaleske, was destroyed in a fire.[12] And though it is sometimes claimed that Stroop identified the leather-bound original shown to him in connection with his Warsaw trial as Himmler's,[13] Stroop – clearly referring to the prosecution's copy of his report – specifically stated in a deposition: "The judge showed me a bound book. Which book it is, I do not know, nor do I know in what way it fell into the hands of the

Americans" (see footnote 9). Stroop also suggested that the burned original referred to by Kaleske may have been Himmler's (*op. cit.*, p. 01020).

Further speculation as to whose original is now in Warsaw, or what became of the two missing leather-bound albums, seems pointless at this time.

From here on, I will refer to the two surviving specimens of the *Stroop Report* as the Warsaw and the NARA documents.

The photographer

Opinions differ as to who recorded the images of surrender and devastation that appeared in the pictorial section of the *Stroop Report*.

Judging from Sybil Milton's writings, it was the work of more than one photographer, and at least some of those involved belonged to PK 689, a propaganda unit (*Propaganda Kompanie*) active since the creation of the Warsaw ghetto, recording scenes of Jewish life and death during the early years.[14] Albert Cusian, Erhard Josef Knobloch and Arthur Grimm were among the photographers of this unit. Sybil Milton suggested that photographers attached to the *Maschinelles Berichtswesen* (MB) of the Organization Todt were also involved, including a man named Ewald Gnilka. When asked in 1982 who took the photograph of the boy with his hands raised, Sybil Milton reportedly told the journalist that it might have been Arthur Grimm (of PK 689), who was still alive at that time.[15]

Another candidate is Albert Cusian, also working in PK 689. On a tip from a survivor of the Warsaw ghetto, he was tracked down to a small German town near the Danish border by the *Sunday Times* of London and interviewed by Antony Terry. On the basis of that interview, Phillip Knightley and Antony Terry then co-wrote an article published on April 21, 1968 and entitled: "25 years after. *The Sunday Times* tracks down the man who found 'the subject matter was so interesting' and took these pictures of man's inhumanity to man."[16] The words "these pictures" ostensibly refer to the two photographs visible just to the right of the title, one of which is the picture of the boy with his hands raised, though that photograph isn't specifically mentioned in the article.

In an effort to find out whether Albert Cusian explicitly stated in his interview that he took that photograph, I contacted Phillip Knightley, who kindly confirmed in an e-mail dated June 9, 2003, that to the best of his recollection, Cusian "made it clear" that he had taken *that* picture. And Phillip Knightley also confirmed that the heading was indeed intended to refer specifically to *that* photograph. However Antony Terry, who actually met with Cusian, died several years ago, which means that no additional first-hand confirmation is now possible.

Very different conclusions were reached by a Polish researcher, Magdalene

Kunicka-Wyrzykowska, who stated categorically in 1983 that the photos in the *Stroop Report* were taken by the Security Police and SS-Obersturmführer Franz Konrad, who was *Leiter für Werterfassung* (in charge of the confiscation of property) in the Warsaw ghetto.[17] According to Magdalene Kunicka-Wyrzykowska, the photos made by the SD and Konrad were collected by Stroop's Chief of Staff, M. Jesuiter, and from this collection, Stroop chose the pictures he would use in his report.[18] Unfortunately, no source is given in the article for this information.

When questioned along with Stroop at their Warsaw trial in 1951, Franz Konrad claimed that he photographed scenes documenting the murder of Jews in the ghetto *in order to incriminate Stroop in a report to be sent secretly to Hitler*.[19] But even if that were Konrad's intention, it would be essential to establish whether the photos Konrad referred to in this connection were the ones appearing in the *Stroop Report* or a separate set of pictures. I have to date found no unequivocal clarification of that issue. Furthermore, Stroop's Warsaw adjutant, Karl Kaleske, made no mention of Konrad in his own brief account, identifying the photographers who took the pictures in the *Stroop Report* as members of the Security Police.[20]

In any event, in the files of the Jewish Historical Institute in Warsaw, the "author" of the photograph of the little boy with his hands raised is unequivocally listed by archivist Jan Jagielsky as Franz Konrad,[21] and a thesis recently defended in the Czech Republic also attributes the photos of the *Stroop Report* to Franz Konrad.[22]

The first public mention of the *Stroop Report* and photo

At the International Military Tribunal in Nuremberg, the U.S. Chief of Counsel, Supreme Court Justice Robert H. Jackson, gave a prominent place to the *Stroop Report* in his opening statement for the prosecution on November 21, 1945, when he said:

> "I shall not dwell on this subject longer than to quote one more sickening document which evidences the planned and systematic character of the Jewish persecutions. I hold a report written with Teutonic devotion to detail, illustrated with photographs to authenticate its almost incredible text, and beautifully bound in leather with the loving care bestowed on a proud work. It is the original report of the SS Brigadier General Stroop in charge of the destruction of the Warsaw Ghetto, and its title page carries the inscription 'The Jewish ghetto in Warsaw no longer exists.' It is characteristic that one of the captions explains that the photograph concerned shows the driving out of Jewish 'bandits'; those whom the photograph shows being driven out are almost entirely women and little children. It contains a day-by-day account of the killings mainly carried out by the SS organization, too long to relate but let me quote General Stroop's summary:

The resistance put up by the Jews and bandits could only be suppressed by energetic actions of our troops day and night. The Reichsfuehrer SS ordered, therefore, on 4/23/1943, the cleaning out of the ghetto with utter ruthlessness and merciless tenacity. I, therefore, decided to destroy and burn down the entire ghetto without regard to the armament factories. These factories were systematically dismantled and then burned. Jews usually left their hideouts, but frequently remained in the burning buildings and jumped out of the windows only when the heat became unbearable. They then tried to crawl with broken bones across the street into buildings which were not afire. Sometimes they changed their hideouts during the night into the ruins of burned buildings. Life in the sewers was not pleasant after the first week. Many times we could hear loud voices in the sewers. SS men or policemen climbed bravely through the manholes to capture these Jews. Sometimes they stumbled over Jewish corpses: sometimes they were shot at. Tear gas bombs were thrown into the manholes and the Jews driven out of the sewers and captured. Countless numbers of Jews were liquidated in sewers and bunkers through blasting. The longer the resistance continued the tougher became the members of the Waffen SS, Police and Wehrmacht who always discharged their duties in an exemplary manner. Frequently Jews who tried to replenish their food supplies during the night or to communicate with neighboring groups were exterminated.

Robert H. Jackson at the podium at the Nuremberg War Trials. Photo by Raymond D'Addario. Used with kind permission of the Robert H. Jackson Center for Justice.

'This action eliminated', says the SS commander, 'a proved total of 56,065. To that, we have to add the number killed through blasting, fire, etc., which cannot be counted.'" (1061- PS)[23]

Although the caption of the photograph of the boy with his hands raised does not contain a reference to bandits – the caption being "Pulled from the bunkers by force" (*Mit Gewalt aus Bunkern hervorgeholt*) – it is clear that this is the photograph Robert Jackson described in his speech, since it is the only picture in the *Stroop Report* showing "almost entirely women and children."

This was the first public mention of the photo, described verbally on that occasion and apparently not projected onto a screen in the courtroom.[24] Nor was it among the five photos from the *Stroop Report* that were projected on a screen on December 14, 1945.[25] It was however one of 18 pictures included in "a selection of photographs from the original document" in *Trial of the Major War Criminals before the International Military Tribunal, Nuremberg 14 November 1945 – 1 October 1946* ("Blue Series"), vol. 26, published in 1947.[26]

In one way or another, several of the defendants at the trial distanced themselves, at least informally, from such SS operations as the *Großaktion* in the Warsaw ghetto. On the day of Justice Jackson's opening address, Hermann Goering, Hitler's second-in-command, complained to a court psychologist that "the German people will be for ever condemned by these brutalities," and claimed that the atrocities were carried out by Himmler's "chosen psychopaths" and were "kept secret from the rest of us."[27] On a subsequent occasion (December 14, 1945) when the *Stroop Report* was again invoked as evidence and damning passages were read aloud in the courtroom, Alfred Jodl, Hitler's Chief of Operations, shouted loudly and vehemently [during an interval],

> "The dirty arrogant SS swine! Imagine writing a 75-page boastful report on a little murder expedition, when a major campaign fought by soldiers against a well armed enemy takes only a few pages!"[28]

The textual sections of the *Stroop Report*

PRELIMINARIES *6 pages, A4 format, Bristol board with ragged edges.*
Immediately following the title page is a section listing the troops killed or wounded in the service of their Führer and Fatherland "in the battle for the destruction (*Vernichtung*) of the Jews and bandits in the former Jewish quarter of Warsaw." The initial note struck by Stroop is therefore one that clearly signals the genocidal nature of the operation, while emphasizing devotion and sacrifice

in the face of danger. This section ends with a list of the SS, Wehrmacht and other units deployed in the *Großaktion*.

INTRODUCTION *12 pages, A4 format, Bristol board with ragged edges. While the Warsaw specimen contains three sections (labeled I, II and III), the NARA copy includes a fourth section (IV), the contents of which are identical to those of the May 24th dispatch, enumerating the total number of Jews captured and killed during the operation as well as the amount of weapons, uniforms and money captured by the SS.*

Signed by Stroop (in the Warsaw specimen) and dated May 16, 1943, this section of the report briefly covers a number of issues, describing for example: the hygienic purpose initially served by isolating the Jews in a ghetto; the subsequent need to remove them altogether because of "security considerations"; the "resettlement" of 310,322 Jews in the first deportation of July 22 to October 3, 1942, and the deportation of approximately 6,500 more in January 1943; Himmler's decision to transfer armament and defense industries from the ghetto to Lublin and to clear the ghetto of all remaining Jews – an operation expected to take three days; the failed attempt of Stroop's predecessor Sammern-Frankenegg to penetrate the ghetto at 6 a.m. on April 19, 1943 and Stroop's taking command, at Himmler's orders, as of 8 a.m. on the same day, eventually forcing "the enemy [...] to withdraw from roofs and from strongholds above ground level into basements, bunkers, and sewers;" the suffering inflicted on the Jews, of whom a total of 56,065 were "apprehended and/or destroyed," while an additional, indeterminate number were killed in explosions, fires, etc.

Perhaps the most graphic passage in the introduction is one that the U.S. Chief Prosecutor Robert Jackson quoted in his opening statement at the International Nuremberg Tribunal on November 21, 1945, cited on p. 33 above.

DAILY REPORTS *[Tägliche Meldungen] 57 and 56 pages, incl. section title page, in the Warsaw and NARA specimens respectively, both of which contain 32 communiqués (24 of them typed on both sides of the page, the remaining eight fitting on one side of the page); the pages in the Warsaw specimen appear to be original typed copies on ordinary A4 paper, with the exception of the May 24th communiqué which is clearly a photostat;[29] the pages in the NARA specimen appear to be either original typed copies or good carbon copies, including the May 24th communiqué.*

Whatever else these dispatches may be, they are above all a kind of score sheet, indicating not only the number of Jews killed or captured each day, but also – beginning with the seventh communiqué – providing the *cumulative* count, starting

with a total of 19,450 Jews "apprehended or destroyed" as of April 23, and ending with a grand total of 56,065 on May 16.

According to these dispatches, the killing of the Ghetto Jews took a number of forms.

5,000 to 6,000 – the figure is Stroop's own guess (dispatch of May 24) – were burnt to death or died in explosions when their hideouts were set alight or blown up by his forces.

Another 7,000 (again Stroop's estimate) "were destroyed directly in the course of the Grand Operation." This figure covers not only those who were killed in battle or while resisting arrest. It also refers to two categories of victims who offered no resistance whatsoever. Some were shot while trying to escape from the flames:

> During the night, the fires we had started earlier forced the Jews to appear in front of the housing blocks to escape from the flames in any way they could. Until then, they had remained hidden in attics, cellars, and other hideouts despite our search operations. Masses of burning Jews – entire families – jumped from windows or tried to lower themselves using tied-together bed sheets, etc. Measures had been taken to liquidate these as well as the other Jews immediately (first of three dispatches dated 22 April).

Others were shot after being extracted from their hideouts, and surrendering to their captors. Stroop wrote in two dispatches:

> A total of 1,690 Jews was apprehended alive […] Because darkness set in, we did not proceed with the immediate liquidation. (*Die sofortige Liquidierung wurde wegen Eintritt der Dunkelheit nicht mehr durchgeführt.*) I will try to obtain a train for T II tomorrow. Otherwise the liquidation will be carried out tomorrow (25 April). [The entire dispatch is reproduced on pp. 37-38 below.]

> Results of today's operation: 30 Jews transferred; 1,330 Jews pulled from bunkers and immediately destroyed (*1 330 Juden aus Bunkern hervorgeholt und sofort vernichtet*); 362 Jews shot dead in battle. Total apprehended today: 1,722 Jews (26 April).

"T II" refers to the Treblinka extermination camp, to which more than 300,000 Jews were "resettled" during the first deportation from the Warsaw ghetto (July 22 – October 3, 1942), and which at the time of the "Grand Operation" was being dismantled but could still accommodate smaller batches of victims. According to Stroop, "6,929 were annihilated (*vernichtet*) via transport to T II" (May 24th).[30]

Returning now to the photograph, and using these dispatches as a basis for understanding what is likely to have happened to Jews who were classified as

```
Absender:  Der SS- und Polizeiführer im Distrikt Warschau

                           Warschau, den 25.4.1943.

Az.: I ab -St/Wdt.- 16 o7 - Tgb.Nr. 549/43 geh.
Betr.: Ghettoaktion

An den
Höheren SS- und Polizeiführer Ost
SS-Obergruppenführer und General der Polizei
K r ü g e r - o.V.i.A.
K r a k a u

   Verlauf der Aktion am 25.4.43, Beginn 13.oo Uhr.
   Es wurden für den heutigen Tag 7 Durchkämmungsstoßtrupps ge-
   bildet, Stärke 1/70, denen je ein bestimmter Häuserblock zuge-
   wiesen wurde.
   Auftrag: "Nochmalige Durchkämmung sämtlicher Gebäude, Feststel-
   lung von Bunkern und Sprengung derselben sowie Erfassung der Ju-
   den. Dort, wo sie irgendwie Widerstand leisten oder die Bunker
   nicht erreicht werden können, sind die Gebäude niederzubrennen".

   Neben der Tätigkeit dieser 7 Durchkämmungsstoßtrupps wurde ein
   besonderes Unternehmen gegen ein außerhalb der ehem. Ghetto-
   mauer liegendes Banditennest unternommen, welches nur von Polen
   bewohnt war.

   Das heutige Unternehmen endete bei fast sämtlichen Stoßtrupps
   damit, daß Riesenbrände entstanden und dadurch die Juden zum Ver-
   lassen ihrer Verstecke und Schlupfwinkel veranlaßte. Es wurden
   insgesamt 1 69o Juden lebend erfaßt. Nach Erzählung der Juden
   sind hierunter mit Bestimmtheit abgesetzte Fallschirmspringer
   und solche Banditen, die von einer unbekannten Stelle mit Waffen
   beliefert wurden. 274 Juden wurden erschossen und wie an allen
   Tagen ungezählte Juden in gesprengten Bunkern verschüttet und
   wie immer wieder festgestellt werden kann, verbrannt. Mit der
   heutigen Beute an Juden sind meines Erachtens ein sehr
   großer Teil der Banditen und niedrigsten Elemente des Ghettos
   erfaßt worden. Die sofortige Liquidierung wurde wegen Eintritt
   der Dunkelheit nicht mehr durchgeführt. Ich werde versuchen, für
   morgen einen Zug nach T II zu erhalten, andernfalls die Liqui-
   dierung morgen durchgeführt wird. Auch am heutigen Tage wurde
   wiederholt Widerstand mit Waffen geleistet und in einem Bun-
   ker 3 Pistolen und Sprengkörper erbeutet. Ferner wurden am heu-
   tigen Tage erhebliche Bestände an Papiergeld, Devisen, Goldmün-
   zen und Schmuckgegenständen sichergestellt. Die Juden verfügen
   immer noch über erhebliche Vermögenswerte. Wenn gestern nacht
   das ehem. Ghetto von einem Feuerschein überzogen war, so ist
   heute abend ein riesiges Feuermeer zu sehen. Da bei den plan-
   mäßigen und regelmäßigen Durchkämmungen immer wieder Juden in
   großer Zahl aufgespürt werden, wird die Aktion am 26.4.43 fort-
   gesetzt. Beginn 10.oo Uhr.
```

The dispatch Stroop teletyped to Krüger on April 25, 1943. The main paragraph on this page contains a passage cited above: "A total of 1,690 Jews was apprehended alive [...] A total of 274 Jews was shot. [...] Because darkness set in, we did not proceed with the immediate liquidation. I will try to obtain a train for T II [Treblinka] tomorrow. Otherwise, the liquidation will be carried out tomorrow." My photo of the NARA document.

Mit dem heutigen Tage wurden insgesamt 27 464 Juden des ehem. jüd. Ghettos Warschau erfaßt.

Eigene Kräfte: Wie am Vortage.

Eigene Verluste: 3 Angehörige der Waffen-SS und ein Angehöriger der Sicherheitspolizei verwundet.

Bisherige Gesamtverluste:

Waffen-SS	27	Verwundete
Ordnungspolizei	9	"
Sicherheitspolizei	4	"
Wehrmacht	1	"
Trawniki-Männer	9	"
	50	Verwundete

und 5 Tote, davon:

Waffen-SS	2	Tote
Wehrmacht	2	"
Trawnikim	1	"
	5	Tote.

Der SS- und Polizeiführer
im Distrikt Warschau

gez. Stroop
SS-Brigadeführer
und Generalmajor d. Polizei

F.d.R.:

SS-Sturmbannführer.

089778

The back of the April 25th dispatch, indicating that as of that date, "a total of 27,464 Jews of the former Warsaw Jewish Ghetto have been apprehended." Note that this copy of the dispatch, like all others in the NARA document, is neither signed by Stroop nor counter-signed by his chief of staff, suggesting that this document is indeed the file copy to which Stroop referred under interrogation, rather than one of the three leather-bound specimens. My photo of the NARA document.

"Pulled from the bunkers by force" (*Mit Gewalt aus Bunkern hervorgeholt*), we can conclude that there are basically two possibilities: either they were marched off to the *Umschlagplatz* and then herded into trains bound for a death camp, or they were "liquidated" on the spot.

There are of course many other issues raised by these dispatches, some of which will be briefly mentioned on p. 55 below.

The photographic section of the *Stroop Report*

"Pictorial Report" [Bildbericht], 50 and 52 pages (including section title page), in the Warsaw and NARA specimens respectively, both of which contain 53 photos. The photos in the Warsaw specimen are mounted on the same A4 Bristol board pages, with ragged edges, used in the preliminary and introductory sections. All but three of the photos in the NARA specimen are mounted on Bristol board pages with ragged edges, the only exceptions being those numbered 14, 34 and 39 below, which are mounted on cardboard with straight edges. This is worth noting since the first of these three photos (number 14) is that of the boy with raised hands.

While the only difference between the textual sections of the NARA and Warsaw specimens concerns the inclusion or omission of a fourth section in Stroop's introduction, the "Pictorial Report" of the NARA copy diverges from that of the Warsaw document in a number of ways. For the sake of clarity, I will make the Warsaw specimen the basis for a description of the photographic section, and will point out divergences in the NARA copy whenever relevant.

In order to give the reader a sense of exactly what the photographs show, I am providing an overview containing small reproductions of all 53 photographs in the Warsaw document, along with translations of their handwritten captions. And since it would be useful to refer to specific pictures by number from this point on, I am numbering the photos from 1 to 53, disregarding the more complex numbering system used on the pages of the "Pictorial Report." The measurements listed below include a white border found on most of the pictures and generally about 5 mm in breadth.

NB. *The 53 images reproduced below were all provided by the Institute of National Remembrance – Commission for the Prosecution of Crimes against the Polish Nation, Office for the Preservation and Dissemination of Archival Records.*

1. The building of the former Jewish Council 13 x 18 cm

2. Vacate the plants! 13 x 18 cm

3. Discussing the evacuation of an enterprise 12.5 x 17.5 cm

4. The Jewish department heads of the armament firm Brauer 13 x 18 cm

5. The Brauer firm 13 x 18 cm

6. On the way to the Umschlagplatz 18.3 x 12.8 cm [This photo is missing from the facsimile editions and from web sites offering scans of the photos.]

7. Pulled from the bunkers by force
17.8 x 12.4 cm

8. To the Umschlagplatz 18 x 13 cm

9. Search and interrogation 18.5 x 13.8 cm

10. Jewish rabbis 17.8 x 12.4 cm

11. Jewish rabbis 17.7 x 12.5 cm

12. Dregs of humanity 12.5 x 17.7 cm

13. An assault detachment 17.5 x 12.5

14. Pulled from the bunkers by force 17.75 x 12.5 cm

15. These bandits offered armed resistance 12.4 x 17.7 cm

16. Just pulled from a bunker 17.7 x 12.4 cm

17. Bandits 18 x 13 cm

18. Bandits destroyed in battle 18.3 x 12..8 cm

19. *A bunker being opened 18 x 13 cm*

20. *Jewish traitors 17.5 x 12.5 cm*

21. *Smoking out the Jews and bandits 18 x 12.3 cm*

22. *A spot that has been readied for escape and jumping 18 x 13 cm*

23. *Destruction of a housing block 18 x 13 cm*

24. *[No caption] 18 x 13 cm*

25. [No caption] 18 x 13 cm

26. HeChalutz women captured with weapons 13 x 18 cm

27. A housing block being destroyed 13 x 18 cm

28. Transporting Jews onward 18 x 13 cm

29. [No caption or border, white "1" near top] 17 x 12.2 cm

30. [No caption or border, white "2" near top] 17.8 x 12.5 cm

31. [no border, white "3" near top] Pictures of so-called residential bunkers 17 x 12.5 cm

32. [No caption or border, white "4" near top] 12.4 x 17 cm

33. [No caption or border, white "5" near top] 12.4 x 17 cm

34. Before the search 14 x 9 cm

35. Securing a street 9 x 14 cm [on same page as preceding picture]

36. They were also found in underground bunkers 14 x 9 cm

37. In combat against a resistance pocket 12 x 9.1 cm [on same page as preceding picture

38. In combat against a resistance pocket 12 x 9.1 cm

39. Bandits jump to escape arrest 12 x 9.1 cm [on same page as preceding picture]

40. Bandits who jumped 12 x 9 cm

46 RICHARD RASKIN

41. *Radio car of the command post*
18 x 13.1 cm

42. *Askaris assigned to the operation*
12 x 9 cm

43. *The leader of the grand operation 17.7 x 12.5 cm [on same page as preceding picture]*

44. *Views of the former Jewish quarter after its destruction 18 x 13 cm*

45. *[No caption] 17.5 x 12.6 cm*

46. *[No caption] 18 x 13 cm*

47. *[No caption] 18 x 13 cm*

48. *[No caption] 18 x 13 cm*

50. *[No caption] 18 x 13.1 cm*

49. *[No caption] 13.1 x 18 cm*

51. [No caption] 13.2 x 18 cm

52. [No caption] 17.8 x 13.2 cm

53. [No caption] 18 x 13 cm

 37 of the 53 photos in the Warsaw document are also in the NARA copy, though not necessarily in the same order nor of the same size.[31] And in the case of three other photos, the 7th, 15th and 41st in the Warsaw document, there is a NARA variant, taken of the same scene but a moment earlier or later and from another angle. Two of those sets of variants – the ones involving pictures often appearing in collections of Holocaust images – are shown here:

7th photo, Warsaw document

7th photo, NARA document

Mit Gewalt aus Bunkern hervorgeholt
Pulled from the bunkers by force

Nach dem Umschlagplatz
To the transfer station

15th photo, Warsaw document *18th photo, NARA document*

Diese Banditen verteidigen sich mit der Waffe *Diese Banditen verteidigen sich mit der Waffe*
These bandits defend themselves with weapons *These bandits defend themselves with weapons*

The two photos from the Warsaw document were provided by the Institute of National Remembrance – Commission for the Prosecution of Crimes against the Polish Nation, Office for the Preservation and Dissemination of Archival Records. My reproductions from the NARA document.

Note that in the uppermost pair of variants, the captions differ as well. In the Warsaw document, the caption is the same as that of the photo of the boy with his hands raised ("Pulled from the bunkers by force"), while in the NARA document, the caption reads "To the *Umschlagplatz*." And as it happens, the identity of the four people at the head of the column of prisoners is known.[32] This and the photo of the boy with his hands raised are the only photographs in the "Pictorial Report" clearly showing one or more children in the picture;[33] but although a little girl is in the front row of the marching column, she is not the center of attention in the photo in the same way that the boy is in his. Nor are there in this photo of the marching column other children clearly present, as in the photo of the boy.

Of the 16 photos in the Warsaw document that are not represented in the NARA specimen, the one that is most striking is the picture of the captured *HeChalutz* women (the 26th in the series, shown on p. 44 above). And of the 16 photos in the NARA document not found in the Warsaw specimen, none stands out as particularly memorable.

The captions in both sets of photos are hand-written in the same Gothic script, probably not by Stroop himself.[34] The word "bandits" is used to refer to Jews in the captions of five photos ("These bandits offered armed resistance," "Bandits," "Bandits destroyed in battle," "Bandits jump to escape arrest," and "Bandits who jumped," photos 15, 17, 18, 39 and 40 respectively), while in a sixth photo (No. 21, "Smoking out the Jews and bandits") the word presumably refers to Polish

resistance fighters if to anyone at all. Other captions define the Jews shown in the photos for example as "Dregs of humanity" (12), or traitors (20).

More than half the pictures in both the Warsaw and NARA documents fall into one of two categories. Approximately 15 show buildings on fire or in ruins, or deserted smoke-filled streets and the point they make is that of the full title of the report: that the Warsaw ghetto has been destroyed and is no more. Another 15 or so show Jews taken prisoner, or leaping to their deaths or already shot. In eight or nine of the photos showing Jewish prisoners the captives have their hands up, and here again the overall message is clear: that Jewish resistance has been crushed and that surrender is now the order of the day.

Two smaller blocks consist of about 5 photos each, one borderless series (numbered from 1 to 5 on the photos themselves) showing the insides of bunkers, while the pictures in the other block illustrate SS or their helpers at work (that is pictures that do not include Jewish prisoners). The remaining pictures are each in a category of its own, showing for example the Jewish counsel building when it was still intact, Jews vacating a plant, two men conversing with SS officers and labeled "Jewish traitors" in the caption, etc.

Intended and unintended functions of the *Stroop Report*

The following discussion is by no means exhaustive, nor does it deal directly with the photograph that is our primary interest. But it will help to pave the way for the approaching study of the photograph itself, as seen from an SS perspective, and will conclude our discussion of the *Stroop Report* in general.

1. A commemorative function

As already mentioned at the start of this chapter, Krüger urged Stroop to produce a report and photographic documentation that would preserve a record of their "accomplishments," and that would serve as

> invaluable tools for future historians of the Third Reich – for the Führer, for Heinrich Himmler, for our nationalist poets and writers, as SS training materials and above all, as proof of the burdens and sacrifices endured by the Nordic races and Germany in their attempt to rid Europe and the world of the Jews.[35]

The destruction of the ghetto and slaughter of its approximately 60,000 remaining inhabitants were for Stroop the results of an ultimately successful hunting expedition. Seen in this light, the photographs were essentially trophies, and the

The 14th photo in the Warsaw specimen of the **Stroop Report**. *The photograph, mounted on ragged-edged Bristol board, measures 17.75 x 12.5 cm (including a white border of approx. 5 mm). The caption, "Mit Gewalt aus Bunkern hervorgeholt" ("Pulled from the bunkers by force"), is hand-written directly on the Bristol board, below the photograph. Photo provided by the Institute of National Remembrance – Commission for the Prosecution of Crimes against the Polish Nation, Office for the Preservation and Dissemination of Archival Records.*

The 17th photo in the NARA specimen of the Stroop Report. *The photograph is one of three mounted on straight-edged cardboard, rather than ragged-edged Bristol board. The photographic paper measures 19.7 x 15.6 cm, while the image itself measures 17.2 x 11.2 cm. The caption, "Mit Gewalt aus Bunkern hervorgeholt" ("Pulled from the bunkers by force") is photographically reproduced along with the image; in other words, the photo and caption on the Warsaw page were photographed, and reproduced on the photo paper mounted on the corresponding page in the NARA document. In the process, the upper, right and left edges of the Warsaw photo were slightly cropped. Note, for example, that the fingers on the right hand of the woman standing farthest to our left, cannot be seen on the NARA copy of the photo, while they are visible on the Warsaw original. My photo of the NARA document.*

THE ORIGINS OF THE PHOTO: THE STROOP REPORT

dispatches score-sheets enabling Stroop to relive what he saw as his life's triumph and to present it as such.

That Stroop had been encouraged by Himmler to perceive his own management of the operation as a performance, was made clear in the conversations Stroop had with Moczarski in their shared prison cell in 1949. Recalling the euphoric moment when he replaced von Sammern-Frankenegg (mentioned on p. 35 above), Stroop told of the phone call he received from Himmler on the night of April 19, 1943, when the Reichsführer SS said to him:

> …you've only been through Phase One of the Grand Operation. The events of April nineteenth were a mere prelude to an event which will go down in history: Warsaw's *Großaktion.* You conducted the overture magnificently. It was a particularly fine performance when compared to that nincompoop von Sammern's rendition. As a lover of Wagner and our National Socialist opera conductors, permit me to say: 'Play on, Maestro. Our Führer and I won't forget you.[36]

It was in this spirit that Stroop elaborately planned a fitting end for the operation (ibid., p. 164):

> "After a careful review of the situation, I decided to end the Grand Operation on the evening of May sixteenth, 1943, at eight-fifteen in a suitably artistic manner – by blowing up the Great Synagogue near Tlomacka Street. Krüger had suggested this finale during his Warsaw visit, giving Jesuiter plans prepared by his top engineers in Krakow, showing how and where to bore holes and place explosives. The operation took ten days to prepare… " Stroop sighed, his eyes gleaming with remembered pleasure. "What a marvelous sight it was. A fantastic piece of theater. …an unforgettable tribute to our triumph over the Jews."[37]

The Jewish Quarter of Warsaw Is No More! was at least in part a memento and permanent record of that triumph for Jürgen Stroop.

2. Narrative appropriation of the event

For Jürgen Stroop, making a book about the operation was a way of taking fuller possession of it, of turning it symbolically into his own narrative, by ascribing to himself the role of historian, presiding over the telling and transmission of the story. In this perspective, the photographs were expressions of Stroop's power over the ghetto and over those who had been forced to live and die there, in the sense that "To photograph is to appropriate the thing photographed," as Susan Sontag wrote.[38] Furthermore, the captions that were undoubtedly added on Stroop's instructions, enabled him to define the point of each photo as he chose. And making

the album was his way of achieving closure, of wrapping up the sprawling and often uncontrollable event in one neat package.

3. Face-saving functions

An operation that was expected to take three days required an entire month to complete, despite the heavy artillery, tanks and even air strikes used against a small number of poorly armed civilians. And while much of it was a cat-and-mouse game that Stroop undoubtedly enjoyed – the look of satisfaction on the face of "The leader of the *Großaktion*" (No. 43, reproduced on p. 47 above and p. 97 below) was not entirely posed – he was nevertheless frustrated by the Jews who had the effrontery to defy him and the Nazi state by attempting to hide, to escape or even to resist. And he was certainly aware that his every move had been monitored by Himmler.

In one of the best studies of the Warsaw ghetto, Yisrael Gutman described the embarrassment caused by the length of time required to complete the *Großaktion*:

> A clear-cut order demanded that every Jew be trapped and liquidated or sent to a camp. Yet in the heart of a large metropolis, clandestine Jewish life continued to go on below ground, and even after weeks of employing the most radical and brutal tactics, the Germans had difficulty snuffing it out. The "battle of the bunkers" held down German troops and above all, took time. And that time – the days and weeks – was precisely what discomfited the Germans most. The *Aktion*, conceived as a three-day final purge of the Warsaw ghetto, had turned into a drawn out and far from routine battle in which German military and police forces were pitted against Jewish civilians holed up in bunkers. In full view of the Polish public, under the curious and mocking gaze of the population of a city that was the focus of constant security problems, the "battle of the bunkers" was regarded as a blot on the Germans' prestige and a serious security risk.[39]

In his texts and photos, Stroop could attempt to counteract that loss of prestige by: a) portraying himself and his men as the heroes of the story and the Jews as treacherous bandits;[40] b) giving himself alibis for needing so much time to put down the revolt;[41] and c) accounting in some face-saving way for the pitifully small number of captured weapons he could produce.[42]

4. A warning against future uprisings

It appears that Himmler passed his copy of the *Stroop Report* to his subordinate Adolf Eichmann, for a very specific purpose that overshadowed the intended functions of the report for the top SS leadership.

In his memoir, the first part of which was published by *Life Magazine* in November 1960, Eichmann wrote:

> The uprising of the Warsaw Ghetto in 1943, however, taught us a bitter lesson about putting excessive numbers of people into these enclosures. Not long after this uprising I received in my office a photo album with an accompanying memo from Reichsführer Himmler, the album showed the phases of that battle, whose severity surprised even the German units fighting in it. I still recall today how we in the SS and the Wehrmacht suffered disproportionately high casualties putting down this revolt. I could not believe, seeing the pictures, that men in a ghetto could fight like that. During this great blood-letting in Warsaw the order went out to the German occupation authorities to comb the country relentlessly. This was done so thoroughly that after a while there was no more Jewish question in Poland at all. Elsewhere, even inside the Reich itself, the Warsaw Ghetto uprising had its effect in stringent measures against those Jews still engaged in forced factory labor. It was not in vain that Himmler put his entire weight behind this severity. Previously the directors of the big German factories, even Göring himself, the administrator of the Four Year Plan, had intervened on behalf of sparing Jews for the labor force. Now we in the Gestapo said simply, "Very well, you take the responsibility that things do not come to an uprising like the Warsaw Ghetto." When we said that, the urge to intervene left them. The Warsaw Ghetto uprising had an equally strong effect with authorities in the other occupied countries. Every national leadership was anxious to remove factors of unrest. My advisers now had a perfect entree in the countries where they were assigned. We could and did use the Warsaw example like a traveling salesman who sells an article all the more easily by showing a special advertising attraction. With Hungary we were particularly concerned. The Hungarian Jews had lived through the war relatively untouched by severe restrictions. Now Himmler made it clear that he wanted Hungary combed with a tremendous thoroughness before the Jews could really wake up to our plans and organize partisan resistance. For this reason, he chose me to lead the march into Hungary in person.[43]

The photograph appearing on the page in which this passage begins in *Life Magazine*'s publication of the Eichmann memoirs is that of the boy with his hands raised.

5. Evidential functions

The importance of the *Stroop Report* as evidence of war crimes at the Nuremberg trials has already been pointed out with respect, for example, to Chief Prosecutor Robert H. Jackson's opening speech (pp. 32-34 above). Having Stroop's own painstaking written and photographic documentation for the mass murder of Polish Jews was of incalculable importance in establishing the scope and nature of Nazi

atrocities and has also been an invaluable source of information for historians of the Warsaw ghetto.

6. Memorial functions

Some of the photographs in the "Pictorial Report" have appeared in numerous collections of Holocaust images and have for decades been part and parcel of a collective process of grieving and remembrance.[44] Readers of these photo anthologies are not always made aware of the SS origins of these photographs, and the images are often perceived as though they had been intended as damning records of Nazi outrages, rather than as celebrations of a genocidal project.

Appendix I

THE WARSAW GHETTO: A CHRONOLOGICAL OVERVIEW

27 Sept. 1939 — German troops enter Warsaw.

4 Oct. 1939 — Adam Czerniakow, leader of the Jewish community of Warsaw, is given 24 hours to set up a Jewish Council (*Judenrat*), with himself as its head.

12 Oct. 1940 — Hans Frank, the German *Generalgouverneur* of Poland, issues a decree announcing the establishment of a ghetto in the old Jewish quarter of Warsaw. The ghetto is initially to contain the Jews of Warsaw, then numbering approx. 360,000.

15 Nov. 1940 — Walls and barbed wire surrounding the ghetto now seal it off completely from the rest of the city.

1 Dec. 1940 — Every Jew in Warsaw, from the age of 12, is required to wear a white armband with a blue Star of David on his or her right arm.

Jan. 1941- July 1942 — Jews from other Polish communities and from Germany, as well as several hundred Roma (Gypsies), are herded into the ghetto, whose population peaks in March at 445,000. There are on average about 15 persons per apartment, and 6 or 7 persons per room. As a result of starvation, typhus and exposure, as well as random beatings and shootings, thousands die each month.

22 July 1942 — *The first deportation*. The Nazis begin transporting massive numbers of Jews from the ghetto to the Treblinka II extermination camp, 50 miles northeast of Warsaw, via freight cars the Jews are forced to board at an assembly point (*Umschlagplatz*). Unwilling to assist the Nazis in organizing the deportations, the head of the Jewish Council, Adam Czerniakow, commits suicide on July 23. Between July 22 and October 3, 310,322 Jews are "resettled" (according to the Nazis' own figures).

28 July 1942 — Representatives of Hashomer Hatzair, Dror, HeChalutz, and Akiva found the Jewish Fighting Organization of the Warsaw ghetto.

22 Sept. 1942	The formal control of Jewish affairs in the ghetto is transferred from the Jewish Council to the SS and SD.
20 Oct. 1942	With approx. 60,000 Jews left in the ghetto, and the prospect of further deportations at some future point, a coordinating committee of underground resistance groups is formed. The main group is the leftist ZOB (*Zydowska Organizacja Bojowa* or Jewish Fighting Organization), led by 23-year-old Mordecai Anielewicz. At the time of the April uprising, ZOB will be about 600 to 700 strong, consisting of about 22 combat units, each with 20 to 30 combatants. Also active is the ZZW (*Zydowski Zwiazek Wojskowy* or Jewish Military Union), consisting of three combat groups, about 400 strong in all, mostly former officers and non-commissioned officers of the Polish Army and members of the Zionist Organization, BETAR. The ZZW is commanded by Pawel Frenkel. The Polish underground Home Army delivers a small number of weapons and explosives to the Jewish Fighting Organization (ZOB), including 1 light machine gun, 2 submachine guns, 50 handguns, 10 rifles, 600 hand grenades, and 30 kilograms of plastic explosives – no match for the massive German arsenal. Plans are made for the coordination of Jewish and Polish underground attacks on German forces once the uprising begins. Polish units are to carry out diversionary operations and blow up portions of the ghetto wall, providing escape routes for ghetto fighters.
Jan. 1943	*The second deportation.* Heinrich Himmler, chief of the SS, visits the ghetto and orders a resumption of the deportations. On Jan. 18, resistance fighters infiltrate a column of Jews being led to the *Umschlagplatz,* attack the German troops escorting the column, then scurry away to safety over rooftops. In the wake of this attack, 1000 Jews are murdered in the ghetto streets between Jan. 18 and Jan. 21. After the transfer of about 6,500 Jews to Treblinka (again, the Nazis' own figures), the Germans suspend deportations and the resistance groups, encouraged by their initial success, continue preparations for an uprising, building underground shelters, strongholds and tunnels.

16 April 1943	SS Major General Jürgen Stroop is transferred to Warsaw to be on hand for the final clearing of the ghetto or *Großaktion*, should the present SS and Police Commander of the Warsaw district – Colonel Ferdinand von Sammern-Frankenegg – prove ineffective. Stroop had demonstrated his ruthlessness in dealing with the Jewish population of Lvov.
19 April 1943	At 6 a.m. (on the eve of Passover), Sammern-Frankenegg sends his forces into the ghetto to clear it once and for all. Their extensive arsenal includes a tank and two heavy armored cars. Poorly armed Jewish units open fire and repel the stunned German troops. Himmler, informed of the events, orders Stroop to take over. From 8 a.m. on, Stroop is in charge of the operation and soon sends more troops and heavy artillery into the ghetto.
19 April 1943 -16 May 1943	With unparalleled courage and no illusions about the inevitable outcome of the uprising, Jewish combat units engage the German troops in street battles – the first urban uprising in territory controlled by the Nazis. The *Großaktion*, originally expected to last three days, will require an entire month. Polish underground units, operating both outside and within the ghetto, assist the Jewish resistance. People ordered to report for deportation go into hiding instead, in strongholds ("bunkers") prepared for that purpose. After several days of fighting, Stroop's forces begin systematically to set fire to the buildings in the ghetto, street by street, to force Jews out of hiding. According to Stroop's own figures, "the total number of Jews apprehended and thereafter destroyed" is 56,065 (*Gesamtzahl der erfaßten und nachweislich vernichteten Juden beträgt insgesamt 56 065*). The tranport of captured Jews to Treblinka or other death camps during this period is *the third deportation*. Having ultimately reduced the ghetto to rubble, Stroop has the Great Synagogue on Tlomacki Street destroyed on May 16, as a final symbolic act of conquest.

Appendix II

OFFICE OF U.S. CHIEF OF COUNSEL
FOR THE PROSECUTION OF AXIS CRIMINALITY

Doc. No. 1061 PS Date 23 October 1945

STAFF EVIDENCE ANALYSIS

DESCRIPTION OF ATTACHED DOCUMENT (Under following headings).

 Title and Nature: Report on the destruction of the Warsaw Ghetto (2 originals)

 Date: May 1943 Original (X) Copy () Language: German

LOCATION OF ORIGINAL (also WITNESS if applicable) as of 23 Oct 1945:

 1. OCC Files Nurnberg; 2. OCC Files Nurnberg (on loan from MIRS, London)

SOURCE OF ORIGINAL: 1. 7th Army Intelligence Center; 2. MIRS, London

PERSONS IMPLICATED: HIMMLER, Heinrich; FRANK, Hans

REFERENCES TO INDEX HEADINGS (Key to Par. nos. of Summary below):
ATROCITIES:against civilians--CONCENTRATION CAMPS--DEPORTATION--
FORCED LABOR--IDEOLOGY NAZI:Racial Supremacy--JEWS, PERSECUTION OF--
POLICE--SS--WEHRMACHT:Army:OKH--SPOLIATION OF FOREIGN PROPERTY:
Direct Seizure

NECESSARY PROCESSING TO PUT IN EVIDENTIARY FORM; LEADS: Maj. of
Police Sternagel, SS Gen Krueger, Police Lt. Diehl, SS Gen Stroop

SUMMARY OF RELEVANT POINTS (with page references):

1. This is the German report on the famous "Battle of the Warsaw Ghetto" which the leader of the action, Stroop, prepared for a conference of SS and Police Leaders scheduled to take place on 18/5/43 (see reports of 13 and 16 May). It is found in a fancy leather cover and consists of a comprehensive report to which are attached copies of Stroop's daily reports to Krueger and a pictorial appendix.

2. Himmler ordered the action originally (p.3) and on 23/4/43 issued the subsequent order to complete it with utter ruthlessness and unforgiving toughness (p.8). Stroop executed it on his own responsibility. Krueger supervised it, received the daily reports and was present on one day (rep. of 2/5/43). Sternagel was one of Stroop's subordinates who was in command 20 April (rep. of 20 April). Diehl was another leading officer (27 April). Von Herf Stroop's superior, was present on 27 April. The Engineer Commanders not only executed Stroop's orders but participated with such eagerness that it was mentioned in some daily reports (e.g. 22 April and 10 May).

 Doc. No. 1061-P

Doc. No. 1061-PS

3. Special camps had been established for the killings, on of which plays a prominent part in the document. It is called by the code name "T II". (cp rep. of 25, 26 April, 12, 24 May). This stands for section II (the extermination compound) of the Trawniki camp near Lublin. The German army had a number of factories for its own uses in the Warsaw Ghetto; they were mostly staffed by Jews who obviously led a relatively bearable existence, since they wer under the protection of the Army and remained outside the domination of Himmler's SS. Himmler at first ordered merely the transfer of these enterprises to Lublin, where the camp was under his own orders (p.3). The German governor of Warsaw towards the end of the action issued a proclamation to the Polish population link ing the operation with "assassinations in Warsaw," and even with the mass graves in Katyn." (p.10)

4. When the Warsaw Jews resisted the evacuation, a reign of unprecedented terror began. Especially after Himmler's order of 25/4, quite clearly only those Jews were left alive who had been employed in the Forces-enterprises and surrendered. They too were carted off, and it is not clear to what destination. All others were destroyed. The whole ghetto was burnt down and the walls were blown up. When burning Jews, whole families jumped from the upper storeys. "Steps were taken to liquidate them at once" (report of 22/4). Innumerable people became insane or perished in the flames and explosions. Their number cannot even be ascertained, but it is estimated in the final report as amounting to 5-6,000. 7,000 were executed and 6,929 "destroyed after transporting them to T.II" (24/5). Although the report is full of sneering remarks against the Jews, it involuntarily reveals untol heroism on the part of the defenseless Jews. The arms captured were so few and of such small calibres that Stroop has to give a special explanation for this fact. (24/5). One signle machine gun, which the Jews are alleged to possess, is mentioned on many pages. Against these civilians the Germans used on the average ? officers and 2,054 men daily for 28 days, armed with heavy automatic weapons, and supported by one howitzer, one tank, and two armoured cars (cp. the list before the report and daily report of 20/4). The Engineers used flame-throwers (2nd rep. of 20/4) and blew up innumerable dug-outs and sewers, together with the inhabitants. Innumerable corpses floated in the sewers (27/4). Even an air attack was made against the Ghetto, a fact which is not mentioned in the comprehensive report, but is found in the report of 13/5. Many smoke-candles were used for smoking-out the Jews. All these facts are stated with great pride by Stroop himself, b actually many more atrocities must have taken place which Stroop did not feel it right to reveal. Statements like the following quite indicative: "Nowadays we are unable to extract informatio on the whereabouts of further dug-outs from the captured Jews." (13/5).

5. The property of the Jews was simply appropriated by the SS. The report gives the figures. The Polish police were promised a portion of the cash found on any Jew captured by them, which led to good results" (rep. P.10, daily report of 6/5).

Doc. No. 1061

My photograph of the NARA document.

NOTES TO CHAPTER TWO

1. The very best edition for English-speaking readers is *The Stroop Report. The Jewish Quarter of Warsaw Is No More!* Translated from the German and annotated by Sybil Milton, with an introduction by Andrzej Wirth (New York: Pantheon Books, 1979). The same edition was published in London by Secker & Warburg in 1980. Though this is not stated in the book itself, the Milton facsimile edition is based on the specimen of the *Stroop Report* now in the care of the Institute of National Remembrance in Warsaw. Discolorations of the paper, handwritten page numbers on upper right corners and the stamped and handwritten information on the pages in the photographic section, make this clear.

2. For German text (facsimile pages) and English translation: *Holocaust History Project*, http://www.holocaust-history.org/works/stroop-report/htm/intro000.htm. For the photo section: http://www.holocaust-history.org/works/stroop-report/jpg/img001.jpg For an overview of all scans (text and pictures): http://www.holocaust-history.org/works/stroop-report-old/htm/intro001.htm
 The *Stroop Report* is also available only in English translation at three websites: 1. *The Avalon Project at Yale Law School* http://www.yale.edu/lawweb/avalon/imt/document/1061-ps.htm 2. *The Mazal Library* http://www.mazal.org/archive/nca/03/NCA03-0768.htm and 3. *A Teacher's Guide to the Holocaust* http://fcit.coedu.usf.edu/holocaust/resource/document/DOCSTRO2.htm

3. Protocol covering the hearings of September 25, 27, 28 and 29, 1948, in *Akta w sprawie likwidacji Getta w Warszawie*, vol. V, pp. 01018-01019, at the Institute of National Remembrance – Commission for the Prosecution of Crimes against the Polish Nation, Office for the Preservation and Dissemination of Archival Records. My translation from the German, which reads: *Da Himmler und Krüger sich für den Verlauf dieser Aktion sehr interessierten, musste ich täglich Berichte an Krüger erstatten, der sie an Himmler weiterleitete. Nach Abschluss der Aktion wurde auf Wunsch Krügers aus diesen Berichten drei abgesonderte eingebundene Bücher gemacht, von denen eins für ihn, das zweite über Krüger an Himmler übersandt wurde, und das dritte hatte ich. Das Konzept, soweit erinnerlich, uneingebunden blieb im Amte des SS-u. Polizeiführers in Warschau beim Stabsführer Jesuiter.*

4. Kazimierz Moczarski, *Conversations with an Executioner*. Edited by Mariana Fitzpatrick (Englewood Cliffs: Prentice-Hall, 1981; orig. published in Polish 1977), p. 151. From March 2 to November 11, 1949, Stroop shared a cell with Kazimierz Moczarski, a member of the Polish Resistance movement during the war, jailed since 1945 as a political dissident by the Stalinists. Also present in the cell was another SS officer named Gustav Schielke. During those 255 days, Stroop told about his life and exploits, and the copious notes Moczarski took would later become the book cited here and published after Moczarski's death.

5. *Ein ausführlicher Bericht mit Bildanhang werde ich, falls kein anderer Befehl folgt, bei der SS- und Polizeiführertagung vorlegen.*

6. http://www.geocities.com/~orion47/SS-POLIZEI/SS-Gruf_O-Z.html

7. A number of commentators agree that a copy of the report was found on a bookshelf in Stroop's villa, though that villa is alternately located in Bavaria and Wiesbaden:

When in 1945 the 7th U.S. Army occupied the territory of conquered Germany, a thick typewritten volume, prettily bound in buck-skin fell into their hands in Bavaria. This volume was lying in the bookcase of a villa belonging to SS-General Jürgen Stroop. […] The command of the 7th U.S. Army delivered this document to the 2nd Detachment of the U.S. Army Staff in Europe, which included Stroop's Report among the materials of the Nuremberg Process, where it was given the number 1061-PS.

> *The Report of Jürgen Stroop Concerning the Uprising in the Ghetto of Warsaw and the Liquidation of the Jewish Residential Area.* Introduction and notes by Prof. B. Mark. (Warsaw: Jewish Historical Institute, 1958), pp. 9-10.

After the war, he was arrested by American MPs […] In prison, he hid his true identity for a period of two months, trying to pass for a Captain Josef Stramp [sic]. A search conducted in his villa led to the discovery of an album containing his teletyped dispatches and photos taken during the fighting in the Warsaw ghetto.

> Michel Borwicz, *L'insurrection du ghetto de Varsovie* (Paris: Julliard, 1966), pp. 198-199. My translation.

Stroop saw to it that his document was duplicated in a number of copies, and one of them was confiscated at his villa in Wiesbaden by an American army unit.

> Yisrael Gutman, *The Jews of Warsaw 1939-1943. Ghetto, Underground, Revolt.* (Sussex: Harvester Press, 1982), p. 365.

Soon [after the end of the war], Stroop was discovered, while attempting to change his identity, in the Wiesbaden area, which was in the hands of the United States army. In a search conducted in his home, an elegantly organized album was found, containing his reports from the Warsaw ghetto campaign and a series of photographs taken by the Germans during the uprising.

> *Encyclopedia of the Holocaust*, entry "Stroop, Jürgen." ed. Israel Gutman. (New York: Macmillan, 1990.), vol. 4, p 1416.

One commentator explicitly describes a causal relationship between the discovery of the report and the disclosure of Stroop's identity:

> When the Americans pushed into Germany, Stroop, concealing his identity, surrendered to them on May 8, 1945. But soon his captors found his reports on the daily fighting on the Warsaw ghetto and learned who he was.

> Dan Kurzman, *The Bravest Battle. The Twenty-eight Days of the Warsaw Ghetto Uprising* (New York: Putnam's Sons, 1976) p. 337.

Though Kurzman's version undoubtedly makes a better story, it is possible that the causality went the other way around: that it was after the interrogation unit knew who they were dealing with that they had Stroop's villa searched, and then discovered a copy of his report.

8 This report, dated July 26, 1945 and assigned the reference number SAIC/PIR/220, includes the following summary in the section called Administrative Data: "Source was captured 8 May 45 in ROTTAU, Bavaria. He carried false discharge papers made out to Capt of Reserve Josef STRAUP. He was interned in PWTE C-4, HEILBRONN. On Jul 2 he confessed, was taken into custody by CIC and arrived at SAIC from 307 Det 14 Jul 45 on authority of G-2 Seventh Army. Documents: False discharge papers; official German army discharge, obtained by CIC HEILBRONN to facilitate handling of the case." Had the discovery of his copy of the *Stroop Report* played a role in his decision to confess, that would most likely have been mentioned here.

 The same applies to the "CI Intermediate Interrogation Report" of October 18, 1945, reference number CI-11R/25, signed by Leroy Vogel, Captain, Infantry, CI [Counter-intelligence] Section, which mentions Stroop's capture and use of an alias, but omits any reference to a discovery of his report.

9 During his interrogation in Warsaw, Stroop was shown the specimen of the *Stroop Report* that had been sent to Nuremberg in 1945 by the U.S. Seventh Army and was forwarded in 1948 to the Polish authorities preparing to try Stroop. He said of the copy of the album he was shown: "*Der Richter zeigt mir ein eingebundenes Buch […], welches Buch das ist, weiss ich nicht, sowie auf welchem Wege es in die amerikanischen Hände gelangte*" (The judge shows me a bound book […], which book it is I don't know, nor in what way it wound up in the hands of the Americans). That this bound volume was the prosecution's copy of the *Stroop Report* is made abundantly clear as Stroop's statement continues, with references to his signature on the nineteenth page (the final page of the introduction, signed by its author), to the daily dispatches, etc. *Akta w sprawie likwidacji Getta w Warszawie*, vol. V, p. 01019.

10 In worksheet #26543 prepared by the U.S. Holocaust Memorial Museum Photo Archives in connection with the photo of the boy with his hands raised, the following is stated about the *Stroop Report*: "Three albums were prepared: for Himmler, Krueger and Stroop, all of which were recovered after the war. One of them was introduced as evidence at the International Military Tribunal in Nuremberg and later published under the title, 'The Stroop Report.' The albums – which bear slight discrepancies in the number of photos they contain – are currently located at the National Archives (Washington), the Bundesarchiv (Koblenz), and the Main War Crimes Commission (Warsaw)." The same claim is made on that portion of Yad Vashem's web site dealing with the photos in the *Stroop Report*: "Three elegant copies of the report were produced. One was sent to Himmler, one went to Krüger (the supreme commander of the SS and German police in the *Generalgouvernement*) and the last copy was kept by Stroop himself. […] The original albums are presently located in the National Archives of the United States, the Federal Archives in Germany, and the Central Committee for Criminal Investigation in Warsaw." http://www.yad-vashem.org.il/exhibitions/warsaw_ghetto/home_stroop_collection.html

11 Letter dated Dec. 2, 2002 and e-mail sent to me on Dec. 10, 2002 by Torsten Zarwel (Bundesarchiv, Berlin), assuring me that neither the Koblenz nor any other branch of

the *Bundesarchiv* has a specimen of the *Stroop Report*. This was further confirmed in a letter from a Frau Kuhl at the Bundesarchiv Koblenz (Jan. 6, 2003).

12 *Akta w sprawie likwidacji Getta w Warszawie*, vol. V, p. 01020.

13 Stroop "identified the exhibit in his Polish trial as Himmler's copy," according to Robert Wolfe at the time he was Chief of the Modern Military Branch, Military Archives Division, NARA, in a letter to Dr. Josef Henke at the *Bundesarchiv* in Koblenz, dated June 25, 1980. Wirth (op. cit.) also wrote: "According to Stroop, the set that has been deposited with the Central Commission for the Investigation of War Crimes in Poland is the one that Himmler had received. It was found at the end of the war by soldiers of the U.S. 7th Army."

14 Sybil Milton, "The Camera as Weapon: Documentary Photography and the Holocaust," Simon Wiesenthal Center, Annual 1, 1997. http://motlc.wiesenthal.com/resources/books/annual1/chap03.html

15 David Margolick, "Rockland Physician Thinks He Is the Boy in Holocaust Photo Taken in Warsaw," *The New York Times* on May 28, 1982, p. B2. The article will be discussed on pp. 87-89 below in connection with the possible identity of the boy in the photo.

16 *Sunday Times*, April 21, 1968. The tip was from Dr. Alexander Bernfes, a survivor of the Warsaw ghetto, who spent many years gathering documentation of Nazi crimes.

17 "Raport Stroopa: Historia Dokumentu Zbrodni," *Główna Komisja Badania Zbrodni Hitlerowskich w Polsce Międzynarodowa Sesja Naukowa, Hitlerowskie ludobójstwo w Polsce i Europie 1939-1945*, 14-17 kwietnia 1983, p. 13. Magdalene Kunicka-Wyrzykowska wrote: "*Fotografie zamieszczone w trzeciej części sprawozdania zatytułowanej 'Bildbericht' wykonywane byly podczas 'Grossaktion' przez policję bezpieczeństwa oraz SS-Obersturmführer Franza Konrada, kierownika Werteerfassung w getcie warszawskim*" (The pictures included in the third part of the report called *Bildbericht* were taken during the *Großaktion* by the security police and SS-Obersturmführer Franz Konrad, who was in charge of confiscation in the Warsaw ghetto).

18 Ibid. "*Z fotografii tych, zebranych przez M. Jesuitera, Stroop wybrał jedynie niektóre dla zilustrowania meldunków dziennych*" (Of these pictures collected by M. Jesuiter, Stroop chose only a few to illustrate his daily reports).

19 *Akta w sprawie likwidacji gettu w Warszawie*, vol. I, protocol for July 18, 1951, pp. 44 and 61. The same claim is made by Konrad in the 67 page interrogation report, "*Aussage von KONRAD Franz, betreffend seine vergangene Betaetigung in dem Warschauer Ghetto*," dated January 2, 1946, and recorded by the Counter Intelligence Corps, Salzburg Detachment, U.S. Forces Austria.

20 Kaleske stated: "Members of the identification section of the Sicherheits Polizei took pictures while the action in the Ghetto took place….. These pictures were checked by STROOP privately [personally] and he chose approximately 25 to 50 pictures which were subsequently inserted into the book." This is part of "a translated verbatim extract from the unpublished account" given by Kaleske when questioned on June 10 and June 21 by U.S. Military Intelligence. The extract is found in Annex III, "STROOP's Activities in Warsaw," CI – IIR/25, dated Oct. 18, 1945, p. 7. (The ellipse is in the printed text, not of my own choosing.)

21 For almost all of the photos in the *Stroop Report*, Jan Jagielski lists Franz Konrad alone as the "author" of each picture, while for the remaining pictures (not particularly interesting ones, such as Nos. 24 and 25 in the Warsaw document) the author is listed as

"the Security Police or Franz Konrad" (*Policja bezpieczeństwa oraz SS.Obersturmführer Franz Konrad*).

22 Matìj Stránski, *Varsavské ghetto ve fotografiích* (2001), section 4 of the paper. Slezská University, Faculty of Philosophy, Department of Photographic Studies. http://216.239.37.100/search?q=cache:5taghvQQaPgJ:itf.fpf.slu.cz/studenti/stransky.rtf+stransky+kunicka&hl=en&ie=UTF-8

23 "Second Day, Wednesday, 11/21/1945, Part 04", in *Trial of the Major War Criminals before the International Military Tribunal*. Volume II. Proceedings: 11/14/1945-11/30/1945. [Official text in the English language.] Nuremberg: IMT, 1947. pp. 98-102.. This excerpt can be found on the Web at the following address: http://www.law.umkc.edu/faculty/projects/ftrials/nuremberg/Jackson.html

24 In response to my inquiry to the Robert H. Jackson Center for Justice, asking whether Jackson showed any photographs while making his opening statement, Rolland Kidder, executive director of the center, relayed John Barrett's reply, stating he did not believe any photos were shown that day (e-mail of Jan. 3, 2003).

25 Major Walsh of the U.S. prosecution staff projected and commented upon the following photographs [his translation of the captions] "Destruction of a block of buildings," "Smoking out of the Jews and bandits," "Fighting a nest of resistance," "Bandits jump to escape arrest," and "The leader of the large-scale operation," corresponding to the pictures I have numbered 26, 20, 36, 38 and 42 respectively. Oddly the page numbers cited by Major Walsh (27, 21, 36, 36 and 39) correspond neither to the pagination of the Warsaw nor the NARA documents. This passage is found on p. 557, vol. 3 of the "Blue Series" (ibid.) and can be accessed at http://www.yale.edu/lawweb/avalon/imt/proc/12-14-45.htm

26 The entire *Stroop Report* is reprinted in this volume, on pp. 628-694 plus an additional 18 pages of selected photographs. Judging from the photographic variants and their captions, the basis for this reprint was the NARA document.

27 G. M. Gilbert, *Nuremberg Diary* (London: Eyre & Spottiswoode, 1948), p.25.

28 Ibid., p. 43. On this occasion, it was Major Walsh who quoted Stroop's words.

29 This communiqué differs markedly in appearance from all the rest. It is the only Photostat, darker and smaller than the other dispatches (19.5 x 27.5 cm instead of 20.7 x 29.2 cm), and its front and back are on two separate sheets, while all the others appear to be typed originals on thin paper, with text running on to the back of the same page. Penciled on the back lower left-hand corner of page two of the May 24th dispatch: "1061 PS USA 275."

30 According to Martin Gilbert, at the time of the Warsaw ghetto uprising, 15,000 Warsaw Jews were transported to Maidanek where they were put to death, in addition to the 7,000 murdered at Treblinka. *Final Journey. The Fate of the Jews in Nazi Europe* (London: George Allen & Unwin, 1979), p. 114.

31 The 37 photos common to both documents are the ones in the Warsaw specimen that I have numbered: 1-6, 8-14, 16-20, 22-23, 27-35, 39, 43-44, 46-47, 50-52.

32 "The woman at the head of the column, on the left, is Yehudit Neyer (born Tolub). She is holding on to the right arm of her mother-in-law. The child is the daughter of Yehudit and Avraham Neyer, a member of the Bund, who can be seen just behind the little girl. Of the four, only Avraham survived the war." Walter Laqueur, *The Holocaust Encyclo-*

pedia. (New Haven: Yale University Press, 2001), under the entry "Warsaw," p. 693. No source is given for this information.

33 There is also a photo in which at least one dead child appears, though one has to look carefully to see her: the 18th photo (p.42 above), labeled "Bandits destroyed in battle." When asked about this photo during his interrogation in Warsaw, Stroop answered: "I can see only one child in the picture. The other child I can't recognize among the dead. If the child I can see here was killed, his/her own parents are to blame. If they hadn't taken part in the fight, if they had withdrawn and surrendered voluntarily, the child wouldn't have been exposed to the infantry fire."

34 Kazimierz Moczarski (op. cit.) mentioned his cellmate's bent for calligraphy (p. 15) and Stroop's captions on an array of family photographs: "On the cardboard mounts beneath each picture, carefully inscribed in Gothic characters, were the inscriptions '*Unsere Mutter,*' '*Unsere Tochter,*' '*Unser Sohn*' and '*Meine Frau*'" (p. 4). One might easily assume that the captions below the photographs in the *Stroop Report* were written in Stroop's own hand. However, the Instytut Pamięci Narodowej kindly provided a sample of Stroop's handwriting (a letter he wrote from prison on December 12, 1951). Although this letter was not penned in Gothic script and therefore difficult to use as a basis for comparison, and although the only copies I was able to provide the Danish handwriting expert Per F. Andersen with were low-resolution scans, the Danish graphologist – keeping in mind the above-mentioned reservations – finds it improbable that the samples were written by the same person. Here is a sample of Stroop's handwriting, for comparison with a caption:

Stroop's handwriting

Handwritten caption

35 Ibid., p. 151.
36 Ibid., pp. 123-124.
37 Ibid., p. 164.
38 *On Photography* (London: Penguin, n.d.), p. 4; orig. pub. 1977.
39 Yisrael Gutman, *The Jews of Warsaw, 1939-1943. Ghetto, Underground, Revolt.* Trans. from the Hebrew by Ina Friedman (Sussex: Harvester Press, 1982), p. 389.
40 Stroop described Jews as "inherently cowardly" in his Introduction, placed a photo of "Jewish traitors" in the pictorial section (No. 19) and complained in his dispatches of May 3 and May 13, 1943, that "Jewesses had concealed pistols in their underpants" or reached under their skirts to pull hand grenades out of their underpants. His own forces of course deserved only praise "for their daring, courage and devotion to duty" (Introduction).
41 In the introduction, he grumbled about incorrect information provided to him by plant managers, who were also overseeing "their operations so poorly that it was possible for the Jews to produce all kinds of weapons." In a dispatch of April 20, 1943, he wrote: "The operation is being made more difficult by these Ghetto enterprises, whose machines and tools must be protected against bombardment and fire." And in the dispatch of April 27, 1943, he indignantly complained that bandits were disguising themselves in German uniforms, which made the task of an assault unit "extremely difficult."

42 According to the dispatch of May 24, 1943, the only firearms captured were nine rifles and 59 pistols of various calibers. Stroop explained: "Regarding the capture of arms, it must be taken into account that in most cases, arms could not be taken because the Jews and bandits, before their own capture, would throw them into hideouts and holes that could not be located or found. The fumigation of the bunkers also made it impossible for our men to take arms. Since we had to blow up the bunkers immediately, it was not feasible to take arms later on."

43 I transported them… to the butcher. Eichmann's story, Part I," by Adolf Eichmann. *Life*, November 28th 1960, vol. 49, No. 22, pp. 106, 109. This article (though without photos) can also be accessed at: http://hometown.aol.de/rolftueschen/Eichmann.html

44 Marianne Hirsch has devoted considerable attention to the photograph in the perspective of what she calls the work of postmemory. See for example "Projected Memory: Holocaust Photographs in Personal and Public Fantasy" (*op.cit.*) and "Nazi Photographs in Post-Holocaust Art: Gender as an Idiom of Memorialization" (*op.cit.*).

Chapter Three
THE PHOTOGRAPH IN CONTEXT

Introductory note

Previous attempts to describe the photograph in its original context have focused, for example in Lucy S. Dawidowicz's words, on the Germans' delusional perception of *themselves* as "innocent and aggrieved victims," while every Jewish man, woman and child – such as those appearing specifically in this photograph – was "a supercunning and all-powerful antagonist," a "warrior of a vast Satanic fighting machine" bent on destroying the German people.[1] Seen in this perspective, the SS men in the picture would be the defenders of innocence, while the Jewish women and children would be the shameless aggressors.

Other writers, including Herman Rapaport, have found it useful to invoke the concept of a "murderous gaze" in discussing this photograph.[2] For Rapaport, what appealed to the compilers of the *Stroop Report* was the utter inevitability of the death awaiting the child with raised hands – "a being-toward-death [that] is as fated to occur as a stone is fated to fall down a steep mountain slope" (p. 197). Taking two levels of meaning into account, Rapaport suggested that "the camera has been used obscenely to document not only the child's destruction but also the gazer's pleasure, which emanates from the secure sovereignty of the viewer, a sovereignty we are being tempted to share" (p. 203). In this way, the contemporary viewer as well as the 1943 photographer are both encompassed by the concept of the gazer.

Largely in agreement with Rapaport, and also citing Sybil Milton's contention that "photography was a routine part of the extermination process in Nazi Germany," Marianne Hirsch focused on the "conflation between camera and weapon," suggesting that photographer and executioner played parallel roles in the same murderous process, shooting the victims first in one way and then another.

> The soldier pointing his gun at the boy, with his characteristic helmet and uniform, is an embodiment of genocidal intent. The camera gaze mirrors the machine gun, and announces the gas chamber.[3]

Also considering two levels of meaning, Marianne Hirsch found that this photograph "is evidence not only of the perpetrator's deed but also of the desire to flaunt and advertise the evidence of that deed." Aptly designating the photograph as a "perpetrator image," Hirsch also pointed out that "the photographer, the perpetrator and the spectator share the same space of looking," originally defined by the photo as positioning "the genocidal gaze of the Nazi death machine."

All of these commentaries are invaluable contributions to an understanding of the photograph in its original context, and should be kept in mind.

I will however propose a somewhat different approach, more concretely grounded in specific structures of SS thought, in an attempt to understand what this photograph may have meant to Jürgen Stroop and to the two SS dignitaries to whom he sent it in his report.

Possible meanings and functions of the photo for Stroop, Krüger and Himmler

It is in more than one way that this photograph is likely to have given an "us and them" experience to the three SS men for whom the *Stroop Report* was made.

The obvious sense of course is in the playing off of the Jewish prisoners, embodying defeat and surrender, against the SS soldiers embodying power in the photo – soldiers carrying out orders issued by the SS hierarchy and therefore literally acting as agents of Stroop, Krüger and Himmler.

But far more interesting than that all too evident "us and them" dichotomy is an implicit one that played a major role in the SS mentality with respect to the routine slaughter of Jewish women and children. And this other dichotomy, which will eventually lead us into the very heart (or heartlessness) of the picture, concerns a distinction between two ways of being in relation to the killing of helpless victims.

As a starting point for considering these two ways of being, we will look at several revealing statements made by Stroop himself in conversation with his Warsaw cell-mate, beginning with a bizarre comment on Christianity. This is what Stroop told Moczarski on that subject (*op. cit.*, p. 58):

> "Christ [...] was half-Nordic, of course. His mother, who served in the Temple under the protection of an important priest, became pregnant by a blond German, a soldier from one of the Germanic tribes that reached Asia Minor from the Carpathians. That's why the Christ was fair-haired and thought differently from the Jews who doctored his teachings and spread them around the world to further their own aims – the weakening and debasement of man through guilt."

What this implies, among other things, is that for Stroop, to experience guilt is to allow oneself to be infected by a Jewish poison. In this delusional perspective, guilt is simply written off as an unacceptable Jewish invention, and regardless of what one may or may not do, to feel guilty would be to betray one's Aryan nature and to succumb to the Judaic plot.

Stroop was just as adamant with regard to the question of pity, as can be seen in relation to two separate incidents.

One concerned an Askari, a member of an auxiliary unit assigned to the ghetto and comprised of Ukrainian, Latvian and Lithuanian solders. The story begins this way:

> As I was leaving the Ghetto that afternoon, I heard a shot on the Aryan side of the wall. I rushed toward the culprit, a young Askari in a black coat, and gave that Latvian hell! 'But it's so boring here sir,' he insisted. 'When will we begin firing at the animals in this Jewish zoo?' I slapped his blond head with my glove (he was an Aryan), then slipped him a Reichsmark. Fine fellows, those Askaris, or so I thought at the time (*ibid.*, p. 118).

Photo No. 42 in the Warsaw specimen, showing Stroop in the company of Askaris. Photo provided by the Institute of National Remembrance – Commission for the Prosecution of Crimes against the Polish Nation, Office for the Preservation and Dissemination of Archival Records

At a later point in his conversations with Moczarski (p. 138), Stroop returned to the story of this Askari once again, this time bringing it to completion:

> ...There was fire everywhere. Walls crumbled, balconies, masonry, and timber crashed into the street. The smoke made it impossible to breathe. The SS watched from a distance. I stood behind them, protected by my bodyguard unit. I had stopped using those Askaris, who turned out to be a real disappointment. In fact I'd assigned half of them to the Schutzpolizei for other less responsible work. Do you remember that Askari I told you about earlier – the one who couldn't wait to fight the Jews? Well, that Latvian turned out to be a total idiot. I ran into him in the Ghetto one day, and can you believe it, he was crying. A Nordic, with blue eyes, who spoke half-decent German, an anti-Semite, and he was crying. He mumbled something about he couldn't... the blood... the corpses... the children... I completely lost my head and gave him a punch in the nose. Then I had him thrown out of the Ghetto area along with a hundred and fifty or so of his lily-livered pals.

What was contemptible in Stroop's eyes was the Askari's attack of pity for the victims. Stroop would tolerate no such feelings on the part of men serving under his command.

The other incident concerns women of the *HeChalutz* movement,[4] whom Stroop called *Haluzzenmädeln* and whose ferocity as fighters had made a great impression on him. Here is the story as Stroop told it to Moczarski (p. 132):

The 26th photo in the Warsaw specimen, showing women of the HeChalutz movement captured by the SS. Photo provided by the Institute of National Remembrance – Commission for the Prosecution of Crimes against the Polish Nation, Office for the Preservation and Dissemination of Archival Records.

Stroop expressed his admiration of the *Haluzzenmädeln* on a number of occasions. "I sometimes think that they were super-beings – demons or Amazons," he reflected. "Nerves like steel and the dexterity of circus performers. They often fired two pistols simultaneously, one in each hand. They were fighters to the end and extremely dangerous at close quarters. I remember *Haluzzenmädeln* we cornered who blinked at us like frightened rabbits. But when our men began to move in, they'd pull grenades from their skirts or trousers and hurl them at us, shrieking curses that made our hair stand on end! They caused us so many losses that I ordered them cut down from a distance, instead of taken alive."

I gasped. "You mean you felt no pity for their youth and womanhood?"

There was a long silence during which Stroop methodically kneaded the area surrounding his heart. Finally, he looked up, smoothed back his hair, and said in clipped tones:

"Anyone attempting to be a true man – that is a strong one – would have been forced to act like me. *Gelobt sei was hart macht*."

Moczarski explains that *Praise be to what hardens one* is "a quote from Nietzsche used as a Nazi slogan."

Here, as was the case with the Askari incident, manhood is categorically defined by Stroop as incompatible with pity.

But this stigmatization of guilt and pity is still only a small part of the overall picture, which will now be further illustrated in a broader SS perspective.

In her book on Eichmann and the banality of evil, Hannah Arendt mentions the ways in which Himmler solved problems of conscience by coining slogans or other one-liners in his speeches to the commanders of the *Einsatzgruppen* and the Higher S.S. and Police Leaders, such as: "The order to solve the Jewish question, this was the most frightening order an organization could ever receive." Or: "We realize that what we are expecting from you is 'superhuman,' to be 'superhumanly inhuman.'"[5]

Further developing her analysis of the ways in which Himmler conceptually packaged the slaughter of women and children for those serving under him, Arendt puts her finger on a specific mechanism whereby the perpetrator turned the killing of innocent victims into a heavy burden he himself had to bear:

>…the problem [for the murderers] was how to overcome not so much their conscience as the animal pity by which all normal men are affected in the presence of physical suffering. The trick used by Himmler – who apparently was rather strongly afflicted with these instinctive reactions himself – was very simple and probably very effective; it consisted in turning these instincts around, as it were, in directing them toward the self. So that instead of saying: What horrible things I did to people!, the murderers would be able to say: What horrible things I had to watch in the pursuance of my duties, how heavily the task weighed upon my shoulders!

This analysis is certainly borne out by the description given by Rudolf Höss, commandant of Auschwitz, of the ways in which he managed and experienced his own role in the murder of Jewish women and children. It is only fair to mention that the following quote from Höss's autobiography may be upsetting and might best be skipped by readers who don't wish to know more than they already do on this particular subject.

> The smaller children usually cried because of the strangeness of being undressed in this fashion, but when their mothers or members of the Special Detachment [*Sonderkommando*, consisting of prisoners (RR)] comforted them, they became calm and entered the gas chambers, playing or joking with one another and carrying their toys.
>
> I noticed that women who either guessed or knew what awaited them nevertheless found the courage to joke with the children to encourage them, despite the mortal terror visible in their own eyes.
>
> One woman approached me as she walked past and, pointing to her four children who were manfully helping the smallest ones over the rough ground, she whispered:
>
> "How can you bring yourself to kill such beautiful, darling children? Have you no heart at all?" […]
>
> This mass extermination, with all its attendant circumstances, did not, as I know, fail to affect those who took a part in it. With very few exceptions, nearly all of those detailed to do this monstrous "work," this "service," and who, like myself, have given sufficient thought to the matter, have been deeply marked by these events.
>
> Many of the men approached me as I went my rounds through the extermination buildings, and poured out their anxieties and impressions to me, in the hope that I could allay them.
>
> Again and again during these confidential conversations I was asked: is it necessary that we do all this? Is it necessary that hundreds of thousands of women and children be destroyed? And I, who in my innermost being had on countless occasions asked myself exactly this question, could only fob them off and attempt to console them by repeating that it was done on Hitler's order. I had to tell them that this extermination of Jewry had to be, so that Germany and our posterity might be freed forever from their relentless adversaries.
>
> There was no doubt in the mind of any of us that Hitler's order had to be obeyed regardless, and that it was the duty of the SS to carry it out. Nevertheless we were all tormented by secret doubts.
>
> I myself dared not admit to such doubts. In order to make my subordinates carry on with their task, it was psychologically essential that I myself appear convinced of the necessity for this gruesomely harsh order.
>
> Everyone watched me. They observed the impression produced upon me by the kind of scenes that I have described above and my reactions. Every word I said on the subject was discussed. I had to exercise intense self-control in order to prevent my innermost doubts and feelings of oppression from becoming apparent.
>
> I had to appear cold and indifferent to events that must have wrung the heart of

anyone possessed of human feelings. I might not even look away when afraid lest my natural emotions got the upper hand. I had to watch coldly, while the mothers with laughing or crying children went into the gas chambers.

On one occasion two small children were so absorbed in some game that they quite refused to let their mother tear them away from it. Even the Jews of the Special Detachment were reluctant to pick the children up. The imploring look in the eyes of the mother, who certainly knew what was happening, is something I shall never forget. The people were already in the gas chamber and becoming restive, and I had to act. Everyone was looking at me. I nodded to the junior noncommissioned officer on duty and he picked up the screaming, struggling children in his arms and carried them into the gas chamber, accompanied by their mother who was weeping in the most heart-rending fashion. My pity was so great that I longed to vanish from the scene; yet I might not show the slightest trace of emotion.

I had to see everything. I had to watch hour after hour, by day and by night, the removal and the burning of the bodies, the extraction of the teeth, the cutting of the hair, the whole grisly, interminable business. I had to stand for hours on end in the ghastly stench, while the mass graves were being opened and the bodies dragged out and burned.

I had to look through the peephole of the gas chambers and watch the process of death itself, because the doctors wanted me to see it.

I had to do all this because I was the one to whom everyone looked, because I had to show them all that I did not merely issue the orders and make the regulations but was also prepared myself to be present at whatever task I had assigned my subordinates.

The *Reichsführer* SS sent various high-ranking Party leaders and SS officers to Auschwitz so that they might see for themselves the process of extermination of the Jews. They were all deeply impressed by what they saw. Some who had previously spoken most loudly about the necessity for this extermination fell silent once they had actually seen the "final solution of the Jewish question." I was repeatedly asked how I and my men could go on watching these operations, and how we were able to stand it.

My invariable answer was that the iron determination with which we must carry out Hitler's orders could only be obtained by a stifling of all human emotions. Each of these gentlemen declared that he was glad the job had not been given to him.

Even Mildner and Eichmann, who were certainly tough enough, had no wish to change places with me. This was one job which nobody envied me.

I had many detailed discussions with Eichmann concerning all matters connected with the "final solution of the Jewish question," but without ever disclosing my inner anxieties. I tried in every way to discover Eichmann's innermost and real convictions about this "solution."

Yes, every way. Yet even when we were quite alone together and the drink had been flowing freely so that he was in his most expansive mood, he showed that he was completely obsessed with the idea of destroying every single Jew that he could lay his hands on. Without pity and in cold blood we must complete this extermination as rapidly as possible. Any compromise, even the slightest, would have to be paid for bitterly at a later date.

> In the face of such grim determination I was forced to bury all my human considerations as deeply as possible.
>
> Indeed, I must freely confess that after these conversations with Eichmann I almost came to regard such emotions as a betrayal of the Führer.
>
> There was no escape for me from this dilemma.
>
> I had to go on with this process of extermination. I had to continue this mass murder and coldly to watch it, without regard for the doubts that were seething deep inside me.[6]

As Höss narratively framed these events and shaped his own experience of them, he turned himself into a kind of tragic figure, whose job it was to carry out these monstrous tasks, sacrificing his own inner peace in the process and having to stifle all natural and instinctive reactions to the suffering of his victims. In his own telling of this story, it is he even more than the women and children he murdered, who truly deserved compassion. Yet at the same time, Höss implicitly took pride in his ability to carry out a heavy duty that even Eichmann might not have been able to execute.

Something of this same "martyrdom of the executioner" was incisively depicted by Jorge Luis Borges in a short story entitled "*Deutsches Requiem*," told in the first person by a man who was made sub-director of the Tarnowitz concentration camp. The fictional speaker of this tale describes his overcoming of compassion in dealing with a well-known Jewish poet, David Jerusalem, who had turned up as a prisoner at the camp.

> Nazism is intrinsically a moral act, a stripping away of the old man, which is corrupt and depraved, in order to put on the new. In battle, amid the captains' outcries and the shouting, such a transformation is common; it is not common in a crude dungeon, where insidious compassion tempts us with ancient acts of tenderness. I do not write that word "compassion" lightly: compassion on the part of the superior man is Zarathustra's ultimate sin. I myself (I confess) almost committed it when the famous poet David Jerusalem was sent to us from Breslau. […] I was severe with him; I let neither compassion nor his fame make me soft. […] In late 1942, Jerusalem went insane; on March 1, 1943, he succeeded in killing himself.
>
> I do not know whether Jerusalem understood that if I destroyed him, it was in order to destroy my own compassion. In my eyes, he was not a man, not even a Jew; he had become a symbol of a detested region of my soul. I suffered with him, I died with him, I somehow have been lost with him; that was why I was implacable.[7]

Here, we rejoin Stroop's view of guilt and pity as Jewish poisons and of the necessity of ridding oneself of them. What Borges makes explicit is that for the Nazi, the killing of the Jewish victim and the amputation of one's own compassion are one and the same act – and that it is through the one that the other is achieved.

Here again, the overcoming of pity is both a burden requiring the sacrifice of one's humanity, and also implicitly a matter of exhilarating pride in the accomplishment of becoming a "new man" in place of the old one who could still be tempted to perform "ancient acts of tenderness."

Returning now to the photograph, I would suggest that this particular picture – the only one in the *Stroop Report* showing women and children at close quarters – was in a sense the most daring image in that document. In sending this picture to Krüger and Himmler, Stroop was in effect saying to them: "While *others* may not be able to rise to this historic occasion, because pity and other archaic forms of weakness hold them back, *we* are able to carry out our mission of killing even women and children without batting an eye." This is the underlying "us and them" dichotomy implied by the photograph for people like Stroop, Krüger and Himmler, and for them it was just as palpable as the more obvious "Jew versus Nazi" dichotomy portrayed in the picture.

The message this photograph communicated from its sender to its recipients was a complicitous one, shared by the three "new men." It is precisely because the little boy with his hands raised looks so utterly helpless and vulnerable, and appeals so forcefully to whatever protective instincts the spectator may harbor, that only those who had shed all vestiges of pity and compassion could applaud the photo and see it as a trophy. Had the photo been less potentially moving, it would not have had this demonstrative value for those who had trained others to become "superhumanly inhuman," in Himmler's words.

The message it sent was also self-congratulatory – "*We* can do this!" – and at the same time, expressive of a burden or responsibility: "We *have* to do this!" As an obligation carried out unflinchingly, for the sake of future generations who would not have to do such things, this arrest and imminent *Vernichtung* of Jewish women and children was seen by the SS elite as deserving of gratitude and admiration, a difficult task well done. This too could be shared by Stroop, Krüger and Himmler.

In their eyes, what the picture told was not the story of the victims but that of the SS, faithfully discharging their duties and utterly unmoved by a powerful spectacle that would reduce lesser men – like Stroop's Askari – to tears.

For men who felt they had to set an example, as Höss claimed he was obliged to do at Auschwitz when subordinates looked to his demeanor as mothers and babies were gassed, the photo appeared *to be* that example: an ultimate celebration of the heartlessness necessary for exterminating every last Jewish man, woman and child.

NOTES TO CHAPTER THREE

1. Lucy S. Dawidowicz, *The War Against the Jews: 1933-1945* (New York: Bantam, 1975), p. 166.
2. Herman Rapaport, "The Eye and the Law" in *Is There Truth in Art? (op. cit.).*
3. Marianne Hirsch, "Nazi Photographs in Post-Holocaust Art: Gender as an Idiom of Memorialization" (*op. cit.*), p. 106.
4. The *HeChalutz* ("Pioneer") movement was a secular Zionist youth organization, which along with *Hashomer Hazair, Dror* and *Akiva*, helped to found the Jewish Fighting Organisation (*Zydowska Organizacja Bojowa* or *ZOB*) in the Warsaw ghetto in 1942 and played an important role in planning and carrying out the armed uprising. See, for example, Marek Edelman's first hand account, presently accessible at http://www.english.upenn.edu/~afilreis/Holocaust/warsaw-uprising.html
5. Hannah Arendt, *Eichmann in Jerusalem. A Report on the Banality of Evil* (New York: Penguin Books, 1994; orig. pub. 1963), pp. 105-106.
6. Rudolf Hoess, *Commandant of Auschwitz. The Autobiography of Rudolf Hoess* (Cleveland and New York: World Publishing Co., 1959), pp. 165, 169-172.
7. Jorge Luis Borges. "*Deutsches Requiem*"[1949] in *Collected Fictions*, trans. Andrew Hurley (New York: Viking, 1998), p. 231-232. The entire story is presently accessible in Spanish on the web at http://ar.geocities.com/into_oblivionn/elotroborges_deutsches.html

Chapter Four
IDENTITIES

Introductory note

With respect to the possible identity of captives in the photograph – the little boy as well as other children and adults, it should be kept in mind that no hard evidence can be produced in support of any given claim. There simply are no dental records, x-rays or DNA samples available for comparison.

With most of the claims, relatives who have recognized family members in the photograph have filed reports at various commemorative institutions, such as Yad Vashem in Jerusalem, the U.S. Holocaust Memorial Museum in Washington, the Institute of National Remembrance in Warsaw, the Ghetto Fighter's House in the Western Galilee, the *Centre de documentation juive contemporaine* in Paris. While we have no way of evaluating the validity of these personal testimonies, the mere possibility of their being correct requires that they be given serious attention here. It would be a travesty to exclude any one of them from the present study, on the grounds that it cannot be independently confirmed. At the same time of course, the reader is now apprised that these reported identifications are unverifiable.

We also have reports by two survivors, each believing that he is or might be the boy in the photograph. Both of their accounts will be included here, as well as possible arguments against them – most of these arguments dating from the time each of the survivors came forward with his claim, though I will be adding one important factor not previously brought into play. The relevant material will be presented here as fairly as possible, leaving it up to the reader to draw his or her own conclusions.

The case of the SS trooper aiming his submachine gun in the direction of the boy is of another kind altogether. There can be no uncertainty as to his identity, since we have statements signed by him, to the effect that he is the soldier in the picture.

In a concluding note (p. 98 below), the importance of dealing with these questions of identity in the photograph will be briefly discussed.

The boy in the photo: four possible identities

1. ARTUR DĄB SIEMIĄTEK

NB. The middle and last names are pronounced DOMB and SIEMIONTEK and are generally spelled that way in Western media.

That this was the name of the child in the photograph is the oldest and most persistent of the claims concerning his identity.

It was advanced as early as the 1950s, according to one source,[1] but published documentation that the claim was made begins in the period 1977-1978, and stems primarily from one person: a woman named Jadwiga Piesecka (generally spelled Hedwiga Pitztak in the Western press), who was living in Warsaw at the time.

According to a statement she signed on January 24, 1977, the boy in the photograph was named Artur Siemiątek born in Lowicz in 1935. He was the son of Leon Siemiątek and Sara Dąb, and the grandson of the signatory's brother, Josef Dąb.[2]

A similar attestation was signed the following year in Paris by Jadwiga Piesecka's husband, Henryk Piasecki, dated December 28, 1978;[3] in his letter, he further stated that the photograph was taken no earlier than 1943, and he provided the names and addresses of other relatives who could confirm the information offered.

In July 1978, several Western newspapers carried the story, attributing their information to a woman they called Hedwiga Pitztak. This coverage was published, not in the form of signed articles, but rather as captions appearing under or beside a cropped version of the photograph. Of the four captions I have been able to track down in French, Danish and English newspapers, two of them claim that the boy in the photo is still alive and lives on a kibbutz in Israel.[4]

Some ten years later, the same identity was attributed to the boy once again in the carefully researched work of fiction entitled *Umschlagplatz*, and already cited above (p. 5). After a detailed description of the photograph, the narrator identifies the boy as "Artur Siemiątek, son of Leon and Sarah née Dąb, born in Lowicz" (op. cit., p. 326).

Further references to the boy as "Arthur Chmiotak" or "Arthur Schimiontak" are found in a revisionist journal.[5]

2. AN ANONYMOUS SURVIVOR

One of the captions mentioned above appeared in the *Jewish Chronicle* (London) on July 28, 1978, beside a cropped version of the photograph, as shown below. In the caption, the boy was identified Arthur "Shimyontek" Domb.

Approximately two weeks after the appearance of the photo and caption on page 32 in the *Jewish Chronicle*, the story became front-page material when a London businessman contacted the paper and insisted that *he* – not someone named Arthur Domb – was the boy in the photograph. Hence the headline for Joseph Finklestone's lead article in the August 11, 1978 issue of the *Jewish Chronicle*, which read: "'Ghetto boy' lives here." The man who contacted the paper asked that his name be withheld, but was subsequently identified by the sensationalist tabloid, *News of the World*.[6] Though his name has appeared in both a British and an American newspaper 25 years ago, and is currently listed on revisionist websites, I would still prefer to respect his wish for anonymity and will therefore refer to him as X.

In the opening portion of his statement, he is quoted by the *Jewish Chronicle* as saying:

> I dreaded the moment when I would have to come forward and speak about the photograph. For very good reasons I do not want my name mentioned but I cannot

> 32 JEWISH CHRONICLE JULY 28 1978
>
> The identity of the Warsaw Ghetto boy in the famous photograph which is one of the most poignant symbols of Jewish suffering at the hands of the Nazis, has been revealed by a Polish woman in Israel. She said he was Arthur "Shimyontek" Domb, the son of Leon and Sarah Domb, and he was aged eight years when he was driven out of the Warsaw Ghetto in 1943. The picture, which is in the Bernfes collection, shows a small boy as he is marched away by Germans

Copyright © Jewish Chronicle, 28 July 1978. Reproduced with permission.

> allow a false name to be given to the little boy. The scene in the Warsaw Ghetto in 1941 when the photograph was taken is still vivid in my mind.
>
> I was wearing a pair of shoes which were too big for me and which I borrowed from the boy on my right who worked in a baker's shop. I had no socks on. We and other Jews were rounded up because, so we were told, an important German official had arrived.
>
> We were taken to the local police station. I stayed there a number of hours. My mother who had been searching for me arrived and we both claimed that we were not Jewish. We spoke very good Polish and somehow managed to persuade the police to let us go…

Two problems are raised by statements in this first portion of X's interview.

First, citing 1941 as the year the photo was taken, places it considerably earlier than the Warsaw ghetto uprising, which began on April 19, 1943. Edward Kossoy pointed this out in his article in the *Jerusalem Post*, "The boy from the ghetto" (September 1, 1978, see footnote 1). And as already mentioned on p. 83 above, Henryk Piasecki specifically wrote that "claims in the press stating that this photo dates from 1941 are false."

The journalist who had broken the story, Joseph Finkelstone, was also interested in defending its authenticity, and with respect to the dating of the photograph, his comments were summarized in this way by fellow journalist, Clay Harris (footnote 6):

Finkelstone compared the photograph to others known to have been taken in 1943. The soldiers in this photo are "ordinary German Wehrmacht soldiers" and seem to be more relaxed and less obviously brutal than soldiers, wearing different insignia, who appear in 1943 photos, according to Finkelstone.

As it turns out, however, the reference to *Wehrmacht* soldiers was unfortunate since it is inconsistent with what we know of the soldier carrying the submachine gun, who in two signed statements (as will soon be shown) described himself in the photo as wearing an SS uniform and as accompanied by Gestapo or other SS men. (As will soon be shown on pp. 96 and 97 below, the same soldier appears in two other photos in the *Stroop Report*, which could only have been taken during the *Großaktion*.) How "obviously brutal" the solders look in the photo of the boy with raised hands is a question that reflects naïve assumptions as to the visibility of evil on the face of a mass murderer.

The second problem raised by the initial portion of the interview concerns the assertion that when the photograph was taken, the boy with his hands raised was not wearing stockings ("I had no socks on.") The interviewee had apparently only seen the cropped version of the photograph as it appeared in the July 28th edition of the *Jewish Chronicle*, in which the boy's legs were not visible. Presumably he was unaware that in the full photo, the boy is seen to be wearing knee-high stockings. This detail may seem trivial, but the inconsistency is difficult to reconcile with the "vivid" recollection of the scene, as reported in the interview.

The year 1941 and the comment about wearing no stockings are the two main problems raised by the account, which is long and convoluted and needn't be described more fully here.[7]

If X was not in fact that boy, that doesn't mean that a deliberate hoax was in play, nor that anyone had acted in bad faith. The *Washington Post* article about the story broken by the *Jewish Chronicle*, ends on a generous note:

> Finkelstone believes that the man is telling a true story, even if he was not the boy in that particular picture.
> "There was more than one little boy who held up his hands," Finkelstone said. "You can imagine that there were many such occasions. There must have been hundreds of occasions when similar scenes happened all over Europe" (*op. cit.*).

No one was more pleased by the story that the boy in the photo was still alive than the revisionist, Robert Faurisson. Fiercely skeptical of any claim running counter to his own theses, Faurisson uncritically embraced the news of the boy's survival, triumphantly presenting it as though it were proof that Nazi genocide is a myth and that claims to the contrary involve ignorance of the facts. Faurisson wrote:

> The ghetto boy was discovered in 1978. He was not assassinated by the Germans in an alleged "extermination camp." He lives in London with his mother and father. He is extremely wealthy. This "ghetto boy" had become a symbol: the symbol of an alleged "genocide" of the Jewish people. It is obvious that if he should remain a symbol, it could only be the symbol of the erroneous claim of genocide. [...]
>
> The ghetto-boy is the very young boy wearing a cap, seen raising his little arms in the air under the threat of armed German soldiers. The photo has traveled around the world. The texts presenting the photo vary but all of them imply that the scene took place during the Warsaw ghetto uprising of April-May 1943 and we are told – or given to assume – that this child and the group of Jews surrounding him were led off to an "extermination camp." However, the reality would be quite different. According to the *Jewish Chronicle* (August 11, 1978, pp. 1-2), it was in 1941 that this scene took place...[8]

In Faurisson's brief retelling of the story, the boy's Jewish identity is not mentioned as the reason for his arrest by the Germans. Faurisson implies that it was as a thief, not as a Jew, that the boy was brought to the police station. Nor is the boy's release attributed to his and his mother's ability to convince his captors that the family was Gentile and that he had been arrested by mistake in a round-up of Jews. Faurisson wrote:

> The child (and the entire group surrounding him, carrying bags or bundles) had been surprised by German soldiers while carrying out a police operation on the occasion of the visit to Warsaw of an important Nazi notable. 'I was a first class thief and only through stealing was I able to survive,' the ex-ghetto-boy would declare to the *Jewish Chronicle*. The child had been conducted to the police station. His mother who had not been present at the scene of the arrest and who wondered what had become of her son, had gone to claim him at the police station. The child was then turned over to her by the German police (*ibid.*).

Compare this to the account Faurisson purports to be summarizing and in which the boy's mother is quoted as stating:

> I was brought up by a Polish woman and spoke perfect Polish. I did not look Jewish... When I arrived at the police station, I immediately saw my little boy who shouted out in Polish: 'Are you blind? Mother, can't you see me? We are not Jewish, we are Polish.' This bluff worked and I got hold of him and we ran away (*op. cit.*).

In Faurisson's sanitized version of the truth, not only were the Nazis innocent of *acts* of genocide; they apparently didn't even *think* in racial terms.

X's story appeared in several German newspapers on August 14, 1978, with headlines indicating that the boy in the photograph had survived.[9] An article ap-

peared four days later in *Frankfurter Allgemeine Zeitung*,[10] deploring the fact that for decades German children had seen that photo in schoolbooks, with a caption claiming that it was taken in 1943 and that the child with his hands raised would soon be annihilated; that caption – according the author of the present newspaper article – now turns out to be a lie. This article provoked a number of letters to the editor in September and October 1978, as to whether the "Final Solution" was a myth or reality.[11]

3. TSVI NUSSBAUM

In 1982, a 47-year old ear, nose and throat specialist in Rockland County, New York, came forward, stating that in 1943, at the age of seven, he had been arrested in Warsaw and ordered to raise his hands by an SS man standing in front of him and aiming a gun at him. And although he doesn't remember that a photograph was taken at that very moment,[12] Dr. Tsvi C. Nussbaum – now 68 and retired – believes that he *might* be the boy in the picture.

But from very the start, and in all subsequent interviews, Tsvi Nussbaum expressed uncertainty as to whether or not he was the child in the photograph. As David Margolick pointed out in an article in *The New York Times*, "Dr. Nussbaum makes the claim almost reluctantly; others seem much more positive than he is."[13]

There are, indeed, two specific factors that weigh against his being the boy in the photograph.

The first is that although he was arrested in Warsaw, he had never set foot inside the ghetto. Here some further biographical details will be of use.

In the early 1930s, Nussbaum's parents emigrated from Poland to Palestine, where Tsvi was born in 1935. When serious conflicts broke out between Jews and Arabs in Palestine, the Nussbaums returned to Poland, settling in what was then a peaceful town called Sandomierz in 1939. By 1942, Tsvi Nussbaum's mother and father had both been murdered by the Nazis, and arrangements were made for the little boy to be brought from Sandomierz to Warsaw, where his aunt and uncle, in hiding in the "Aryan" section of the city, could look after him. They did so for about six months, after which they were caught in what is regarded by some as a clever trap that had been set by the Gestapo for capturing Jews in hiding.

> In July [1943], Nussbaum recalls, his aunt and uncle noticed that Jews seemed to go and come freely from the Hotel Polsky [sic] at 29 Lyuga [sic] Street. German soldiers even seemed to watch over them. A rumor circulated that foreign-born Jews were being issued passports to go to Palestine.

The Nussbaums joined hundreds of other desperate Jews in the Hotel Polsky [sic], and were put on the "Palestine List." On July 13, 1943, trucks came to take them away [...] not to Palestine but to Bergen-Belsen, where they were housed together in a special barracks, given better food, and not forced to work. The "Palestine List" Jews were kept apart from the other prisoners, possibly as potential bargaining chips.[14]

If the boy in the photograph is Tsvi Nussbaum, then the picture would have to have been taken at the Hotel Polski, and not within the Warsaw ghetto, where all of the photos in the *Stroop Report* are generally believed to have been taken.

The second reservation concerns the dating of the photo: Tsvi Nussbaum clearly remembers that he was arrested on July 13, 1943 – nearly two full months *after* the *Stroop Report* (photos and all) is widely presumed to have been completed and sent on to its SS recipients in Krakow and Berlin.

How then, despite these factors, was Tsvi Nussbaum first confronted with the possibility that he might well be the child in the photo after all? The answer can be found in an exceptionally well-researched Finnish documentary film, written and produced by Matti-Juhani Karila, and first broadcast in 1990.[15] In this film, Dr. Nussbaum explains:

> I had a patient in my practice whom I knew to be a Holocaust survivor. [...] he had a very good memory and he knew the era. And one day at the hospital, he was sitting there and I said to him: "Mark, do me a favor, I don't have the time, could you be kind enough to get me this picture of the little boy?" And he started asking me why I wanted the picture, so I told him the whole story. He said to me: "How do you know it is not you?" I said: "Mark, I was never in the Warsaw ghetto. I remember some place, some hotel, I know the date and what happened to me." He was the one who said: "How do you know that it is not you?" I said: "I don't know." He said to me: "Give me the pictures you have when you were young and let me do an investigation." I gave him my pictures, the only pictures I basically have. I have pictures from Israel and I have some pictures from Poland when I was three or four. The next set of pictures is after the liberation, probably August 1945 when I was ten years old. He took the pictures and I suppose he did an investigation. I don't know exactly what he did. He comes back to me and he says: "This is you" (*ibid.*, p. 2).

In the *New York Times* article already mentioned, Dr. Lucjan Dobroszycki of the YIVO Institute in New York is quoted as doubting that the boy in the photo is Tsvi Nussbaum, for the following reasons:

> The scene, he noted, is on a street, not in the courtyard in which the Hotel Polski roundup took place. Some of the Jews are wearing armbands that they surely would have shed while in the "Aryan" quarter of Warsaw. The German soldiers would not

have needed combat uniforms at the hotel. The heavy clothing worn by most of the Jews suggests that the photograph was taken in May – the date General Stroop put on the report – rather than July. Moreover every other photograph in the Stroop report was taken in the Warsaw ghetto (*op. cit.*, p. B2).

Dobroszycki then went on to say something that the revisionists would soon use for their own purposes, as we will see in a moment:

> "I would be more than happy to learn that this boy was not sent to the death camp of Treblinka," he said. "But this great photograph of the most dramatic event of the Holocaust requires a greater level of responsibility from historians than almost any other. It is too holy to let people do with it what they want" (*ibid.*).

The article gives the last word to Tsvi Nussbaum, who as usual refused to make any categorical assertion:

> "I'm not claiming anything – there's no reward," he said. "I didn't ask for this honor. I think it's me, but I can't honestly swear to it. A million and a half Jewish children were told to raise their hands"(*ibid.*).

Despite this relaxed attitude toward the question, Tsvi Nussbaum did of course consider the two aforementioned factors weighing against his being the child in the photograph: 1) that all the pictures in the *Stroop Report* photo album are generally believed to have been taken inside the ghetto; and 2) that they were taken no later than May 1943, when the *Stroop Report* was presumably completed. Evoking the possibility that the photo of the little boy was taken in July 1943 and outside the ghetto, Tsvi Nussbaum stated:

> On May 16, the Warsaw ghetto was liquidated and [Stroop's] final telegram is: "Warsaw ghetto is no longer." It was after the liquidation, after May 16, 1943, that Krüger apparently came to Jürgen Stroop and said to him: "Listen, this is a great victory, why don't you make an album and send it to Himmler." So my way of thinking is that this album was put together after May 16. There was no reason for him to rush with the album, because in my way of thinking, Himmler never expected an album. And the album basically contained three chapters. One was introduction, one was the daily communication which Himmler already received, a long time before it and the other one was pictures. Some of them make sense in connection with the ghetto, some of them do not make sense in connection with the ghetto. There is a picture there of two Jews with scoliosis. What does this have to do with the uprising of the Warsaw ghetto? I'm not a German scholar, but the introduction sometimes talks in the future and sometimes it talks in the present. So if he says that all the material was gathered together and sent to Germany to be re-used, this took another 5-6 months to do. And he specifically said that everything was destroyed with the exception of the prison, the German police [station], which

The boy in the photo, 1943. *Tsvi Nussbaum's passport photo in 1945.*[17]

> became a prison. In my way of thinking… I think he would not gamble, if he did it on May 16, because there still could have been partisans around and they might have destroyed the police station to show him, listen, we are still alive. So I was feeling that the album was composed after May 16.[16]

While to my untrained eye the two photographs provided above certainly look as though they could be of the same boy, I thought it would be useful to get the opinion of someone trained in photo-comparison, and asked for the assistance of Dr. Karen Ramey Burns, a forensic anthropologist at the University of Georgia. I sent both photographs to her and asked whether it would be possible to determine the likelihood that the two photos are of the same boy, taken two years apart and in very different circumstances. Having examined the two photographs, Dr. Burns replied that although the mouth, nose and cheek are consistent, there is one important disparity:

> the ear lobes of the 1943 boy appear to be attached, whereas the earlobes of the 1945 boy are not attached. This genetic trait cannot change with age and the difference indicates the pictures are not of the same boy.[18]

This is, of course, a weighty argument.

However, one additional factor that counts on the other side of the balance sheet, concerns the location at Dluga Street 29. I have visited the address, no longer the Hotel Polski, and – making allowances for whatever rebuilding and renovations were done in the sixty intervening years – I found the physical layout of the gateway consistent with that of the 1943 photograph.

Dluga Street 29 today, where the Hotel Polski once stood.

All things considered, I believe that those institutions and websites currently stating without reservation that Tsvi Nussbaum is the child in the photo,[19] would do well to leave some room for doubt, as does Dr. Nussbaum himself.

*
* *

I mentioned earlier that Dr. Lucjan Dobroszycki's statements on the photograph would be used by revisionists for their own purposes. Just as Faurisson had gloated over X's claim to be the child in the picture (pp. 85-86 above), David Irving was delighted: 1) that once again, it could be stated that the child had not been murdered by the Nazis; 2) that Holocaust scholars appeared to be displeased by Tsvi Nussbaum's coming forward and to feel that the status of the photograph was hurt by it; and 3) that the survivor was thereby placed in an awkward position vis-à-vis Holocaust scholars, who in turn were thereby cast in a negative light. Irving wrote:

The discovery that the boy was not liquidated, as had been popularly believed, caused outrage and consternation among holocaust scholars who were convinced, said the *New York Times*, that "the symbolic power of the picture would be diminished were the boy shown to have survived." These historians had long considered the picture "a sort of sacred document," added the newspaper. Dr Lucjan Dobroszycki, of New York's well-known Yivo Institute of European Jewish History, echoed this, proclaiming that this picture of "the most dramatic event of the holocaust" required "a greater level of responsibility from historians than almost any other." "It is too holy," he added, "to let people do with it what they want." Nussbaum was shocked at this unexpected reaction to his survival: "I never realized that everyone puts the entire weight of six million Jews on this photograph," he said. "To me it looked like an incident in which I was involved -- and that was it."[20]

On another website, David Irving comments on the use of the photograph by anti-German propagandists, who perpetuate the mistaken impression that in a matter of hours or even minutes after the photo was taken, everyone in the picture was dead. Stating that the boy survived to become a wealthy physician in New York, Irving then actually writes: "only the soldier is no longer alive today" (*nur der Soldat lebt heute nicht mehr*), as though the boy's possible survival meant that no one else in the photo perished at the hands of the Nazis.[21]

4. LEVI ZEILINWARGER

In late 1999, the Ghetto Fighters' House in the Western Galilee was contacted by Avraham Zeilinwarger, then 95 years of age. He informed the museum that the boy in the photograph was his son, Levi.[22] As a result of that contact, the following information now accompanies the well-known photograph on the web site of the Ghetto Fighter's House, at catalog number 2698:

According to the testimony of Abraham Zejlinwarger of Haifa, the boy is his son, Lewi (1932 –?), and he suggests that the photograph was taken in the ghetto on Kupiecka Street near Nalewki Street. The father, a ladies' hairdresser by profession, worked at forced labor clearing rubble and damage at a burned-out gas installation in Warsaw, and had escaped to USSR territory at the beginning of 1940.[23]

This photograph of Levi Zeilinwarger, taken before the war, can also be found on the same web site, at catalog number 25239, where the names of both parents are listed as Henia-Chana and Avraham

Chana Zeilinwarger

Zejlinwarger.[24] Unfortunately, the resolution of this picture is not sufficient to permit a forensic comparison with the Warsaw ghetto photograph.

During a telephone conversation I had with Avraham Zeilinwarger on March 30, 2003, at which time he was 98 years old, he told me in no uncertain terms that the woman seen just to the left of the boy (our left) in the foreground of the Warsaw ghetto photograph, is the boy's mother, Chana. Once again, the resolution of my copy of the photograph provided of Chana Zeilinwarger is insufficient for a forensic photo-comparison.

Avraham Zeilinwarger believes that his wife, his 11 year old son Levi and his 9 year old daughter Irina all perished in a concentration camp in 1943.

Other Captives

According to the Yad Vashem *Page of Testimony* number 90540, filled out in 1994, the little girl at the far left of the photograph was identified as Hanka Lamet by her aunt, Esther Grosbard-Lamet, residing in Miami Beach, Florida. The same document lists 1937 and Warsaw as the year and place of the little girl's birth, while the place and circumstances of her death are listed as: "MAIDANEK. CHILDREN TAKEN TO GAS CHAMBER." The same identification of the child can be found on the US Holocaust Memorial Museum website.[25]

On the same *Page of Testimony* cited above, the following was entered in the box in which the first name and maiden name of the victim's mother was to be listed: "MARYLA PRESENT MATYLDA." The USHMM website, also cited above, indicates that the woman standing to the left of the little girl is her mother, Matylda Lamet Goldfinger.

Hanka Lamet *Matylda Lamet* *Leo Kartuzinsky* *Golda Stavarowski*

The boy carrying the white sack near the rear of the group shown in the photo, was identified as Leo Kartuzinsky by his sister, Hana Ichengrin, according to an e-mail I received from the photo archives at Yad Vachem.[26]

According to the USHMM worksheet for photo #26543,[27] the woman "in the back right" was identified as Golda Stavarowski by her granddaughter, Golda Shulkes, residing in Victoria, Australia.

The SS Trooper: Josef Blösche

The one person in the photograph whose identity has been established beyond any doubt is the soldier aiming his submachine gun in the direction of the little boy. He was SS-Rottenführer (corporal) Josef Blösche and of all the predators operating with impunity within the ghetto walls, he was one of those most feared by the Jewish population. Often teamed with SS-Untersturmführer (second lieutenant) Karl-Georg Brandt and SS-Oberscharführer (senior sergeant) Heinrich Klaustermeyer, he terrorized the occupants of the ghetto on "hunting expeditions," randomly shooting whomever he chose. The following is one of many accounts of these murderous sprees:

The two well-known murderers, Blescher and Klostermeier, visited the ghetto every day and whenever they felt like it, they would make a little "action" of their own, shooting in all

directions, each time leaving a few dead bodies in the street. Weeks before, when they did not yet know that the Jews had weapons, they had also entered homes and attics, looking for hiding places, penetrating into every nook, and each time they would get hold of a Jew whom they would torture and kill. Later they became more careful, did not enter homes, only fired into windows.[28]

Thanks to research done by Heribert Schwan and Helgard Heindrichs in former Stasi files now open to scrutiny, a new book and TV documentary[29] have provided a wealth of information about Blösche. However, instead of considering the life and psychology of this man, I want to keep the focus of the present discussion squarely on the photograph. In order to do so, I will draw on several of Blösche's own statements, made after his arrest on January 11, 1967 in the German Democratic Republic, after he was recognized by a survivor of the Warsaw ghetto despite the fact that his face had been severely disfigured by an accident shortly after the war.

When Blösche was first arrested, his interrogators were apparently keen on getting his acknowledgment that he was in fact the man wielding the submachine gun in the photograph. On the first day after his arrest, he dutifully scrawled the following handwritten statement on the back of a copy of the picture:

> The person appearing in the photocopy at hand wearing an SS uniform, with a submachine gun in firing position and with motorcycle goggles over his steel helmet, is me. The picture shows me, as member of the Gestapo in the Warsaw ghetto, with a group of SS members during a deportation action.
>
> [Signed Josef Blösche]
> Berlin, 12 January 1967.[30]

A somewhat more detailed admission was apparently considered necessary, and Blösche was asked at a subsequent interrogation whether he recognized himself in the photo, to which he answered:

> I have looked at the given photocopy. Concerning the person in an SS uniform, standing in the foreground of a group of SS members and holding a submachine gun in firing position and wearing a steel helmet with motorcycle goggles, this is me.
>
> The picture shows how I, as member of the Gestapo office in the Warsaw ghetto, together with a group of SS members, am driving a large number of Jewish citizens out from a house. The group of Jewish citizens is comprised predominantly of children, women and old people, driven out of a house through a gateway, with their hands raised. The Jewish citizens were then led to the so-called *Umschlagplatz* [transfer center], from which they were transported to the extermination camp Treblinka.
>
> [Signed Josef Blösche][31]

Misleadingly captioned "Jewish rabbis" (Jüdsiche Rabiner [sic]), this photo appears in both specimens of the Stroop Report. *As Sybil Milton points out in her facsimile edition, these men were orthodox Jews but nothing identifies them as being rabbis (op. cit., note 33). The three soldiers standing closest to the camera are, from left to right, Klaustermeyer, Blösche and Brandt (as identified by Schwan and Heindrichs, op. cit., p. 285). Blösche served both in the SS (Schutzstaffel) and SD (Sicherheitsdienst). In this photo, as in the one on the facing page, the diamond-shaped patch with the SD insignia is clearly visible on his left sleeve. Photo provided by the Institute of National Remembrance – Commission for the Prosecution of Crimes against the Polish Nation, Office for the Preservation and Dissemination of Archival Records.*

What, according to this statement, would Blösche's role have been at the time the photo was taken? That of leading these prisoners to the *Umschlagplatz*? Let's suspend that question for a moment and consider another account Blösche gave several months into his captivity, in April 1967:

Personal Testimony

I now recall a shooting of Jewish citizens in the Warsaw ghetto. This took place at a time when there was no transportation to the extermination camp Treblinka. Brandt gave each of us at the [SD] office in the ghetto a small box of pistol ammunition. Beside me there were Rührenschopf, Klaustermeier and other Gestapo members whose names I do not know any longer today. Brandt led us into the middle of the ghetto. I can no longer remember the exact time. I know the shooting took place in a courtyard, which one entered from the street through a gateway. Beyond that I

This photo, also in both specimens of the Bildbericht, is captioned "The leader of the Grand Operation" (Der Führer der Großaktion). Of the five men in the foreground, Stroop is second, Klaustermeyer fourth, and Blösche fifth from the left. Photo provided by the Institute of National Remembrance – Commission for the Prosecution of Crimes against the Polish Nation, Office for the Preservation and Dissemination of Archival Records.

still know that during the shooting, a truck carrying Jewish citizens drove by. At that moment, I was standing at the entrance to the courtyard. How many Gestapo members were there I can no longer say exactly, it could have been 15 to 25.

<div style="text-align: right;">

Berlin, 25 April 1967
[signed] Josef Blösche[32]

</div>

This may well refer to the incident Stroop reported in his dispatch of April 25, cited on p. 36 above. Or perhaps it was the one described by the court at the time of Blösche's sentencing in 1969, when among the numerous crimes of which he was found guilty was participation in the shooting of more than 1000 Jews in the courtyard of a building complex on the morning of April 19, 1943, the first day of the *Großaktion*.[33] In any event, it was only one of many mass shootings Blösche took part in during his service in the Warsaw ghetto.

If, as Blösche claimed during his trial in 1969, he never accompanied a transport of Jews to the *Umschlagplatz*,[34] then what was he doing at the time the photograph was taken and shortly thereafter? It is at least conceivable that he was not there in order

to herd these prisoners toward a train that would take them to Treblinka but rather to shoot them on the spot, and that when first questioned about the photograph, he preferred to keep silent about his own role in mass executions and to imply that other people had done the dirty work. This is of course highly speculative, but it was established at his trial that mass shootings were one of Blösche's specialties.

For his zeal and effectiveness, Blösche was awarded the Crosses of War Merit 2nd Class with Swords, when his service in Warsaw ended.[35]

At the conclusion of his trial, he was found guilty of war crimes and of crimes against humanity by the Erfurt circuit court in April 1969, and was executed in Leipzig on July 29, 1969.

Concluding note

Knowing the names of captives in the photograph counteracts in some small way that portion of the Nazi project that sought to reduce these Jewish prisoners to anonymous and interchangeable units, eradicating their identity in addition to destroying them in mind and body.[36] Likewise, knowing the name of the key perpetrator in the picture is in itself a step in the direction of pinpointing *personal* responsibility.

Furthermore, each of the persons we see in the photograph is defined for us by the moment the picture was taken, in his or her role as captive or captor. However inexhaustible the photo may be in the sense that we can indefinitely explore each face, decoding glances and body language, noticing details of clothing, etc., we remain in the moment and necessarily focused on the visual data the photograph offers to our powers of observation and deduction.

Names, on the other hand, anchor each person in a reality that came before the photo and exists outside of it. In that respect, names serve as reminders that everyone in the photograph had a unique personal history and that the photo caught only one fleeting moment of each life. Given the overriding power of this image, that simple fact can be all too easily forgotten.

NOTES TO CHAPTER FOUR

1 In "The boy from the ghetto," a highly informative article appearing in the *Jerusalem Post* on September 1, 1978, p. 5, Edward Kossoy concluded his refutation of another claim (to be discussed below) with an intriguing paragraph:

> In the 1950's, two women came forward independently, claiming to be related to the boy in the picture. They said his name was Arthur Siemiontek deported to the Warsaw ghetto together with his mother from Lowicz, a small township near Warsaw. Adam Rutkowski,

a well-known historian and author of many books on the Holocaust, now living in Paris, examined the claims together with the known criminologist Professor Paul Horoszowski (now at De Kalb University, Illinois). They did not make a positive identification. The identity of the Ghetto boy therefore remains uncertain.

Both Adam Rutkowski and Paul Horoszowski are now deceased. I contacted Dr. Kossoy, who generously shared his files with me, but was unable to provide further details about the women who came forward in the 1950s or exactly where and when the Rutkowski-Horoszowki examination of their claims took place. He did however recall that one of the women was named Domb.

2 A copy of this statement is on file in Warsaw at the Institute of National Remembrance – Commission for the Prosecution of Crimes against the Polish Nation, Office for the Preservation and Dissemination of Archival Records. Yadwega Piesecka mentions in her statement that in 1968, she had given this information along with a photograph of the boy (taken at birth) to Mr. Rutkowski [see footnote 1] at the Jewish Historical Institute.
3 This letter is on file at the *Centre de documentation juive contemporaine,* where it is listed as Document DLXVI-96.
4 Here are the four captions, presented in chronological order (the first three in my translation).

> HIS NAME WAS ARTHUR SCHMIONTAK
> This photo of a Nazi round-up in the Warsaw ghetto has been seen around the world. Poignant evidence of the "final solution," it symbolizes one of the most important dramas of history.
>
> Thanks to investigations carried out in the Polish capital, it has just been established that the "Jewish ghetto child" was Arthur Schmiontak, born in 1935 to Leon Schmiontak and Sarah Domb; this was recently disclosed by a woman living in Warsaw, Mrs. Hedwiga Pitztak.
>
> On the day this photo was taken, Arthur Schmiontak couldn't have been older than eight. He was embarking on the very long journey into the "night and fog."
>
> <div style="text-align:right">*L'Humanité*, Paris, July 24, 1978, p. 5</div>

> HE'S ALIVE. The whole world suffered with him. With his family. With the millions of Jews annihilated by the Nazis during World War II.
>
> He became known around the world when he was driven out of the Warsaw ghetto without understanding and with his arms raised – on the orders of SS men with machine guns. 370,000 Warsaw Jews were murdered.
>
> But Arthur Schmionak is alive. He is now 43 years old, is in good health and lives on a kibbutz in Israel. His parents were Leon Schmiontak and Sarah Domb.
>
> This information was recently given to the museum for war victims in the Galilee via a letter from Hedwiga Pitztak, Warsaw.
>
> <div style="text-align:right">*Ekstrabladet*, Copenhagen, July 25, 1978</div>

> The boy identified: World War II's perhaps most famous picture, a group of Jews "escorted" from the Warsaw ghetto by armed German soldiers, was displayed dur-

ing the war crimes tribunals at Nuremberg in 1946. It was used as evidence against one of the guards, visible in the background, and at that time other people appearing in the picture could not be identified. Now we are told by the French news agency that a woman in Warsaw has identified the photo's "main character," the little, dejected boy with his hands raised. His name is Arthur Schmiontak, according to the woman. He was born in 1935 and was eight years old when the picture was taken. The Polish woman goes on to say that Arthur is alive and lives on a kibbutz in Israel. But the riddle has not been entirely solved. The French news agency has continued investigations in Israel and located several of Arthur Schmiontak's relatives. They deny the report that he is still alive. Arthur was killed in Warsaw in the spring of 1943, they state.

Aarhuus Stiftstidende, Denmark, July 26, 1978

The identity of the Warsaw Ghetto boy in the famous photograph which is one of the most poignant symbols of Jewish suffering at the hands of the Nazis, has been revealed by a Polish woman in Israel. She said he was Arthur "Shimyontek" Domb, the son of Leon and Sarah Domb, and he was aged eight years when he was driven out of the Warsaw Ghetto in 1943. The picture, which is in the Bernfes collection, shows a small boy as he is marched away by Germans.

The Jewish Chronicle, London, July 28, 1978

5 Mark Weber, "The 'Warsaw Ghetto Boy,'" *Journal of Historical Review* 14, 2 (March/April 1994), pp. 6-7. A French translation of the article can be found on the Web at http://www.codoh.com/inter/intwgboy.html
6 See Clay Harris, "Warsaw Ghetto Boy – Symbol of the Holocaust," *The Washington Post*, September 17, 1978, pp. L1 and L9.
7 It involves the boy's need to steal in order to eat, his arrest as part of a roundup of Jews in honor of a visiting Nazi dignitary, the boy's release when he and his mother convinced the Nazis that they were both Aryans, his escape into the woods where he joined a band of partisans and eventually wound up in Turkestan, etc.
8 My translation from "Le 'ghetto-boy' et Simone Veil: deux symboles de l'imposture du génocide?" which can presently be found at: http://www.abbc.com/aaargh/fran/archFaur/1974-1979/RF7912xx2.html
9 "Dieser Junge überlebte das Grauen von Warschau," *Die Welt*, August 14, 1978; "Dieses Kind hat überlebt," *Kölner Stadt-Anzeiger*, August 14, 1978; "Das Kind aus dem Warschauer Getto überlebte," *Neue Rhein Zeitung*, August 14, 1978.
10 "Lehrer und Schüler sind die Opfer," Alfred Schickel, *Frankfurter Allgemeine Zeitung*, August 19, 1978.
11 Four letters in the issue of *Frankfurter Allgemeine Zeitung* of August 28, 1978, p. 6. Thereafter one in each of the following issues: August 31, p. 7; September 2, p. 7; September 4, p. 6; September 11, p. 15; September 14, p. 19; and a full-fledged article, "Alle Anzeichen deuten auf einen Irrtum," by Wolfgang Birkenfeld, October 11, p. 10.
12 Tsvi Nussbaum stated this in reply to my question during an interview that he kindly granted on January 22, 2003.
13 "Rockland Physician Thinks He Is the Boy in Holocaust Photo Taken in Warsaw," David Margolick, *The New York Times*, May 28, 1982, pp. B1 and B2.

14 Sue Fishkoff, "The Holocaust in one photograph," *The Jerusalem Post*, April 18, 1993. The story of the Hotel Polski, which was located at 29 Dluga Street, is extremely complex and confusing. For the most complete account of that strange episode in the war, see Abraham Shulman's *The Case of Hotel Polski* (New York: Holocaust Library, 1982).

15 *A Boy from Warsaw: Tsvi Nussbaum* (Helsinki: MTV, 1990), 50 min. At a memorable meeting in Helsinki in December 2002, Matti-Juhani Karila graciously shared his extensive files with me, and also provided a transcript of his film, serving as the basis for my quotations.

16 *Ibid.*, p. 14 of the transcript.

17 This photograph, taken presumably in August 1945 soon after his liberation from Bergen-Belsen, was kindly given to me by Tsvi Nussbaum when we met for the above-mentioned interview.

18 E-mail sent on March 9, 2003, and quoted with permission.

19 In response to a recent inquiry as to whether the Simon Wiesenthal Center in Los Angeles maintains a file on the photograph or could provide any information on it, I received an e-mail from the Center's Library and Archive Division on April 9, 2003, stating: "The boy in the photo is Tsvi Nussbaum and, fortunately, he is very much alive today."

20 "A Tragic Picture – That Warsaw Ghetto Photograph," in the series "Documents on the Campaign for Real History." http://www.fpp.co.uk/History/General/WarsawGhetto/WarsawPic1.html Though unsigned, this website which purports to be asking questions about the photo, includes the instructions: "E-mail your answers to David Irving," and provides a link to David Irving's e-mail address. See also Mark Weber's "The 'Warsaw Ghetto Boy'" (op. cit.) and two translations of articles by him on the Web: Jean-Marie Boisdefeu's "Le garçon de Varsovie, symbole de l'Holocaust" and Jean-François Beaulieu's "Le petit garçon de Varsovie at http://www.abbc.com/aaargh/fran/bsdf/jmb24.html and http://www.codoh.com/inter/intwgboy.html respectively.

21 http://www.fpp.co.uk/Auschwitz/docs/fake/PhotosForeword.html Irving's text reads as follows: *"Bei jedem aber, der eigene Kinder hat, wird die Propagandawirkung dieses Bildes nicht sein Ziel verfehlen. Wenige Tage, wenn nicht sogar Stunden oder Minuten nachdem diese Aufnahme gemacht wurde, so sagt das Bild im stummen Untertönen, sind alle bestimmt restlos tot. Nur, das stimmt nicht: der Junge überlebte den Krieg und soll heute noch reicher Arzt in New York sein, was wir ihm alle gönnen; nur der Soldat lebt heute nicht mehr. In den sechziger Jahren in der DDR erkannt, soll er zu Tode verurteilt und auch hingerichtet worden sein. Macht nichts, das Foto darf weiter seine Schuldigkeit als anti-deutsche Propaganda tun. Die Fotografen, wie die Soldaten sterben; die Foto-Lügen, wenn nicht dagegen gekämpft wird, marschieren aber weiter."*

22 Zvi Oren, Director of Photo Archives at the Ghetto Fighters' House, graciously supplied this information in an e-mail on March 30, 2003. While on the Ghetto Fighters' House website, the names are spelled "Zejlinwarger" and "Lewi," I am applying the spelling "Zeilinwarger" and "Levi" used in a personal letter to me from the informant himself, dated April 4, 2003.

23 http://www.gfh.org.il/gfhview/PrintItem.asp?pos=1&itemfilename=0000031858&back=dbsearch%2Easp%3F

24 http://www.gfh.org.il/gfhview/PrintItem.asp?pos=0&itemfilename=0000042979&back=dbsearch%2Easp%3F

25 At present, the relevant page can be found at the following web address: http://www.ushmm.org/uia-cgi/uia_doc/photos/2854?hr=null
26 I am grateful to Ella Avital-Florsheim at Yad Vachem for sending this information on November 10, 2002.
27 I wish to thank Leslie Swift at the USHMM for e-mailing this document to me on February 13, 2003.
28 Tuvia Borzykowski, *Between Tumbling Walls*, trans. from the Yiddish by Mendel Kohansky (Tel Aviv: Hakibbutz Publishing House, 1972), p. 46. The names of these and other SS men are often spelled the way they were pronounced by the Jews in the ghetto, Blösche's name often rendered "Blesher" or "Blescher." See also Michal Grynberg (ed.), *Words to Outlive Us. Voices from the Warsaw Ghetto.* trans. Philip Boehm (New York: Metropolitan Books, 2002; orig. publ. in Poland in 1988), esp. pp. 179 and 184, for further eye-witness accounts of Blösche's murderous activities in the Warsaw ghetto. On several websites, he is identified as a man called "Frankenstein" by the Jews of the ghetto: http://waarden.goliath.nl/werkpl/lessug/2warschau/, http://www.einsatzgruppenarchives.com/trials/profiles/warsaw5.html, and http://auschwitz.dk/Holocaust2.htm, http://www.texthalde.de/warschau.html. However, according to other and probably more dependable sources, including an overview of Klaustermeyer's trial records, Blösche and "Frankenstein" were two different people: http://www1.jur.uva.nl/junsv/Excerpts/586005.htm, and Yitzhak Zuckerman ("Antek") *A Surplus of Memory. Chronicle of the Warsaw Ghetto Uprising*. Trans from the Hebrew by Barbara Harshav (Berkeley: University of California Press, 1993), p. 310. The Schwan & Heindrichs book deals with this question only in passing, by citing one witness who identified Frankenstein as Blösche's buddy or accomplice (*Kumpan*), p. 295.
29 *Der SS-Mann. Josef Blösche – Leben und Sterben eines Mörders* (Munich: Droemer, 2003). The TV documentary has the same title.
30 My translation of an authorized copy of the document, generously lent to me by the Finnish TV producer, Matti-Juhani Karila. This document is also reproduced by Schwan and Heindrichs (*op. cit.*), p. 247. Blösche's German text reads: *"Die auf der umstehenden Fotokopic abgebildete Person in SS-Uniform, mit der Maschinenpistole im Anschlag und mit einer Motorradbrille um den Stahlhelm bin ich. Das Bild zeigt mich, als Angehörigen der Gestapo im Warschauer Ghetto, mit einer Gruppe von SS-Angehörigen bei einer Deportationsaktion."*
31 My translation of a duly authorized copy of the document, generously lent to me by the Finnish TV producer, Matti-Juhani Karila. Blösche's statement reads: *"Ich habe mir die vorgelegte Fotokopie angesehen. Bei der Person in SS-Uniform, die im Vordergrund der Gruppe von SS-Angehörigen steht und eine Maschinenpistole in Anschlag und um den Stahlhelm eine Motorradbrille hat, handelt es sich um mich. Das Bild zeigt, wie ich als Angehöriger der Gestapo-Dienststelle im Warschauer Ghetto mit einer Gruppe von SS-Angehörigen eine zahlenmäßig große Gruppe von jüdischen Bürgern aus einem Haus heraustreibe. Bei den jüdischen Bürgern handelt es sich vorwiegend um Kinder, Frauen und alte Leute, die mit erhobenen Händen aus der Toreinfahrt des Hauses getrieben werden. Die jüdischen Bürger wurden dann von den SS-Angehörigen zum sogenannten Umschlagplatz geführt, wo ihr Abtransport in das Vernichtungslager Treblinka erfolgte."*

32 My translation of the document reproduced by Schwan and Heindrichs (*op. cit.*), p. 5. Blösche's statement reads: *"Persöhnliche [sic] Niederschrift. Ich erinnere mich jetzt an eine Erschiessung von jüdischen Bürgern im warschauer Ghetto. Diese hat in der Zeit wo keine Transporte in das Vernichtungslager Treblinka fuhren stattgefunden. Brandt gab auf der Dienststelle im Ghetto einem jeden eine kleine Schachtel Pistolenmunition. Ausser mir war noch Rührenschopf, Klaustermeier sowie andere Gestapoleute dabei deren Namen ich heute nicht mehr weis [sic]. Brandt führte uns in das Innere des Ghettos. An der genauen Zeit [sic] kann ich mich nicht mehr besinnen. Ich weiß daß die Erschiessung in einem Hof stattfand, den man von der Straße durch ein Tor erreichte. Weiter weis [sic] ich jetzt noch, dass während der Erschiessung ein LKW vorbei fuhr, auf dem sich jüdische Bürger befanden. Zu diesem Zeitpunkt hielt ich mich am Eingang zu diesen Hof auf. Wie viel Gestapoangehörige beteiligt waren weis [sic] ich heut nicht mehr genau, es können 15-25 Mann gewesen sein."*

33 Ibid., pp. 309-310. This sentencing took place on April 30, 1969.

34 "[…] habe keine Transporte zum Umschlagplatz begleitet […]" Ibid., p. 286.

35 *The Report of Jürgen Stroop Concerning the Uprising in the Ghetto of Warsaw and the Liquidation of the Jewish Residential Area.* Intro and notes by Prof. M. Mark (Warsaw: Jewish Historical Institute, 1958), p. 119. See also Schwan and Heindrichs, pp. 134 and 290 for other details.

36 Elsewhere, in connection with the Nazis' "Night and Fog" decree, I commented on this same deliberate obliteration of the prisoner's identity. See my book, *Nuit et Brouillard by Alain Resnais: On the Making, Reception and Functions of a Major Documentary Film* (Aarhus: Aarhus University Press, 1986), pp. 16-17.

Chapter Five

THE ROLE OF THE PHOTOGRAPH IN SELECTED WORKS OF ART

Introductory note

Though it is generally assumed that the photo of the boy in the Warsaw ghetto was known throughout the world during the entire post-war period, what the evidence suggests is that prior to 1956, it had little international exposure, and that it was not until 1960 that the picture decisively acquired the prominence it has today. Not even in the wake of the Nuremberg trials did such mainstream news magazines as *Time* and *Life* carry the picture.[1] And the only books in which the photo appeared in the 1940s and 1950s reached a very limited public.[2]

The first person to bring the picture to the attention of a world audience was Alain Resnais, who included the photo in *Nuit et Brouillard* (*Night and Fog*), premiered at the Cannes film festival in 1956, and generally considered the first artistically serious documentary film on the Nazi crimes against the civilian populations of Europe. In a sequence describing the building of the concentration camps, and showing photos of barracks, the narrator states (in words written for the film by the poet Jean Cayrol):

> During this time, Burger a German worker, Stern a Jewish student in Amsterdam, Schmulszki a tradesman in Krakow, Annette a high school student in Bordeaux go on living their daily lives, unaware that a thousand kilometers from their homes a place has already been assigned to them. And the day arrives when their blocks are ready and only they are missing. Deportees from Lodz, Prague, Brussels, Athens, Zagreb, Odessa or Rome…[3]

It is between the words "missing" and "deportees" that the photo of the boy with raised hands appears on screen for four seconds.[4]

But 1960 is the year that the photograph acquired the international status it has today, largely through the efforts of Gerhard Schoenberner whose book *Der gelbe Stern* (*The Yellow Star*) was the first widely circulated and comprehensive collection of Holocaust photographs.[5] Published in Germany in 1960, the book would

The cover of the Danish edition of The Yellow Star *(Copenhagen: Samlerens Forlag, 1978), using the photo that appeared on the cover of the original 1960 German edition of the book. Reprinted here with permission of Samlerens Forlag.*

The cover of the British edition of The Yellow Star *(London: Corgi, 1969 and 1978), reprinted here with permission of Corgi Press.*

soon be released in a number of other countries on several continents, bringing the photo of the boy in the Warsaw ghetto to readers throughout the world. And in the Dutch edition, also published in 1960, the photograph was used on the cover of the book as well, which would also be the case for the British, French and Canadian editions (first appearing in 1969, 1982 and 1985, respectively).

1960 was also the year in which *Life* finally carried the photo (mentioned on p. 56 above),[6] the year in which the first facsimile edition of the *Stroop Report* was published in Germany,[7] and in which the first comprehensive exhibition to include photographs of Nazi crimes against European Jewry was organized in Germany, the photo of the boy with raised hands appearing on the poster for the exhibition.[8]

By the time Ingmar Bergman used the photograph in his film *Persona* in 1966, the image was well known. In a memorable scene in this film, the character played by Liv Ullmann – voluntarily mute as a silent protest against the evil of the world – stares intently at a copy of the picture.

The remainder of this chapter is devoted to the role the photo has played in a BBC television series (1976), a poem (1982), a short film (1985) and a series of

paintings (1995 to the present). After a brief presentation of each work, the reader will find an interview with the person who wrote, acted in, filmed or painted the work in question, describing in his or her own words the meaning of the photograph in that context.[9]

1. Frederic Raphael, *THE GLITTERING PRIZES* (BBC, 1976)

Adam Morris (played by Tom Conti) is an attractive young writer who always carries in his pocket a copy of the photograph of the boy with his hands raised. Adam is inclined toward self-irony, and his passionate concern with the Holocaust often pits him against those he sees as having been indifferent to the fate of European Jews. Though highly successful in English society, as he and other Cambridge graduates shape their lives in the post-war decades, he continues to feel like an outsider. In the scene about to be presented, he stops by the dress shop of his brother Derek's girlfriend, Carol Richardson (played by Prunella Gee), to pick up a present for his wife. It is in this scene we learn about the photograph in his pocket. The scene which follows this brief introduction is in the final episode of *The Glittering Prizes*, and I wish to thank the author Frederic Raphael and producer Mark Shivas, as well as Paul Richmond and Justine Avery at the BBC, for graciously authorizing the reproduction of dialogue and images from this scene.

The Glittering Prizes consists of six episodes, each running 75 minutes, and broadcast on BBC2 in the period 21 January – 25 February 1976. Frederic Raphael

wrote the screenplay that won him a Royal Television Society's *Writer of the Year Award*. Produced by Mark Shivas and directed by Waris Hussein and Robert Knights, it is widely considered a major landmark in quality television drama.

Born in 1931 and a Fellow of the Royal Society of Literature since 1964, Frederic Raphael is a prolific writer whose works span a great variety of genres, including major screenplays (most recently *Eyes Wide Shut*), novels, short fiction, essays and translations of Greek and Latin classics. The following are among his works:

2003	Translation of Petronius' *Satyrica*	1979	*Sleeps Six and Other Stories*
2003	*A Spoilt Boy: A Memoir of a Childhood*	1978/1991	Translation of *The Plays of Aeschylus*, with Kenneth McLeish
2003	*The Benefits of Doubt: Essays*	1976	*W. Somerset Maugham and His World*
2001	*Personal Terms*	1976	*The Glittering Prizes* (screenplay and novel)
2000	*A Double Life*	1975	*California Time*
1999	*The Great Philosphers: Popper*	1975	*Bookmarks*
1999	*All His Sons* (short fiction)	1974	*Daisy Miller* (screenplay)
1999	*Eyes Wide Open: A Memoir of Stanley Kubrik*	1973	*Richard's Things*
1999	*Eyes Wide Shut* (co-author of screen play)	1972	*April, June and November*
		1971	*Who Were You With Last Night?*
1998	*Coast to Coast*	1970	*Like Men Betrayed*
1997	*The Necessity of Anti-Semitism*	1967	*Orchestra and Beginners*
1995	*Old Scores*	1967	*Far from the Madding Crowd* (screenplay)
1994	*"The Latin Lover" and Other Stories*		
1990	director of "The Man in the Brooks Brothers Suit," segment of *Women and Men – Stories of Seduction*	1967	*Two for the Road* (screenplay)
		1966	*Limits of Love*
1989	*After the War*	1965	*Darling* (screenplay)
1986	*Think of England*	1963	*Lindmann*
1985	*Heaven and Earth*	1962	*The Trouble with England*
1982	*Byron*	1962	*The Graduate Wife*
1980	*Oxbridge Blues and Other Stories*	1960	*The Limits of Love*
1979	*Cracks in the Ice: Criticism of Two Decades*	1958	*The Earlsdon Way*
		1956	*Obbligato*

Excerpt from the final episode of *THE GLITTERING PRIZES*
Broadcast by the BBC on Feb. 25, 1976

The actors appearing in this scene are Tom Conti (Adam) and Prunella Gee (Carol).

CAROL: Did you always expect to be successful?
ADAM: Yes. And despite signs to the contrary, I still do.
CAROL: Derek says he's always known.
ADAM: About me or about him?
CAROL: That you'd make it.
ADAM. Ah. He can be jealous of me if I can be jealous of him

CAROL: And what's he got that you could possibly want?
ADAM: Freedom?
CAROL: You can do anything you like.
ADAM: Then why don't I?
CAROL: You tell me.
ADAM: Oh I do. In one volume after another. Few of which are ever reprinted. Success.
CAROL: What about your films?

ADAM: The money is nice.
CAROL: I love money.
ADAM: Are you serious?
CAROL: Sure. If you work hard, what's wrong with it?
ADAM: I feel guilty.
CAROL: Well maybe guilt is just one more of the things one can buy.
ADAM: Touché. Very touché indeed… That's not the full story.
CAROL: What is the full story?

ADAM (takes a photo out of his jacket pocket and hands it to Carol): I always carry it.

CAROL: Is it you?
ADAM: Me, no. It has nothing to do with me.

ADAM: That's some six year old Yid on his way to what's good for him.

Carol gasps.
ADAM: Me, no

ADAM: No, I was eating bread and marmite at the time. Hated it. And learning amo, amas, amat.

ADAM: This is the afterlife as far as I'm concerned, Carol. Nothing has ever happened to me at all. I've led a charmed life. Really have. And I feel guilty about money.
I feel guilty about being alive.

ADAM And about being so nice. I'm a lot nicer than I want to be, hard that that might be to believe.

CAROL: I don't feel sorry for you.

ADAM: Then why am I telling you all this?
CAROL: You lead the life of Reilly.
ADAM: And somewhere that bastard is leading mine.

CAROL: Well what to you want to be?
ADAM: A thorough-going shit. With no conscience, no memory. An immunity to syphilis and a mind that got to Linear-B twenty minutes before that bastard Ventris.

ADAM: Dumas père with a vasectomy. Flaubert without the pox. Cary Grant with a good script. Oh I'd also like to get a bit more topspin on my second service. How soon…

ADAM (cont.): can you have this ready?
CAROL: Instead of which look at you.

ADAM: A happily married man

CAROL: Well what do you want out of life, for God's sake?

ADAM: I'll start with a written apology.

Well anyway, that's my number. If you want any more, you can sing it to yourself.

An interview with Frederic Raphael on *The Glittering Prizes*

RR: There's a scene in The Glittering Prizes *where Adam shows the picture that he's been carrying in his pocket and he says of the picture: "This is the afterlife as far as I'm concerned." That's intriguing and I don't quite know how to understand it. Could you tell me what he means by that?*

FR: You remember when somebody asked Robert Browning what something meant? He said: "When I wrote it, only Robert Browning and God knew what it meant. And now only God does." *[Laughter.]* But I'm not going to say that. I have to read what you just said as if I were a stranger to it rather than as if I were the author in the sense that I don't remember what was going through my mind. But I'll tell you what I *take* it to mean.

I think the answer to your question is – and it's rather a glum one, even perhaps a rather disgraceful one – that no Jew can seriously have much hope that there is anything to come which is going to be any better than what is on that picture. So that although it would be disgraceful – and I've often said so in other contexts – for Jews to go around pretending that they are as persecuted as they were under the Nazis (which would be grotesque), I think what Adam means is that no Jew can escape from the probability that if anything is going to happen further down the track, it's something bad rather than something good. Whether it means that God Himself will do the same thing to us in the next world, I think that's too pessimistic to assert… or should I say, hope? *[Laughter.]*

RR: The idea of having your character carry this photo in his pocket all the time… Now I know we are going back more than 25 years but do you remember how that idea came to you?

FR: I think that as you know very well, otherwise you wouldn't be doing what you're doing, that particular photograph – as I'm afraid they say too often – has become somewhat *iconic*. There is a curiosity which is that like any small Jewish person of six, I probably imagined – and would still imagine maybe – that there was an affinity between him and me. So to that extent, although all I had to do was to put my hands up and go to boarding school in England, which is after all unpleasant but hardly life-threatening, you might say that it was rather immodest to see any comparison. On the other hand, that picture *warns* you – and I don't think it only warns Jews by the way – that life is full of menace. And I think that the reason he put it in his pocket is that it spoke to him in a way which… You know, there is that thing which is not unknown I think in a number of religions, which is rather

like the Mexicans with their skeletons, the *memento mori* thing. And I think no Jew – probably no person – should imagine that he is exempt… The human condition is not something which other people endure, it's something which everybody has to be ready for. At the end of the course, you can never be ready for it.

There's a terrible credit card ad on television in England at the moment. A Viking for some reason comes to collect debts and then finds that the people concerned have got this particular credit card. He then turns to the camera and says: "What's in *your* wallet?" *[Laughter.]* Well, that's what was in Adam's wallet.

It's in effect another version of the famous old line that Solon said to Croesus: "Count no man happy until he is dead." I guess that's how it is, really.

<p style="text-align:right">November 21, 2002</p>

An interview with Tom Conti on *The Glittering Prizes*

> Born in Scotland in 1941, Tom Conti has played leading roles in many plays, films and TV dramas. In 1979, he won a Tony award for his Broadway debut in *Whose Life Is It Anyway?* and in 1983 was nominated for an Oscar and a Golden Globe award for his role in *Reuben, Reuben*, and won the New York Critics' Award for Best Actor in *Merry Christmas, Mr. Lawrence*. Many other leading roles include performances in *The Glittering Prizes* (1976), *The Wall* (1982), *American Dreamer* (1984), *Shirley Valentine* (1989) and *Someone Else's America* (1996).

RR: Your performance as Adam Morris had a great impact on the public at the time, myself included, and one of the aspects of your character that stands out most clearly, even now 25 years later, is his attachment to the photo of the little boy in Warsaw. Could you tell me in your own words – even though we're going back 25 years – why he carried it around in his pocket and what that photo meant to him?

TC: Adam was a character filled with guilt. As for many Jews, as I understand it, it was the guilt of survival. Adam was, in a way, a lost boy whose problem was being part of what he saw as a hostile society. He went to public school where he discovered the natural anti-Semitism of the British, a national trespass sustained even after knowledge of the existence of the camps.

Consequently, he made enemies, so the image of that little boy, surrounded by enemies, was to him, very powerful.

RR: Did playing that role change your own relationship to that photo, make it even more meaningful to you personally?

TC: I had already seen the photograph. It wasn't new to me, so I can't say that it had any more effect on me since playing Adam. But playing Adam certainly had a profound effect on my life. Not only professionally. There was something about Fred's [Frederic Raphael's]writing which penetrated one's deepest self. There was such power in what Adam thought and how he thought. And knowing Fred, of course, and loving him, also had an effect.

I think that the effect which Adam had on the audience was as much sustained by his pain as his wit; observing that degree of pain in someone who seems to have a perfectly nice life. Adam, to the outsider, had a hell of a life but there was a rat gnawing at his soul. "Why am I alive? Do I deserve what I have? And do they really all hate me?" And again, the guilt of having so much when so many of his own kind had nothing at all. Dead or dispossessed.

Another interesting thing about the character was that he was irritated by being a Jew. He found it an encumbrance, a curse. When his Jewish girlfriend came to Cambridge to visit him, he was embarrassed by her attire and enraged by the reactions of his fellow students to her. He was also enraged at having to be enraged, and took it all out on those close to him, like parents. Friday night dinner was as a red rag to a bull.

RR: I haven't seen it yet but I understand that you had the lead role in a film called The Wall, in which you played a fighter in the Warsaw ghetto uprising. How does it happen that you get cast in these roles?

TC: As a good Catholic boy? [*Laughter.*] No, I'm not a good Catholic boy, thank God! I suppose people think I look Jewish. And I have a Mediterranean sensibility. All Mediterraneans have something in common.

Doing *The Wall* was a curious experience, not least because we shot it in Poland while the Iron Curtain still hung menacingly.

One day, we were shooting a scene in which we were digging a tunnel under a bakery. The characters were passing bags of earth back, out of the tunnel. I decided to have a fit of coughing during the take, 'cause there they were, starving and ill, in mud and dust and God knows what. When we got to the end of the take, the director said, "Tom, are you OK?" I said, "Yes." He said, "But do you need some water?" I said: "No! The cough was acting." He said, "Oh, well don't do that." I said, "Why not?" He said, "It's offensive." I said, "We're telling the story of the torture and foul murder of six million people and you think coughing is offensive?"

During a break in shooting, I went, by myself, to Auschwitz and Birkenau. I was apprehensive about being faced with such a place of horror, but I didn't know

what I expected to feel, other than sadness. It was trying to imagine the unimaginable. The emotion it provoked was unexpected, and lasted for a very long time. It was rage. I found it very difficult to rid myself of it because there was really only one way, and that was to find members of the SS and kill them. When I see the picture of the little boy or Anne Franck, the rage returns. There is no greater crime than the hurting of a child.

<div align="right">December 17, 2002</div>

2. Yala Korwin, *The Little Boy With His Hands Up* (1982)

Born and raised in pre-war Poland, Yala Korwin studied art in Lwow. With the aid of forged identity papers provided by Polish Christians, she managed to survive the Holocaust in which her parents and older sister perished. She moved to France after the war, then emigrated to the United States in 1956, resuming her studies nine years later in New York. Her paintings have been exhibited at a number of one-person shows and she now teaches a workshop in drawing and painting at

Photo by Gaston Dubois. Used with permission.

the Alliance of Queens Artists. Writing poetry has also been an important part of her life.

This poem is from the book, *To Tell the Story* by Yala Korwin, and published by the Holocaust Library in 1987. The poem is printed here with the permission of the United States Holocaust Memorial Museum, Washington, DC, USA (www.ushmm.org). I wish to thank Yala Korwin and the USHMM for kindly authorizing the inclusion of "The Little Boy With His Hands Up" in this book.[10]

THE LITTLE BOY WITH HIS HANDS UP

Your open palms raised in the air
like two white doves
frame your meager face,
your face contorted with fear,
grown old with knowledge beyond your years.
Not yet ten. Eight? Seven?
Not yet compelled to mark
with a blue star on white badge
your Jewishness.

No need to brand the very young.
They will meekly follow their mothers.

You are standing apart
against the flock of women and their brood
with blank, resigned stares.
All the torments of this harassed crowd
are written on your face.
In your dark eyes – a vision of horror.
You have seen Death already
on the ghetto streets, haven't you?
Do you recognize it in the emblems
of the SS-man facing you with his camera?

Like a lost lamb you are standing
apart and forlorn beholding your own fate.
Where is your mother, little boy?
Is she the woman glancing over her shoulder
at the gunmen by the bunker's entrance?

Is it she who lovingly, though in haste,
buttoned your coat, straightened your cap,
pulled up your socks?
Is it her dreams of you, her dreams
of a future Einstein, a Spinoza,
another Heine or Halévy,
they will murder soon?
Or are you orphaned already?
But, even if you still have a mother,
she won't be allowed to comfort you
in her arms.
Her tired arms loaded with useless bundles
must remain up in submission.

Alone you will march
among other lonely wretches
toward your martyrdom.

Your image will remain with us
and grow and grow
to immense proportions,
to haunt the callous world,
to accuse it with even stronger voice,
in the name of the million youngsters
who lie, pitiful rag-dolls,
their eyes forever closed.

*Poem and drawing
by Yala Korwin.*

An interview with Yala Korwin

RR: There are many striking photos documenting Nazi war crimes. Yet the photo of the little boy in Warsaw is often singled out as the most moving and haunting picture from that period. Why does this particular photo, perhaps more than so many others, mean so much to you personally?

YK: In 1956 I was a mother of two youngsters, and struggling with the dilemma of how to answer their questions, what and how much to tell them, what not to tell them, without lying, trying very hard not to upset their childhood innocence.

When I discovered the photo of the little boy, I could not help identifying with his mother and thinking thoughts she must have been thinking, knowing her son and herself doomed. I kept imagining myself in the same situation with my little ones. His fear could have been theirs. In the little boy's face I saw what I wanted to protect my children from: premature loss of innocence.

RR: The poem about the little boy is one of the few poems in your book that is written in the second person. From the very start, you address him directly as "you". It is almost as if you were somehow entering the moment of the photo in order to speak to him, engaging the reader in your dialogue with the little boy, though the boy of course cannot answer. May I ask you to describe your choice to address him directly?

YK: The boy was alive at the moment the photo was taken. As I was writing, I had the photo in front of me. I talked to the boy, asking him questions, as an adult would talk to a child, while the child was too frightened to respond. Yet, he talked to me with his posture and his facial expression. I remember my feeling of extreme tenderness for him. Talking to him directly was my way of keeping him alive, of rescuing him, even if I was convinced that he eventually died with the others. Not many children came alive from this kind of situation.

In the original version I wrote: "Like a lost lamb you are standing/apart and forlorn beholding your own death." Only shortly before I submitted the poem for publication, the news came about the boy's possible survival. This made me change the word "death" to "fate."

RR: Is it possible for you to tell what writing this particular poem meant to you personally? Why you needed to write it, if that was the case?

YK: When I first saw the photo, I was far from thinking about writing about him. It took years of struggling with the language, before I dared to express myself in

English. I don't remember the moment when I decided to write "The Little Boy With His Hands Up." I must have seen the photo again and then I knew that I must write. My children were grown, but this little fellow remained as he was, frozen in time, still frightened. Today it seems to me that the poem wrote itself.

RR: Though the prisoners in the photo clearly represent no threat, they are required to put their hands up. We can of course only speculate as to why they were told to do so. What are your own thoughts as to why the SS and SD troopers required this?

YK: I have to refer to my own memories. I saw in my native city the rounded up Jews, who forced out from their homes, or caught on the streets and driven to the unknown, did not have their arms raised. When I found myself in such a crowd, no order was given to keep the hands up. My guess is that these people are being dragged out of a Warsaw bunker or some other kind of hiding place, possibly at the time of uprising, therefore suspected of having weapons. The Germans used to become even more brutal after any incident involving their own had occurred.

RR: Is there anything else you might like to say either about your experience of the photo or the writing of your poem?

YK: I always felt that the little boy, whether he survived or not, would live forever. In my illustration I depicted him symbolically as a ghostlike shape, while I made the soldier behind him very small.

January 8, 2003

3. Mitko Panov, *WITH RAISED HANDS* (1985)

This five-minute film was made in 1985 by a student at the renowned National School for Film, Television and Theater at Lodz, Poland. It went on to win the Golden Palm Award for Best Short Film at the Cannes Film Festival in 1991. The film is pure fiction in the sense that the writer/director imagined what *might* have happened when the photograph was taken.[11]

Mitko Panov was born in 1963 in Macedonia, then part of Yugoslavia. After studying painting at the University of Skopje, he left for Poland to study directing at the National School for Film, Television and Theater in Lodz. In 1988, he moved to New York where he taught film directing at the NYU Graduate Film Department (1992-1995), also helping to found and to design the curriculum of the New York

Film Academy workshop. In 1998 he moved to Austin where he teaches film production in the Department of Radio, Television and Film at the University of Texas, and is also a guest professor in film directing at the Hochschule für Fernsehen und Film in Munich. His most recent film, completed in 2000, is a feature-length documentary entitled *Comrades*.

I wish to thank Mitko Panov for his kind permission to reconstruct the film, shot-by-shot and with numerous stills, in the pages that follow.

WITH RAISED HANDS (Poland, 1985), 5 min., 35 mm, b/w

Principal production credits

Direction and screenplay	Mitko Panov
Cinematography	Jarek Szoda
Film Editor	Halina Szalinska
Music	Janusz Hajdun
Production	PWSFTv&T (National School for Film, Television and Theater), Lodz, Poland

Cast
Etel Szyc
Monika Mozer
Jaroslaw Dunaj

A shot-by-shot reconstruction of *With Raised Hands*

Shot 1 *(17 sec)* Hands adjust the turret of a wartime movie camera and affix a square lens shade to the front of the camera. The title appears momentarily on screen, after which the photographer places his hand in front of the lens and the screen goes black.

Shot 2 *(60 sec) Gradually, a blurry shape appears in the darkness and can barely be made out to be a woman with her hands raised as she approaches the camera. A German soldier, with motorcycle goggles on his helmet, suddenly appears on screen, blocking our view of the woman. He looks around then straight into the lens and smiles at the photographer, after which he looks downward, coaxing someone off-camera to do something. The soldier now moves out of frame, no longer eclipsing the woman who was standing behind him and facing away from the camera. She now turns toward us, still with her hands raised.*

Shot 2 *(cont.) The woman is roughly pushed along by another soldier who abruptly appears within frame, and she is soon followed by other captives – women, children and older men – all roughly made to move along by the soldier. As a woman with a striking face stares at the soldier, the screen suddenly goes black.*

Shot 3 *(28 sec) Again, an image is rotated upward onto the screen, indicating that the turret is turned once again, the present lens now showing a wider shot of the scene. The first soldier pushes a little boy into our field of vision, picking up the boy's cap from the ground, planting it firmly on the boy's head, and holding the boy's arms up in the air. But instead of assuming that position, the boy runs to his mother, clinging to her, as she continues to hold her hands up. When the soldiers pull him away from her, she tries in vain to hold onto him. He gets away from the soldiers and runs out of frame, the first soldier running after him. The screen goes black again.*

Shot 4 *(25 sec) A new image is rotated downward this time and the photographer's face momentarily fills the screen as he looks into his camera., Once he is out of frame, we see the soldier pushing the little boy back to the desired spot. The boy faces him, with his back to us, as the soldier coaxes him once again and finally threatens him by brandishing his submachine gun. Resigned, the boy turns around, facing the camera and raises his hands. The soldier beams and the picture – modeled on the 1943 photograph – is frozen for about five seconds.*

Shot 5 *(3 sec) The photographer cranks his camera.*

Shot 6 *(6 sec) Freeze-frame of the soldier.*

Shot 7 *(9 sec) Close-up of the boy's mother.*

Shot 8 *(3 sec) A younger boy.*

Shot 9 *(5 sec) A woman looking to our right, a boy to our left, as in the photograph.*

Shot 10 *(7 sec) A young girl.*

Shot 11 *(6 sec) Close shot of the boy with his hands raised. A gust of wind suddenly blows his cap off. He looks to our right, in the direction of the cap, then turns back toward the photographer, as if to ask what he should do.*

Shot 12 *(9 sec) After a moment, the photographer stops cranking his camera, looks in the direction the cap was blown, then at the boy. With a panning movement, the camera then returns to the boy, still standing bare-headed and not knowing what to do.*

Shot 13 *(37 sec) All eyes seem to be on the main soldier, but he just stands there, waiting. The camera pans left, past the other soldier…*

Shot 13 *(cont.) …past the boy's mother and other women and children, standing with their hands raised. As it passes the boy, we see only his raised hands, and from their movement, we can see that he is turning around. After showing the little girl, standing at the end of the row of prisoners…*

Shot 13 *(cont.)…the camera changes direction, now panning right and returning to the boy who once again looks toward the photographer.*

Shot 14 *(4 sec.) The photographer is cranking his camera.*

Shot 15 *(8 sec) The little boy looks at the main soldier, who simply stands and waits. The boy turns toward the direction in which his cap had blown, and simply walks out of frame.*

Shot 16 *(7 sec) Filmed now from an entirely different angle, the boy leaves the scene of the filming, walking cautiously at first with hands up, then when he spots his cap, running forward toward it.*

Shot 17 *(6 sec) The cap, lying on the pavement, is suddenly blown away by another gust of wind, just as the boy reaches it. A swish-pan begins.*

Shot 18 *(3 sec) A new swish-pan takes over seamlessly from the first one, apparently bringing us from the spot on the pavement to the boy's new location, even farther from the scene of the filming, which he now looks at from a distance.*

Shot 19 *(5 sec) The scene of the filming, from the boy's point of view.*

Shot 20 *(3 sec) The boy looks at the distant scene, then bends down to pick up his cap.*

Shot 21 *(3 sec) Once again, the cap is blown away by a new gust of wind, just as the boy reaches for it. A swish-pan begins.*

Shot 22 *(3 sec) Again a new swish-pan takes over seamlessly, and once again, the boy turns to look at the distant scene he has left.*

Shot 23 *(4 sec) We see the distant scene of the filming through the boy's point of view once again.*

Shot 24 *(3 sec) After looking he turns and runs after his cap once again.*

Shot 25 *(3 sec) The cap, lying on the pavement, is for the third time blown away by a gust of wind as the boy reaches for it. Again a swish-pan serves as a transition to the next shot.*

Shot 26 *(7 sec) This time the boy manages to grab the cap and puts it firmly on his head. Again he watches.*

Shot 27 *(7 sec) The boy's point of view: the photographer is still cranking his camera, but when the little girl appears in frame and looks for the boy, the photographer also stops what he is doing and looks as well.*

Shot 28 *(5 sec) The point of view of the photographer and little girl: the boy is gone. Billows of black smoke (from burning buildings) fill the air.*

Shot 29 *(26 sec) The boy on his way out of the ghetto.*

Shot 29 *(cont.) Once on the other side of the gate, the boy can no longer be seen. But his cap suddenly appears, thrown up in the air.*

Shot 29 *(cont.) After coming down from its flight, the cap is once again thrown into the air, so high that it is out of frame, and this time it doesn't come down. This picture with nothing more happening persists for several seconds.*

Shot 30 *(7 sec) The cars of a railroad train streak by.*

Shot 31 *(59 sec) The 1943 photo now appears on screen and remains in view with the end credits superimposed over the lower half of the picture.*

126 RICHARD RASKIN

An interview with Mitko Panov

RR: How would you describe your relationship to the photograph that inspired With Raised Hands? *When did you first see the picture and had it been particularly meaningful to you for some time before you made the film?*

MP: I can't say that I had much of a relationship with the photo before I decided to make the film. I first saw the image of the boy (with raised hands) in a painting by a known Italian painter, Renato Gutusso. That must have been about seven years before the film was made. But at that time, I had no idea that the boy in the painting was taken from an authentic photo, nor that it treats a real historical event. I think it was clear that the colorfully painted image of the boy was related to a war, but it was unclear which one. Nonetheless, the image stayed with me for a long time, and when I recognized it in the actual black and white photo, I was surprised to discover that it was taken in Poland, during the extermination of the Jews in the Warsaw ghetto. In any case, that boy with raised hands, surrounded by armed soldiers, aiming their weapons at him, must have spoken to me in some way. At the time I saw the actual photo, I was studying directing in the Lodz Film School, and I very soon decided to make a short film about the photo.

In order to understand the main reason behind that decision, and exactly what attracted me to the photo, I will have to tell you where I saw the print of the original picture. It was in a book of a (former) Yugoslav, I believe a Croat/Jewish art critic Oto Bihalji Merin, another acclaimed name from the post WW II art scene. His book was entitled *A Re-vision of Art* and it is a comparative art study about various "eternal" themes (images, visions, forms) that keep re-appearing throughout the history of culture and civilization. The chapter containing the photo was called *With Raised Hands* and knowing the film's godfather will probably help explain the content of the film, and the reason for it's existence. Basically, Merin was comparing images of the same motif – of raised hands – throughout the history of culture. For thousands of years, these images had been reappearing from the plains of the ancient Latin and Central American civilizations, to the tombstones in the Jewish cemeteries. According to my understanding, they have expressed man's eternal and deep striving toward 'the skies' and in a visual way, spoke of man's innate spiritual aspirations. In a way, they are testimonies of the religious nature of the human.

RR: Did you have any moments of hesitation when you wondered whether or not it was entirely legitimate to weave a fiction around the making of the photograph?

MP: I never had that kind of hesitation. In my eyes, all art and culture weaves fiction with history, sometimes up to the point that no one knows any longer what was real, and what's part of the teller's imagination.

However, I did have some concerns about the fact that the picture was already pretty well known and used in other art forms, and that it was a commentary on an important part of our history. I am not sure whether I make myself clear but: you don't want to make a false or even mediocre piece of media about something that deeply affects millions of people. (Even though journalists do that all the time and they keep getting more sophisticated at it. In my opinion, they specialized in it during the recent wars in former Yugoslavia.)

But to get back to *With Raised Hands*: even though the film uses a real historical event, and brings fiction (or wishful thinking) into it, I don't think it manipulates, abuses or in any way violates the historical truth. People crave freedom and 'salvation' whether they are Jews, Christians or Muslims, and whether they live in conditions of war or peace. I hope that that's a truthful assumption and that's what the film is about: the desire to be free, whatever that means.

RR: Can you describe your preparations, including casting, location scouting, arranging the décor, finding costumes, etc.?

MP: […] When it came to the casting of the child-actors, I had to do everything on my own. I don't know who suggested this idea, but since I was clearly looking for children with Semitic features and there weren't enough kids to choose from, someone suggested that I try the Gypsy communities. It sounds strange to me now, as I tell it, but that's how it was. So I started visiting pretty much all of these communities in Lodz, making portraits of the children, and getting to know them. It took some time to find the right ones, but I was very lucky in general. The boy that I found for the main role was a natural. Of course, it helped that I had the photograph, so I knew exactly what I was looking for. The same was true of the locations. I held the picture in my hands and spent a lot of money on taxis, driving around, looking. I didn't have location scouts or a production designer, so I had to find it all myself and then verify it with the director of photography (Jarek Szoda).

RR: The second shot in your film is quite long and complex. It lasts almost a minute and covers a number of actions: first people out of focus approach the camera, then the main German soldier appears from our left within the frame in a close-up. He smiles to the camera, then begins coaxing someone off-camera to do something. (Soon, of course, we will understand that he was speaking to the boy.) He then moves out of our view and a woman, whose

back was toward the camera, turns around, after which another soldier pushes her away, as well as about 18 other people, one at a time. All of this in a single, unbroken take. It would undoubtedly have been easier for you to divide these various actions into separate shots, but instead, you chose to cover them all in one continuous take. What were your thoughts in going for that kind of continuity rather than cutting at that early point in your film?*

MP: The overall visual concept prevented me from breaking down the opening scene into more shots than there are. The idea was that until the moment of the freeze-frame (when the boy raises his hands and we reveal the full situation as in the documentary photo) everything is seen from the point of view of the soldier who is a cameraman/photographer. So, everything had to be shot from one single angle, the angle of the German photographer. Since that was supposed to be the camera of a war photographer, shooting propaganda footage for the *Wehrmacht*, we decided that our own camera had to behave in a similar way: as if the DP [director of photography] behind it is someone who is just getting ready to shoot his still; someone who is not familiar with the subjects or with what is about to happen. For him, as for us, it is a process of gradual discovery or disclosure. First, he fixes the focus, then adjusts the speed (the shot starts in slow motion and then reaches 24 frames per second) and only then, he starts identifying the characters. Then he switches the turret (shown in the opening shot) in order to find the right lens and camera distance. Since there were three primary lenses on those cameras, there are only three shots until the moment we come to that freeze-frame (the moment when the photographer 'discovers' the image that we recognize from the documentary photo). In other words, the camera behaves like any camera in preparation for a given shot. In addition, the director of photography and I saw a lot of WW II war footage and borrowed the stylistic features of that camera work. As I said, what follows after the freeze-frame is kind of a fantasy, and it's no longer from the POV of the reporter. Therefore, there isn't only one point of view.

RR: The boy's throwing his cap into the air is of course an important symbolic gesture. Your thoughts when you decided to have him do that after he disappears from our view?

MP: I am generally a great fan of film lapses. I like films in which more is hinted than told. I jokingly call them 'interactive films' because they don't spell everything out for you, but leave a lot to your imagination. That way, you can also do your own share in making the film. That's a huge topic and I often like talking about it. Before that moment (in the film) there is another lapse, when the boy actually escapes from the sight of the photographer. We never see that critical moment of the boy running around the corner. We just see that he is no longer there.

RR: Did you ever consider trying to contact Tsvi Nussbaum – possibly the little boy who survived, and to arrange for him to see the film? I believe he was living in upstate New York in 1985. Do you think that it might be interesting to know how he would experience the film or would that not be of particular interest to you, considering that the film is a work of fiction?

MP: I would love to know how he would react to the film. I actually wouldn't even mind making a film about it, even though I am not sure whether that should be a documentary or a fiction.[12]

<div style="text-align:right">October 27, 2002</div>

Samuel Bak, A SERIES OF PAINTINGS (1995-present)

In the mid 1990s, the figure of the boy with his hands raised appeared for the first time in the paintings of Samuel Bak. Haunted by his own first-hand experience of the Nazis – he was born in Vilna in 1933 and escaped from the Vilna Ghetto after its destruction – Bak had for decades chosen not to depict the Holocaust explicitly in his work but eventually felt compelled to do so.

Samuel Bak studied at the Bezalel Art School in Jerusalem and the Beaux-Arts in Paris and has had numerous exhibitions in museums and galleries throughout Israel, Europe and the United States. A number of books have been devoted to his work, including:

- Samuel Bak and Paul T. Nagano, *Samuel Bak, The Past Continues*. Boston: David R. Godine, 1988.
- Jean Louis Cornuz, *Chess as Metaphor in the Art of Samuel Bak*. Boston & Montreux, 1991.
- Georg Heuberger and Eva Atlan, *Ewiges Licht. Samuel Bak – eine Kindheit im Schatten des Holocaust.* Stuttgart: Thorbecke, 1996.
- Lawrence Langer, *Landscapes of Jewish Experience*. Boston: Pucker Gallery & Brandeis University Press, 1997.
- Samuel Bak and Lawrence Langer, *The Game Continues: Chess in the Art of Samuel Bak*. Boston & Bloomington: Pucker Art, & Indiana University Press, 1999.
- Lawrence Langer, *In a Different Light: The Book of Genesis in the Art of Samuel Bak*. Boston: Pucker Art Publication, and University of Washington Press, 2001.
- *Between Worlds: Paintings and Drawings, 1946-2001*. Boston: Pucker Art Publication, 2002.

Courtesy of Pucker Gallery, Boston. Photo by Cary Wolinsky.

In addition to commentaries on his work by Lawrence Langer and others, Samuel Bak's own memoir, *Painted in Words* (2001) is an important resource for anyone interested in his painting in relation to the Holocaust.[13]

I am grateful to Samuel Bak and to the Pucker Gallery in Boston for their kind permission to reproduce these paintings depicting the boy with his hands raised.

Study F (One of the Sameks), 1995. Oil on linen, 60.6 x 39.7 cm.
Courtesy of Pucker Gallery, Boston.

The Star of Vilna, 1997. Oil on linen, 35.6 x 27 cm.
Private Collection. Courtesy of Pucker Gallery, Boston.

Exits, 1997. Oil on linen, 66 x 99.7 cm. Private Collection. Courtesy of Pucker Gallery, Boston.

Exits, 1998. Oil on linen, 86.4 x 127 cm. Private Collection. Courtesy of Pucker Gallery, Boston.

Little Green Trees, 1997. Oil on linen, 66 x 82.6 cm. Courtesy of Pucker Gallery, Boston.

Children's Corner, 1997. Oil on linen, 38.4 x 45.7 cm. Private Collection. Courtesy of Pucker Gallery, Boston.

Into the Trees, 1997. Oil on linen, 41.3 x 33 cm. Courtesy of Pucker Gallery, Boston.

Study G, 1995. Oil on linen, 60.6 x 39.7 cm. Courtesy of Pucker Gallery, Boston.

In His Own Image, 1997. Oil on linen, 27.9 x 34.9 cm. Courtesy of Pucker Gallery, Boston.

Study A, 1995. Oil on canvas, 65.1 x 53.7 cm. Private Collection.
Courtesy of Pucker Gallery, Boston.

Study E, 1995. Oil on canvas, 65.1 x 53.7 cm.
Courtesy of Pucker Gallery, Boston.

Study I, 1995. Oil on linen, 45.7 x 55.2 cm. Courtesy of Pucker Gallery, Boston.

Study D, 1995. Oil on canvas, 53.7 x 65.1 cm. Courtesy of Pucker Gallery, Boston.

Group, 1997. Oil on linen, 66.7 x 100.3 cm. Courtesy of Pucker Gallery, Boston.

Small Target, 1997. Oil on linen, 35.6 x 27 cm. Courtesy of Pucker Gallery, Boston.

Study B, 1995. Oil on canvas, 65.1 x 53.7 cm. Private Collection. Courtesy of Pucker Gallery, Boston.

Study J, 1995. Oil on linen, 33.3 x 40.6 cm. Private Collection. Courtesy of Pucker Gallery, Boston.

Sanctuary, 1997. Oil on linen, 51.1 x 50.8 cm. Courtesy of Pucker Gallery, Boston.

Self-Portrait with Friends, 1997. Oil on linen, 46 x 55.9 cm. Courtesy of Pucker Gallery, Boston.

In the Footsteps, 1997. Oil on linen, 51.1 x 50.8 cm. Private Collection. Courtesy of Pucker Gallery, Boston.

Aleph-Ah!, 1997. Oil on linen, 52.1 x 51.1 cm. Private Collection. Courtesy of Pucker Gallery, Boston.

For Josée, 1997. Oil on linen, 66.7 x 66 cm. Courtesy of Pucker Gallery, Boston.

Double Reflection, 1997. Oil on linen, 52.1 x 50.8 cm. Courtesy of Pucker Gallery, Boston.

Absence, 1997. Oil on linen, 51.1 x 50.8 cm. Courtesy of Pucker Gallery, Boston.

Self-Portrait, 1995-1996. Oil on linen, 160 x 200 cm. Private Collection. Courtesy of Pucker Gallery, Boston.

In his memoir, *Painted in Words* (Boston: Pucker Gallery, 2001), Samuel Bak captioned this painting as follows: "The boy from the Warsaw Ghetto along with Samek Epstein, my murdered childhood friend, and the memory of myself as a child in the tragic years of the Shoah, appear in the large self-portrait, and in many other variations of this inexhaustible image."

An interview with Samuel Bak

RR: I gather from statements you have made that the photograph of the little boy in Warsaw meant a lot to you for many years before you began to use it in your painting. Do you happen to recall when and under what circumstances you saw the photograph for the first time?

SB: I must have seen it for the first time in Israel, in the early 50s. It was a time in which the newly established state kept a lid on its unease about the Holocaust. Images of this sort were not often published. This photo captivated my attention. Since then it inhabits my mind.

Certain images or sounds give me the feeling that they have always existed, and dwell in me as if they were a part of eternity. When I think of the music of Bach or of Beethoven, I cannot imagine that there was a time in which it did not exist. That someone specific had to think of it and bring it to life. I know well the precise situation in which the photo of the Warsaw boy was made. It was taken during the bloody revolt of the ghetto. Yet his figure gives me a feeling of timelessness. It dwells in me as if it had always existed. In today's world of images it is as iconic as the *Mona Lisa*, the *Sunflowers* of Van Gogh, or as Warhol's *Marilyn*, if not more so.

RR: You have also stated that you considered the photo almost a kind of self-portrait since you looked a great deal like the boy in the picture, "same cap, same outgrown coat, same short pants." And surely physical resemblance – and your seeing the boy as a kind of alter ego and also as an echo of your lost friend, Samek Epstein – these are all factors of overriding importance in your relationship to the picture. But for countless other people as well, this photograph seems to have special qualities that distinguish it from virtually all other photographic documents from the Holocaust. Do you have any way of accounting for the fascination this picture seems to exercise on one generation after another?

SB: It is difficult to speak of art and aesthetics when you are aware of the terrifying moment in which this photograph was taken. But this is one of those moments that great photographers dream of. The shutter falls on the precise hundredth of the right second.

This photograph is a masterpiece of composition and of storytelling. It compares with Mantegna's *Crucifixion*, or other great works of art. Because what is so extraordinary in this photograph, beyond its structure and richness of detail, is the depth of its narrative material. You have the drama of the group, and you have the drama of the little boy, of the individual. He is all by himself, his frail figure

is visually cut out and isolated from the others. Observe the group, the women with their uplifted arms, the other little boy who looks towards a woman who might be his mother with a questioning look, as if to say: "You always said that nothing would happen, that you'll protect me. What is happening to us now?" When you see the drama of these desperate people, frozen by the camera in their hopelessness, you are greatly touched. An observer of this image may have a harder time to identify with the emotions of an entire group than he'll experience with a single figure. For that, you have in the foreground this boy. He is all by himself in a solitude that is terrible.

Think of the abused child. What could better symbolize the nature of a society than the condition of its children's lives, and the suffering that some regimes impose on them? If you want to look at the darker side of Victorian society, you go to Dickens's little heroes. On a much bleaker level, when you ponder the horror of the Holocaust, you think of the million children that perished. Children are helpless beings, and every society owes them protection, a protection that in the tragic time of the Shoah the Jews of Europe could not provide. These children (and I was one of them) were destined to be exterminated by the Nazi machine of death. What horror could be greater?

Let us return to the scene of the photo. A German soldier, perhaps a father of children, points at the little boy a machine gun. The robust and confident soldier is doing his job. He is not unlike a Roman legionary in a depiction of a Crucifixion, impassive to human suffering. It is a powerful and chilling image. The fear on the boy's face alone must shatter anyone who looks at it. Notice the boy's rucksack. A rucksack is something that you take along only if you believe that the next day you will still be alive. In this photo it symbolizes the persistence of hope. What irony! Here it underlines the magnitude of the despair.

There is so much that this image offers to us that I could go on forever. The various details of this photo work on each level of its beholder's sensitivity, but even on its most shallow it is packed with power. And this may be the reason why this photograph has become such an extraordinary and captivating symbol of the Holocaust.

RR: You have described the photograph as "the most poignant image of Jewish Crucifixion." May I ask you to tell what you meant by this?

SB: Well, I think that to some extent I have already answered this question. A Crucifixion evokes for a great number of people the idea of redemption. Personally I do not believe in a world that is beyond the one in which we live, and in a possible redemption "over there." But I accept the possibility of redemption in

this life. Germany, in its effort to come to terms with the Holocaust, and its eager Pacifism, has been moving in such a direction.

The idea of a crucified Jew is not new. Chagall painted him on many of his canvases. Possibly the photograph we speak of, because here the crucified victim is a child, is more powerful than all the crucified Jews of Chagall put together. This child makes me think of the child at the end of Elie Wiesel's "Night."

Let me return to the iconography of the Crucifixion. In some early depictions, Jesus' arms are placed horizontally, and closely fit the shape of the cross. In paintings of the 17th and 18th centuries his arms moved upward. As if the artists are trying to render a more realistic image of a victim actually suspended from a cross. This painful suspension gives the arms a gesture of reaching out to God. Jesus is dying on the cross, and crying out Lama Sabachthani, why did you sacrifice me? It is an image of incredible poignancy.

A man's arms that reach for the sky are also a gesture of surrender, of giving up. When you superimpose the image of a crucified Son on the image of the little Warsaw boy with his uplifted arms, you wonder where is God the Father?

Sometimes people ask me: "What is your belief?" And I answer that I am a most God-fearing atheist. And not only on account of all the killings that go on in the names of various gods that rule the world, but because I think that basically people are made of what is good and what is bad in human nature, they are bundles of contradictions, and I fear situations in which absolutism and religious fanaticism take over.

To sum up, let me say that I am aware that a regular Jewish identity and the worship of a Crucifixion are not supposed to go together. They are perceived as a contradiction in terms. But the fact remains that contradictions are very human.

RR: For a long time, you preferred not to bring the photograph into your painting. You said that you "dared not challenge the terrible power of the photograph's authenticity." Can you tell a bit more about this reluctance you experienced?

SB: Let me begin with my "journey" as an artist. When it became clear to me that my personal trauma of surviving the Holocaust had to have an outlet and find in me its proper mode of expression, I felt almost embarrassed. In the early sixties I considered myself a young modern artist and was harnessed in a tangle of conceptual prescriptions as to what it was right or wrong to do. I was reluctant to let myself go in the direction of pictorial narration because that seemed to belong to other times. Thus I chose a much more abstract mode of expression. It took me some years to overcome this reluctance.

When I finally chose a way of painting that would deal with my experience of the Shoah, I refrained from the use of specific imagery. And for a good reason. I felt that nothing could compete with the weight of the authentic photographs of the Holocaust. They have such an expressive power that in comparison all art pales.

Yet photographs tend to be specific and anecdotal. Images of art have the possibility of embracing a more universal dimension. For example, Picasso's *Guernica*, far from being realistic, is still a very powerful evocation of war. Whatever happens on this painful canvas engages us deeply, but without causing the physical revulsion that a more realistic depiction of the same events would have engendered.

Upon reflection I must admit that the photographs of the Holocaust have in them something of both qualities, the specific that revolts and the universal that makes us ponder. Because when I see those heaps of emaciated bodies that a machinery of dehumanization had deprived of all individuality, I do not think of Jews and Germans, I think of what man is capable of doing to man. They have become universal. Like the photos of the skulls of Cambodia.

So I don't know. Surely there is a place for art, and a place for photography, and a place where the two of them meet, enrich each other, or fuse.

RR: I believe it was in the mid 1990s that you finally overcame your reluctance to portray the Holocaust [explicitly] in your paintings. And you have wondered whether – when this happened – you were "trying to redeem the banalization" of the boy's image. In what ways did you see his image as being banalized? Did anything in particular happen at this time to precipitate a kind of turning point for you in your relationship to the photo? (This is of course a long shot, but it didn't by any chance have anything to do with seeing Schindler's List*?)*

SB: No, I think that *Schindler's List* had little effect on me personally; I was disturbed by its cliches and its sentimentality. But I must recognize that the film did a good job of bringing a large public to engage a very painful subject.

Returning to my own art, I must say that evocations of the Holocaust, though not as openly explicit as they have become with time, were always part of my work. In the mid-nineties, as you mentioned, I decided to tackle the subject of the Warsaw boy. I must have been troubled by the fact that he had become a sort of a logo of the Holocaust. Reproduced thousands of times, on innumerable brochures and books, repeatedly reprinted in the press, and sometimes used for the wrong reasons, this photo became banalized. And I felt sad that this exceptional image was doomed to lose the poignancy of its uniqueness.

On the other hand, something that typifies my creative process is imbedded in my attraction for things that seem banal; I wish to reinvigorate them. I am fas-

cinated by the thin line that stretches between what is called stereotype and what is perceived as myth.

This, for example, is why I do paintings with chess figures. Think of it, what could be more banal than the game of chess? We all know that it deals with a list of pre-established rules of war, with guessing an opponent's plans, with accepting sacrifice. Besides, don't we all often feel that we are pawns in a game that somebody else is playing? Chess provides me with metaphors that are easily readable; it is a sort of icon of a popular myth. And mythological themes have always fascinated artists.

So I guess that the attraction that I feel toward things that have been rendered banal challenges me to transform them, to return to them an original freshness and immediacy. My way of handling the figure of the Warsaw boy is such an attempt.

RR: You have stated that the process of painting the boy again and again might in some way have been part of an effort to find answers "to some of the endless questions that linger" in your mind. Can you say any more about those questions?

SB: Well, these are the same questions that many survivors ask, and not only survivors of the Holocaust but survivors of all the hardships and painful upheavals of life. The mere fact of being born and projected into a world that offers us no guarantees comes to us as a shock. Why am I here, and why is all this happening to me? The big "why" stands for so many things. What meaning does all this have? …

I look at the Warsaw boy and wonder. I know that such a boy did perish, one among an entire million of Jewish children, and even if this specific boy in the photo should happen to be still alive (he would now be seventy), that fact would be irrelevant. But I know I am still alive. Which brings me to the question of why survivors feel guilty. I suffered from this affliction for many years. Yet they or I did not perpetrate crimes? The impassive wheel of fortune offers no answers. One will never know why the Nazis executed my childhood pal Samek Epstein and not me. Nor will we truly know why the Nazis came to power. Why did all this happen? If we start to reflect on ultimate meanings, our endless questioning may depart into the infinite and endanger our passion for life and block our creativity. The only answer is that these things are a mystery, but life goes on.

RR: May I ask about the empty shoes that turn up in a number of your paintings inspired by the photograph?

SB: Well, again, there is not one single answer to that question. First of all, "to be in someone's shoes" means to put yourself in his position. In many of my paintings I projected myself into the Warsaw boy's shoes. Besides, empty shoes signify that the person who had worn them is no more.

Discarded shoes remind me of the camps. As Primo Levi said, having shoes in those times often made the difference between life and death.

Shoes in art can be quite expressive. Think of the pile of shoes in Van Gogh's early painting, *Potato Eaters*. How well they express the hardships of the peasant's life.

RR: You have described your paintings as "acts of remembrance," largely in relation to your lost friend, Samek Epstein. These portrayals focus exclusively on the victims and never include images of the criminals who perpetrated the crimes. I can of course try to guess why you would not want them in your paintings. But would you be willing to tell me why, in your own words?

SB: True, my paintings evoke victims and not perpetrators. I guess I cannot identity with a perpetrator, or express his substance in my art.

When we identify with victims, whether in films, books, or paintings, we become aware that something unforgivable has happened, perhaps it is still happening, maybe one day it will happen again. Some conclusions must be derived from this perception. Can a man learn from his mistakes, and not repeat them? But I don't think I should get into this kind of moralization.

RR: When inspired by the photo, do you paint the figure of the boy from memory, or do you look at it while painting?

SB: I look at the photo, and I draw it. Sometimes, in order to have the outline of the boy in its most correct shape I project his image directly on the painting and trace it. A precise outline enables one to identify a presence that has been decomposed. I am careful to make him easily identifiable. Because in my paintings, as I am hinting at the scared child's emotional state, his image is often very decomposed. His de-structured states say also something else: real memorials are not eternal, they tend to fall apart.

When I think about my work in general, I believe that I am doing a multi-layered art, one that encompasses many meanings. The concept of irony is a crucial one, yet I find it is not well understood today. Irony carries within it a sad and almost helpless dimension of disenchantment. The great artists of irony were Shakespeare, Kafka, Thomas Mann. Today the word is devalued. It is confused

with parody, derision or sarcasm, whereas irony is actually a system for trying to distance ourselves from something painful in order to see it more richly and fully.

So, together with my fascination with the drama of the human condition and my desire to produce visionary objects of beauty, all colored by the experience of a survivor, I inject into my work a component of irony. This component aspires to distance, to protect the sensitive scar of an ancient wound while still remaining true to my knowledge of the wound itself. It is not unlike the irony that you find in Art Spiegelman's *Maus*. I believe that the presence of irony enriches my art. It is to be found in my choice of a style of painting, my use of an "old-masters" technique as a device for creating distance while retaining specificity. If my paintings seem to evoke a certain kind of surrealism, it is not true surrealism. It is no dream world, but rather reality experienced and expressed through metaphor. If you look at what happens on my canvases, if you focus your eyes on to the decomposed image of the Warsaw boy, you will discover what I feel about the de-structured world in which we live, our troubled times, the contradictions and losses that we must face.

RR: Is there anything else you would like to add at this point?

SB: Any act of remembrance is very important in that it helps to keep memory alive. When one loses one's memories, one is no longer the same person. A people that forgets is an endangered people. So the conservation of memory is a critical human endeavor. Psychologists tell us that memory is not something that is just there like a recorded and unchangeable videocassette. It is something we must reconstruct continuously, daily. Often, to help it out, we encase it in forms of ritual.

When I was a child, my parents were secular Jews who hardly observed religious ceremonies. But in the small room of our Russian housekeeper, under the small image of a woman and child, flickered a little light. And I realized that for our housekeeper this was an object of extreme importance. The Russian icon of the Madonna reminded her of where she came from, and who she was.

Sometimes I have the feeling that I would like to paint one million Jewish icons. One million of these Warsaw boys, for the number of children who were murdered. Perhaps as a way to deal with the enormous void left by all of them? I can see the boy's little figure over a flickering light in every Jewish home. A reminder of what has happened, and of what in some way has defined our contemporary Jewish identity.

The presence of the Warsaw boy's figure in my art is for me an act of remembrance that safeguards our collective memory.

<div style="text-align: right">February 17, 2003</div>

NOTES TO CHAPTER FIVE

1 I examined every issue of the International Edition of *Life*, from August 1946 to December 1959, and of the Atlantic Overseas edition of *Time* from November 1945 to December 1948, without finding a copy of the photograph in either magazine.
2 This applies for example to volume 26 of *Trial of the Major War Criminals before the International Military Tribunal, Nuremberg 14 November 1945 – 1 October 1946* ("Blue Series"), published in Nuremberg in 1947, and already mentioned on p. 30 above. It is also true of Leon Poliakov's and Josef Wulf's scholarly work entitled *Das Dritte Reich und die Juden. Dokumente und Aufsätze* (Berlin-Grunewald: Arani, 1955) in which the photo appears on p. 163.
3 This portion of Jean Cayrol's text reads as follows: "*Pendant ce temps, Burger ouvrier allemand, Stern étudiant juif d'Amsterdam, Schmulszki marchand de Cracovie, Annette lycéenne de Bordeaux vivent leur vie de tous les jours, sans savoir qu'ils ont déjà, à mille kilomètres de chez-eux, une place assignée. Et le jour vient où leurs blocks sont terminés, où il ne manque plus qu'eux, déportés de Lodz, de Prague, de Bruxelles, d'Athènes, de Zagreb, d'Odessa ou de Rome.*"
4 The copy of the photo Resnais used was found at the Jewish Historical Institute in Warsaw, according to the shooting script kindly provided by Argos Films in Paris. For a fuller discussion of *Nuit et Brouillard*, see my book on the film, cited in footnote 36 on p. 103 above. This film – like the photo of the boy – has a unique status, this time of course within the genre of Holocaust documentary. When the Jewish cemetery at Carpentras was desecrated on May 9-10, 1990 and all of France was in a state of shock and shame, *Night and Fog* was broadcast simultaneously on all French TV channels at the request of Jewish and other anti-racist organizations. To broadcast *Night and Fog* in that way was in itself a symbolic act, showing that the film is experienced as a potent warning and an antidote against racism. Two years later, it became known that a certain M. Touvier, who had participated in the murder of French Jews during the occupation, had enjoyed the protection of both ecclesiastic and political authorities right up until 1992. Again the French had a reason to feel ashamed. And on that occasion, the Minister of Culture, Jacques Lang, took the initiative to have video copies of *Night and Fog* sent to all French lycées. To this day, deniers of the Holocaust are still upset by that initiative.
5 Gerhard Schoenberner had first seen the photo of the boy with his hands raised during a visit to Warsaw in 1957. I am grateful to Gerhard Schoenberner for the information he kindly conveyed to me during telephone conversations on July 29 and August 7, 2003, and in a letter dated July 31, 2003.
6 As already mentioned on p. 56 above and its accompanying footnote, the picture appeared in the issue of November 28th 1960, in connection with the first installment of

"Eichmann's Story." The photo was used on p. 106 with the caption: "Grim roundup of young Jews takes place in Warsaw after conquest of Poland. Germans sent some to ghettos, but the killings had already begun."

7 *Es gibt keinen jüdischen Wohnbezirk in Warschau mehr!* (Neuwied: Luchterhand, 1960), edited by Andrzej Wirth. This edition appeared thanks to the efforts of Günther Grass and Andrzej Wirth.

8 The exhibition – organized by a group of four people, which included Gerhard Schoenberner – was called *Die Vergangenheit mahnt* (The Past as Warning). It was held from April 8 to May 3, 1960 in Berlin's new Congress Hall, and covered the persecution of the Jews from the Middle Ages onward. In a telephone conversation on August 7, 2003, Gerhard Schoenberner told that initially, Berlin's minister of culture objected to the use of the photo of the Warsaw ghetto boy on the exhibition poster because he couldn't believe it was an authentic photo. The boy reminded him of Jackie Coogan and, in his eyes, the SS looked so stupid and brutal that he thought the photo could have been a shot from an anti-German propaganda movie made in Russia. [In May 1960, the exhibition was moved to the City Hall at Charlottenburg for a month, followed by a tournée through major West German cities – Frankfurt, Hamburg, Mannheim and Essen – before being sent on to Israel in 1962].

9 I had hoped to devote a section of this chapter to *Persona*, but neither Ingmar Bergman nor Liv Ullmann responded to my letters. And it was their voices I was hoping to bring to the reader, not my own comments on the film. The best resource for studying this film is a collection of essays edited by Lloyd Michaels and called simply *Ingmar Bergman's Persona* (New York: Cambridge University Press, 1999).

10 Other poems by Yala Korwin are now accessible on the Web at http://www.thehypertexts.com/

11 Readers interested in additional information on *With Raised Hands*, as well as several articles on the film, are referred to the March 2003 issue of *p.o.v. – A Danish Journal of Film Studies*, accessible on the Web at: http://imv.au.dk/publikationer/pov/Issue_15/POV_15cnt.html

12 Since the time this interview was made, Mitko Panov and I visited Tsvi Nussbaum and showed him *With Raised Hands*. When I asked Tsvi Nussbaum how he experienced the film, he answered: "It touched my heart." And Mitko Panov did in fact film our meeting.

13 The fullest commentary to date is Lawrence L. Langer's text in *Landscapes of Jewish Experience* (Boston: Pucker Gallery, 1997), and Chapter Five in Langer's *Preempting the Holocaust* (New Haven: Yale University Press, 1998). Langer's discussion of four of Bak's paintings, including "Self-Portrait," is available on the Web at: http://www.jhom.com/arts/bak/index.htm See also Marianne Hirsch's comments on Bak in "Nazi Photographs in Post-Holocaust Art: Gender as an Idiom of Memorialization" already cited. The Pucker Gallery website at http://www.puckergallery.com/samuel_bak.html provides reproductions of and commentaries on an extensive selection of Bak's paintings.

Chapter Six

PALESTINIAN PARALLELS? USES OF THE PHOTO IN A WAR OF IMAGES

NB. This chapter deals with extremely sensitive issues that some readers may find upsetting. Its purpose is to look at the ways in which the photograph of the boy with raised hands has been used in relation to the Israeli-Palestinian conflict, generally by people who suggest that Israel is now doing to the Palestinians what the Nazis did to the Jews. For whatever my own views on this question may be worth, I believe that those who compare the Sharon administration's glaring human rights abuses to Nazi genocide, grossly distort the truth – perhaps out of ignorance of what the Nazis actually did – and blur issues that need to be confronted with clarity and precision. The final word in this chapter is given to the late Palestinian intellectual, Edward W. Saïd, who rejected such misleading comparisons.

Introductory note

The specter of World War II haunts the Middle East and remains a source of the imagery with which spokesmen for both Israelis and Palestinians characterize the conflict.

Nowhere is this more evident than in the language of Menachem Begin, who repeatedly invoked the Holocaust to justify his decisions while serving as prime minister of Israel (1977-1983). This applied for example to the bombing of Iraq's nuclear reactor in 1981, when Begin explained in a letter to Ronald Reagan:

> A million and half children were poisoned by the Ziklon gas during the Holocaust. Now Israel's children were about to be poisoned by radioactivity. For two years we have lived in the shadow of the danger awaiting Israel from the nuclear reactor in Iraq. This would have been a new Holocaust. It was prevented by the heroism of our pilots to whom we owe so much.[1]

Similarly, in speaking to his cabinet in June 1982 of the necessity of invading Lebanon, Begin stated: "Believe me, the alternative to fighting is Treblinka, and we have resolved that there would be no Treblinkas."[2]

And in another letter to Reagan in 1982, Begin described the bombing of Beirut

in terms that implicitly likened Arafat holed up in his Beirut fortifications to Hitler entrenched in his Berlin bunker:

> I feel as a Prime Minister empowered to instruct a valiant army facing Berlin where amongst innocent civilians, Hitler and his henchmen hide in a bunker deep beneath the surface. My generation, dear Ron, swore on the altar of God that whoever proclaims his intent to destroy the Jewish state or the Jewish people, or both, seals his fate, so that which happened once on instruction from Berlin – with or without inverted commas – will never happen again.[3]

This may have been part of Begin's reply to a remark made by Ronald Reagan, who had asked the Israeli prime minister to stop the bombardment of Beirut, calling the result of those bombings "a holocaust." At a later interview with *New York Times* journalist David K. Shipler, Begin told how hurtful he had found Reagan's remark, to which he had immediately answered: "Mr. President, I know what is a holocaust." As the interview with the journalist continued, it became clear that the photograph of the boy with raised hands had a unique status for Begin:

> Then Begin turned to his press secretary, Uri Porat. "Will you please bring me the picture?" Uri didn't have to ask which one. He picked up a framed photograph from the prime minister's desk: the famous picture of Jews being rounded up in the Warsaw Ghetto. Begin held the photograph in front of him. "This is holocaust," he declared. "This is the Warsaw Ghetto, 470,000 Jews already taken out and brought to Treblinka. And these are the children and the women. Look at this child. Look at the fear in his eyes, how he tries to raise his hands, and look at this mother, looking at the other Nazi soldier lest he open fire at the child. Such children were killed – one and a half million for six years, brought to Auschwitz, Treblinka, Maidanek, etc. This is holocaust. And I later wrote to the president that he hurt me deeply and personally by using that word."[4]

Reagan's choice of words was unforgivable for Begin, who did in fact believe that the threat of a new holocaust loomed on the horizon, but with Israel as the potential victim and the Arabs as the would-be perpetrators. The prime minister's constant projection of the Nazi role onto the Arabs led Jacobo Timerman to deplore "Begin's thesis that every act of aggression against the Israelis constitutes a continuation of the Holocaust."[5]

While such Labor leaders as Yitzhak Rabin and Shimon Peres systematically avoided references of that kind, Menachem Begin's successors in the Likud party have continued to use the Holocaust as a frame of reference for describing the current situation. An article in the *Washington Post* in 1995 referred to "the familiar message, still in use [in Israel] on the political right, that equates the Arabs with the Nazis, and Palestinian leader Yasser Arafat with Hitler."[6] And at a speech

in London in 2002, Benjamin Netanyahu continued this tradition, indirectly but unmistakably comparing Arafat to Hitler.[7]

For those championing the Palestinian cause, there has been an equally strong tendency to cast Israel in the role of the Nazis, playing irresistibly on the irony that those who once were the victims of Nazi persecution now appear (in the eyes of their critics) to have adopted the methods of their persecutors. Needless to say, the effect of such claims on Israeli sensibilities is infuriating.

One high-profile case in point is the statement made in 2002 by the Portuguese author, José Saramago, who in 1998 was awarded the Nobel Prize for Literature. Along with seven other members of the International Parliament of Writers (IPW), including Nigerian author Wole Soyinka (another Nobel Laureate), Saramago visited the West Bank and was appalled by what he saw. After touring an Israeli military checkpoint on the outskirts of Ramallah and meeting with Yasser Arafat, Saramago stated on March 26, 2002:

> We must ring all bells in the world to tell what is happening in Palestine is a crime, and it is within our power to stop this. We can compare it to what happened in Auschwitz. Even if we consider the differences in place and time, it is still the same thing. From the military point of view… Ramallah is the barracks of the camp, and the Palestinians are the prisoners inside.[8]

This comparison produced a storm of protests, even on the part of Amos Oz, an outspoken critic of the Israeli occupation and an advocate of the immediate establishment of a Palestinian state.[9] Oz responded angrily in a front-page article in *Yediot Ahronot* on March 26, 2002, accusing Saramago of "moral blindness" (a reference to Saramago's 1995 novel *Blindness*) and asserting that "He who fails to distinguish between different levels of evil becomes a servant of evil." Oz also argued that comparing the West Bank to Auschwitz was an implicit call for the destruction of Israel, and added:

> Because I am an activist on the left, and one who struggles for Palestinian rights to independence I find Saramago's views a spit in the face of the Nazi victims, and a spit in the face of the peace camp in Israel and a spit in the face of the whole of humanity.[10]

Meanwhile other critics of Israeli policy took issue with Saramago in an entirely different way, as was the case with James Petras who wrote:

> While I agree with Saramago's general characterization of the Israeli attack on the Palestinians, I think the most appropriate analogy is the Warsaw ghetto uprising

against the Nazis and not Auschwitz. Of course, both the Israelis and the Nazis were intent on destroying the social fabric of the oppressed people and expelling them from the conquered land. In the case of the Nazis via the ovens and gas chambers; in the Occupied Territories by systematic terror and destruction of the basic structures of society…[11]

Comparisons with the Warsaw ghetto were further developed by still other critics of Israel, some claiming that the Israeli Defense Forces studied the *Stroop Report* in working out their own tactics against the Palestinian residential areas,[12] and some "comparing the valiant resistances conducted by the Warsaw Ghetto Polish Jews against the SS in April 1943 and that by the Jenin Refugee Camp Palestinians against the Israel Defence Forces (IDF) in March 2002."[13]

The Holocaust has also been invoked by prominent Israelis critical of the IDF's treatment of Palestinians. Yaffa Yarkoni, who sang khaki-clad to the soldiers in every war, has for decades been a symbol of Israeli patriotism.[14] On April 15, 2002, Yarkoni – then 76 – was still shaken by the images she had just seen of Jenin and gave an interview to Army Radio in which she stated:

> When I saw the Palestinians with their hands tied behind their backs, I said, 'It is like what they did to us in the Holocaust.' We are a people who have been through the Holocaust. How can we be capable of doing these things?[15]

As a result of these and related remarks, the Israeli Union of Performing Artists cancelled the lifetime tribute that had been planned for her, youth organizations declared a boycott of her records, and she began to receive death threats. A left-wing member of the Knesset, Naomi Chazan, explained: "What happened to Yaffa Yarkoni exemplifies the fact that in the current climate in Israel, anything that is not the official line is considered treachery or betrayal."[16] And in an editorial in *Yediot Ahronot* (April 24, 2002), Eitan Haber deplored what he saw as the folly of Yaffa Yarkoni's words, but added that "the ganging up on her says more about us than it does about her. We are a hysterical country. We have lost our brakes and run off the rails."[17]

More recently, Gaza was compared to the Warsaw ghetto by two British MPs, one of whom – Oona King (Labour) – stated in a piece published by the *The Guardian* on June 12, 2003:

> The original founders of the Jewish state could surely not imagine the irony facing Israel today: in escaping the ashes of the Holocaust, they have incarcerated another people in a hell similar in its nature – though not its extent – to the Warsaw ghetto.
>
> Any visitor to the Palestinian ghetto can see the signs: residents are sealed off

and live under curfew; the authorities view torture as acceptable and use collective punishment as a means of control; soldiers drive families from their homes, confiscate property and demolish neighbourhoods; unemployment runs in places at 80%, and utilities such as water are withheld; the economy has "client" status, and is subservient to the occupiers in every way.[18]

Shocked by this statement, Ari Sharev, the chairman of the Yad Vashem directorate, wrote a letter to the two MPs, sharply criticizing them for choosing

> to compare events in the Holocaust to a long and complex conflict between two nations. Whereas it is legitimate to disagree with Israeli policies and actions, it is grossly illegitimate and malicious to compare them to the most evil and massive crime in modern history in order to heighten the disagreement.
>
> Your statements completely distort historical facts and context. The Nazis' worldview claimed that the Jews were the source of all evil and called for a radical solution to the so-called "Jewish problem". In the case of Israel and Palestine, it is a matter of conflicting claims over territorial sovereignty that has deteriorated into a longstanding conflict. Neither side aims to annihilate the other.[19]

And Charlotte West described Oona King's statement as one of many recent examples in the U.K. of what she dubbed "playing the Nazi Comparison Card."[20]

By and large, those Israeli critics whose remarks have had the greatest impact and who are best informed as to exactly what is going on in the Occupied Territories, have not evoked misleading parallels between the Holocaust and human rights abuses committed against the Palestinians. This applies, for example, to recent comments made by Lt. General Moshe Yaalon, Chief of Staff of the Israeli armed forces. Yaalon deplored repressive measures applied in the Occupied Territories, arguing that the daily humiliations and hardships imposed upon the Palestinians in the West Bank and Gaza fuel hatred and undermine Israel's own strategic interests.[21] In stating his criticism in these specific terms and without reference to other historical situations, Yaalon made it difficult for anyone to dismiss his remarks.

However, anyone wishing to understand why idealistic Israelis sometimes evoke unfounded comparisons of their government's policy with Nazi genocide, may find the answer in David Shipler's discussion of that issue. Having argued vigorously against such comparisons, Shipler writes of a specific critic of Israeli policy in 1982, who had fought for Israel in several wars:

> For an idealistic old veteran who imagined his country forsaking its ideals, the Holocaust became the only container large enough to hold the grief and the guilt, the only metaphor atrocious enough to accommodate the shame. In the autumn of 1982, after the invasion of Lebanon, the siege of Beirut, the massacre by Israel's

Lebanese Christian allies in the Sabra and Shatila refugee camps, many of the old veterans and new veterans who searched for a denunciation had to use the Holocaust. Nothing else seemed sufficient to capture their deep agony and anger. They recognized the differences of course; they were trying to measure not the objective events in Lebanon but their feelings about what they, their army, had done there (*op. cit.*, p. 319).

We will now look at some of the ways in which the photo of the boy with raised hands has been enlisted in the "war of images."

A political cartoon and its background

Between September 16 and 18, 1982, hundreds of Palestinian men, women and children were butchered by Lebanese Phalangist militiamen, admitted to the refugee camps of Sabra and Shatila by the Israeli Defense Forces that had encircled and sealed off the camps. Despite the Phalangists' extreme enmity toward the Palestinians, exacerbated by the assassination of the Phalangist leader Bashir Gemayel only days before (on September 14), they were allowed to enter the camps on their own, unaccompanied by IDF troops whose presence would undoubtedly have curbed their acts of revenge. When Morris Draper, then U.S. Special Envoy to the Middle East, heard that Sharon had allowed the Phalangists to enter the camps and that the bloodshed had already begun, he cabled Sharon, urging him:

> "You must stop the slaughter…. The situation is absolutely appalling. They are killing children. You have the field completely under your control and are therefore responsible for that area."[22]

But the Israeli troops did nothing to stop the ongoing massacre, and in the eyes of the world community, Israel bore an important share of the moral responsibility for the 62-hour rampage that resulted in the deaths of hundreds of Palestinian children, women and men of all ages.

The subsequent findings of the Kahan Commission, officially established by the Israeli government to carry out an independent investigation, retrospectively confirmed the worldwide indignation over what Sharon had allowed to happen. In February 1983, the Commission concluded: "In our view, the Minister of Defense made a grave mistake when he ignored the danger of acts of revenge and bloodshed by the Phalangists against the population in the refugee camps."[23] Consequently the Kahan Commission recommended that Sharon be discharged from serving as Minister of Defense.

© António Antunes, 1982. Reprinted with permission of the artist.

But let's return to September 1982, when in the wake of the tragic events that had transpired at Sabra and Shatila, the Portuguese artist António Moreira Antunes based a political cartoon on the 1943 photograph. Only now the boy with raised hands wore a PLO scarf around his head, as did the other prisoners with raised hands, and the German helmets of the photograph were replaced by helmets bearing a Star of David, identifying the captors as Israeli soldiers.

Published in the Portuguese newspaper *Expresso* in 1982, this cartoon won the Grand Prize at the 20th International Salon of the Cartoon in Montreal in 1983.

An incident that occurred at the University of Western Ontario clearly indicates the role this cartoon has played in the war of images in at least one confrontational setting. In March 1987, a group called Canadians Concerned for the Middle East arranged for PLO representative Abdullah Abdullah to give a talk at the university.

> Promotional posters for the lecture, titled "Palestinian Resistance to Israeli Occupation," featured a drawing by Portuguese cartoonist António Moreira. Inspired by a famous photograph of Jewish women and children surrounded by German soldiers in the Warsaw Ghetto, the drawing depicted Palestinian women and children surrounded by Israeli soldiers. The poster provoked complaints and was removed with both Western's president and its dean of law saying that it was offensive. Later, Abdullah's lecture was disrupted by demonstrators.[24]

Hanoch Levine's *The Patriot*

Essentially the same transposition of identities found in the Portuguese cartoon was staged in a "satirical cabaret" called *The Patriot*, first performed in Israel in 1982, and written by Israeli playwright Hanoch Levine (also spelled Hanokh Levin).[25]

The relevant scene in that play was described as follows by Sidra Ezrahi:[26]

> …Mahmud, the Arab boy, assumes the capitulary pose that recalls, iconographically, the figure of the terrified boy, hands raised, who was photographed in the Warsaw Ghetto presumably moments before he was shot. Lahav, the main character in Levin's play, addresses his mother while aiming his revolver at Mahmud's head:
>
> He will avenge your blood and the blood of our murdered family, as then, mother, when your little brother stood alone in front of the German, at night, in the field, and the German aimed his revolver at his head, and your little brother, trembling with fear, said (and he sings as he aims the revolver at Mahmud):
>
>> Don't shoot
>> I have a mother
>> She is waiting for me at home.
>> I haven't eaten yet.
>> Dinner.
>> Don't kill me.
>> I am a child.
>> I am a human being like you.
>> What did I do?
>> What difference would it make to you
>> if I yet lived?

According to David K. Shipler, the introductory passage which refers to the German aiming his gun at the Jewish child, was deleted by the board of censors, though Mahmud was allowed to sing the song quoted above, after which "Lahav shoots the boy, who falls and dies."[27]

Also particularly interested in this scene was James E. Young, who devoted a chapter of his book, *Writing and Rewriting the Holocaust*,[28] to the anti-war verse of soldier-poets in Israel. Young mentioned the importance of the so-called "R.P.G. kids" of the PLO – children used as soldiers in the Lebanon War of 1982, who were trained to aim and shoot shoulder-fired missiles or RPGs (Rocket Propelled Grenades) at the IDF. According to Young, confronting and having to wound or

Lahav, standing in the middle, aims his submachine gun (barely visible in this dimly lit photo) at Mahmud, seated on the floor at the right with his hands up. This photo was provided by The Israel Goor Theatre Archives and Museum in Jerusalem.

kill these children on the battle field moved some Israeli soldiers "to compare the child-victims of the War in Lebanon with the child-victims of their own [Holocaust] memories." Young wrote:

> Even though the "R.P.G. kids" of the P.L.O. proved to be as lethal to the Israeli soldiers as the P.L.O. regulars, the crises of conscience they provoked may have been more traumatic still; for they destroyed in the Israelis both a perceived sanctity in children as well as the belief that they were fighting a conventional war. Ultimately, the R.P.G. kids also incited an even deeper hatred for an enemy that would use its children both as protective shield and frontline soldiers. On the other hand, however, as children, the R.P.G. kids were regarded in the tradition as victims, in this case, of both enemy and friendly soldiers.[29]

Having pointed out this special role of children in the ranks of the enemy forces in Lebanon and their effect on IDF morale, Young wrote of the relevant scene in *The Patriot*:

...a Palestinian child standing center stage, his arms upraised, surrounded by laughing Israeli soldiers – possibly the most explicit comparison until then between Jewish suffering in the Holocaust and the Arabs' condition on the West Bank. As the most recognizable symbol in the iconography of Jewish suffering, this studied pose on stage provoked outrage among survivors, though most condemned not so much the comparison between children as the implied suggestion that Israelis now behaved like Nazis. [...]

[...] By yoking this Holocaust icon, his personal memory, and the figure of the Palestinian child into one moment, the playwright simultaneously reflects and compels Jewish understanding of the Palestinian child (pp. 140-141).

A Palestinian child

On a revisionist web site called "David Irving's Action Report" and dated November 2001, a cropped version of the photograph of the boy in Warsaw is juxtaposed with a Reuter's photo of a Palestinian child being led away by a group of Israeli soldiers and so terrified that he has wet his pants.[30] According to a commentary by C.E. Carlson, who in turn cites *The Washington Report on Middle Eastern Affairs*, the Palestinian child is Kamal Ali As'idah, ten years old when the picture was taken in April 2001. And according to Carlson, the boy was held in custody for eight hours, beaten by the IDF on the head and legs, and had a broken arm when he was released at the end of his ordeal.[31]

The same juxtaposition of photos is made on another web site as well, called the "Ukrainian Archive."[33] Here the heading used is a Latin proverb which reads: *Mutato nomine de te fabula narratur* (With a mere change of name, the story told is about you). The anonymous commentator suggests that while the photograph of the Palestinian child is clearly authentic, that of the Jewish boy in Warsaw "can be suspected of being misrepresented or staged." Apparently unaware that this was a photo taken by the SS, the commentator casts doubt on its authenticity by pointing out what he sees as a revealing incongruity:

> With civilians lugging possessions, and soldiers walking beside them, and with their backs to them, there appears to be none of the concern for a sudden attack using concealed weapons that raised hands intend to preclude.

Here, the very absurdity of the SS requirement that unarmed and harmless women and children put their hands up, is misinterpreted as a sign that the event recorded in the photograph is unlikely to have occurred. If only that were true.

The two photos are linked in another and far more imaginative way in a work called "The Legacy of Abused Children: from Poland to Palestine – Digitally Altered

Scanpix/Reuters/Evelyn Hockstein. The official caption begins as follows: "A frightened young Palestinian protestor wets his trousers while being arrested by Israeli border police in Jerusalem's Old City, April 6, 2001."[32]

Photographs and DVD" dated 2003.[34] In this project, an Israeli artist named Alan Schechner explores connections between the Holocaust and the Intifada. First, the Warsaw ghetto photograph is shown on screen or projected on a wall, and the camera zooms in on the right hand of the little boy, which has been digitally manipulated in such a way that he appears to be holding a photograph in that hand.

> The camera zooms in to the image to reveal a young Palestinian boy, who has wet himself with fear, being hauled off by Israeli Soldiers. He too holds an image in his hand, that of the Jewish boy in the Warsaw Ghetto (ibid.).

In this work, Alan Schechner presents the two children as calling out to the viewer that each of them protests against the suffering inflicted on the other. In doing so, the artist focuses attention on the children, rather than on supposed parallels between the SS and Israeli soldiers.

© *Alan Schechner. Used with permission of the artist.*

Mohammed al-Dura

The pictures of 12-year old Mohammed al-Dura[35] (also spelled al-Durreh, al-Durha, al-Durrah and El-Dorra) and his father Jamal, bear no physical resemblance to the 1943 photo of the boy in the Warsaw ghetto. However, as will soon become clear, this event gave rise to what is probably the most startling verbal evocation of the Warsaw photograph to date in the context of the war of images in the Middle East.

Netzarim is an Israeli settlement in the Gaza Strip, housing some 60 families and defended by an Israeli army post resembling a fortress, with watchtowers at each of its four corners. On the morning of September 30, 2000, the second day of the Second Intifada, the Israeli army base came under attack, first with stones and Molotov cocktails hurled at the Israeli positions, and eventually by gunfire. As the day progressed, there were exchanges of fire between the IDF and Palestinians, some of whom were shooting from a small command post lying diagonally across from the Israeli army base at the Netzarim Junction.

Jamal al-Dura and his son Mohammed were returning home that afternoon and crossed the Netzarim Junction on foot just as salvos were fired. Father and son sought refuge behind a concrete cylinder standing before a cement-block wall, the father attempting to shield the boy from the gunfire and frantically gesturing and crying out for the firing to stop.

So much is generally agreed upon by both sides, but little more. And none of the parties involved is entirely above suspicion with regard to the withholding or destruction of evidence: the Israelis bulldozed the building with the cement-block wall at the Netzarim Junction soon after the incident occurred, making further logistic tests and measurements impossible; and the Palestinians never authorized an autopsy of the boy to established the direction from which the bullets had entered his body, nor did they ever display the bullets that killed him.

Since important evidence is unavailable and the stakes are high with respect to world opinion, it is not surprising that there are a number of versions of the story in circulation. The four main variants of the story might be briefly outlined as follows:

1) Mohammed and his father were knowingly and deliberately targeted by the Israelis and both were intentionally hit by IDF fire. This was claimed by the Palestinian cameraman who shot the footage and is the position adopted by the *Guardian*.[36]

2) Mohammed and his father were fired upon by an Israeli soldier from whose obstructed vantage point it was impossible to see who was hiding behind the concrete cylinder. This was the explanation initially put forward by an IDF commander but subsequently retracted.[37]

3) Mohammed and his father must have been struck by Palestinian bullets – one of the arguments being that Israeli fire would have had to pass through the impenetrable concrete cylinder in order to hit the father and son.[38] (This is why the original Israeli explanation was later retracted.)

4) The incident was staged by the Palestinians in order to "manufacture a child martyr, in correct anticipation of the damage this would do to Israel in the eyes of the world"[39]– a conclusion arrived at by several researchers and detailed in a recent book.[40]

In any event, the image of Mohammed al-Dura quickly acquired within the Moslem world a status comparable to that of the boy in Warsaw, as the following quotations clearly illustrate:

> Like the photograph of the boy with his hands raised standing in the Warsaw Ghetto, nobody who saw desperate Jamal Al-Durrah vainly trying to shield 12-year old Mohammed can ever forget the terror in their eyes.[41]

> That image, encapsulating life and death, pain and despair not to mention bestiality, has become an icon of the Intifada, an emblem of the tragedy.[42]

> Mohammed al-Dura soon became the poster child, rallying cry and virtual symbol of the "al-Aqsa intifada." Heartwrenching photographs of father and son were posted everywhere alongside roads throughout the West Bank and Gaza. Egyptian authorities named a street after the boy…[43]

> Several Arab countries have issued postage stamps carrying a picture of the terrified boy. One of Baghdad's main streets was renamed The Martyr Mohammed Aldura Street. Morocco has an al-Dura Park.[44]

Catherine Nay, a French radio commentator speaking on the station Europe 1, went even further. After comparing the two images, she announced during her broadcast: "with the symbolic charge of this photo, the death of Mohammed cancels, erases, that of the Jewish child" (*"avec la charge symbolique de cette photo, la mort de Muhamad annule, efface celle de l'enfant juif"*).[45]

This position – declaring null and void the death of a Jewish child at the hands of the SS in 1943 – differs markedly from the view proposed by Edward W. Saïd, not specifically with regard to Mohammed al-Dura and the boy in the Warsaw ghetto, but more generally concerning the Holocaust and Palestinian suffering dating back to the events of 1948 when 700,000 Palestinians became refugees. There

is no more fitting way to conclude the present discussion than to cite Edward W. Saïd's words on this issue:

> […] there is a link to be made between what happened to Jews in World War II and the catastrophe of the Palestinian people, but it cannot be made only rhetorically, or as an argument to demolish or diminish the true content both of the Holocaust and of 1948. Neither is equal to the other; similarly neither one nor the other excuses present violence; and finally, neither one nor the other must be minimized. […]
>
> […] Who would want morally to equate mass extermination with mass dispossession? It would be foolish even to try. But they *are* connected – a different thing altogether – in the struggle over Palestine which has been so intransigent, its elements so irreconcilable.[46]

It's scandalous and offensive to compare suffering. To say that "what they are doing to the Palestinians is what [the Nazis] did to the Jews" is not true at all. What the Jews went through is horrendous, and really without precedent. But on the other hand, that can't be used as a way of diminishing the terrible punishment that Palestinians have received at the hands of Israel. It's not a matter of comparison. It's a matter of saying that both are unacceptable.[47]

NOTES TO CHAPTER SIX

1 Avi Shlaim, *The Iron Wall. Israel and the Arab World* (London: Penguin, 2000), p. 387.
2 Ibid., p. 404.
3 Ibid., p. 411.
4 David K. Shipler, *Arab and Jew. Wounded Spirits in a Promised Land*, revised edition (Harmondsworth: Penguin, 2002), p. 316.
5 Jacobo Timerman, *The Longest War. Israel in Lebanon* (New York: Vintage Books, 1982), p. 73.
6 Barton Gellman, "Israel Commemorates Holocaust 50 Years After the Nazi Defeat, *The Washington Post*, 28 April 1995. The article is currently accessible at: http://www-tech.mit.edu/V115/N21/israel.21w.html
7 Netanyahu stated in his speech at Trafalgar Square on May 6, 2002:

> Imagine how the people of Britain would have felt if the free world would have told them that while they stand with them in the fight against Nazism, Britain would nonetheless have to come to terms with Hitler, the legitimate leader of the German people.
> The people of Britain knew then that the road to peace with Germany did not go through Hitler or around Hitler, but over Hitler. His Nazi regime had to be dismantled if there were to be any hope for peace.

Likewise, the people of Israel know that the path toward peace with the Palestinians does not go through Arafat, nor around Arafat, but over Arafat.

The entire speech can be found at http://www.cs.biu.ac.il/~davoudo/trafalgar.html

8 Ellis Shuman, "Storm over Nobel Prize laureate's Auschwitz comparison," March 26 2002, *Israelinsider*, at http://www.israelinsider.com/channels/diplomacy/articles/dip_0184.htm
9 See for example "Three articles by Amos Oz" at http://www.chicaopeacenow.org/rr-15.html
10 Fakhri Saleh, "The opportunism of Amos Oz," *The Star*, April 4-10, 2002, at http://star.arabia.com/article/0,5596,150_3999,00.html "Author compares Palestinian city to Nazi death camp," *Miami Herald*, March 27, 2002, at http://www.miami.com/mld/miami-herald/news/world/2944455.htm
11 James Petras, "Jenin: Auschwitz or the Warsaw Ghetto?" *Rebelión*, April 29, 2002, at: http://www.rebelion.org/petras/english/jenin020502.htm
12 *Paul Gallagher*, "Israeli Warsaw Ghetto Methods: U.S., Europe Are Accountable," *Executive Intelligence Review (EIR)*, Feb. 8, 2002, at: http://www.cecaust.com.au/culture/jewish/p4/article15.htm or http://www.larouchepub.com/other/2002/2905israel_warsaw.html Gallagher wrote:

> Repeated public warnings by U.S. Presidential pre-candidate Lyndon LaRouche against "the insane fascism of Ariel Sharon," were terribly confirmed by an Israeli officer's report to the daily *Ha'aretz* on Jan. 25: The Israeli Defense Forces (IDF) have been studying the 1943 military tactics of the Nazi SS against the Jewish resistance in the Warsaw Ghetto, for application against the Palestinians of the West Bank and Gaza today. [...] The anonymous IDF officer's shocking confession was reported in a Jan. 25 article by veteran *Ha'aretz* reporter Amir Oren, on Sharon's moves toward eliminating Yasser Arafat and the Palestinian Authority. The admission in the English-language edition of *Ha'aretz* two days later. White House spokesman Ari Fleischer, on Jan. 27, heatedly refused to answer EIR's questions on it, saying that he "does not respond to reports with no names attached." But Sharon's own press spokesman, Ra'anan Gissen, was unblushing. Asked by EIR on Jan. 30 about IDF officers studying the Nazi Warsaw Ghetto strategy, Gissen replied, "Some officers may have been looking at that. They thought that it was similar, because you would be fighting street-by-street against the Palestinian Authority." Oddly, Gallagher wrote near the end of his piece: "Stroop was captured in 1945 by the Soviet Red Army, underwent a personality disintegration during his brief imprisonment, was tried for war crimes, and executed." Perhaps this is a measure of the accuracy of the piece in general.

13 Mumtaz Iqbal, "Jenin and Warsaw Ghetto compared," *Holiday* [Bangladesh], April 19, 2002, at: http://www.weeklyholiday.net/190402/comm.html
14 "Yarkoni served as a radio operator in Israel's War of Independence in 1948 and began her career singing the songs adopted as anthems by the Palmach, the Jewish underground militia that fought the British and the Palestinians in the pre-state days. In 1967, after Israel captured Jerusalem's Old City, it was Yarkoni who sang *Jerusalem of Gold*

in front of the Western Wall, Judaism's holiest site. And on Israel's 50th Independence Day, in 1998, she was awarded the prestigious Israel Prize for her contribution to the nation's music." Mary Curtius, "A Venerable Voice in Israel Is Muted After Questioning Army's Actions," *Los Angeles Times*, April 29, 2002, http://www.latimes.com/news/nationworld/nation/la-042902speech.story

15 Ibid. See also Celean Jacobson, "Israeli Singer Shunned for Questioning," *Associated Press Online*, April 20, 2002., and Phil Reeves, "Embattled Israel clamps down on dissent; A hardening mood allows authorities to restrict news and stifle critics – even the army's heroine has been silenced," *The Independent* (London), May 5, 2002. Reeves wrote: "It was as if Vera Lynn had appeared on the BBC and denounced the conduct of British troops in Northern Ireland. Reprisals swiftly followed. A ceremony where she was to receive a lifetime award was cancelled. Israeli youth organisations declared they would boycott her songs. She was denounced by ministers, and told by one town – Kfar Yona – that she would no longer be welcome to perform at its Memorial Day event."

16 Curtius, *op. cit.*

17 Ibid. See also http://www.mfa.gov.il/mfa/go.asp?MFAH0llv0. Haber had been Yitzhak Rabin's top aide and speechwriter.

18 Oona King, "Israel can halt this now," *The Guardian*, June 12, 2003; accessible at http://www.guardian.co.uk/comment/story/0,3604,975423,00.html

19 June 22, 2003. Most of Ari Sharev's letter is reproduced in the Yad Vashem press release at http://www.yad-vashem.org.il/about_yad/press_room/press_releases/chairman.html

20 http://www.israelnationalnews.com/article.php3?id=2489

21 See for example Molly Moore, "Top Israeli Officer Says Tactics Are Backfiring," *Washington Post*, October 31, 2003, p. A01.

22 "Israel: Sharon Investigation Urged," *Human Rights News*, June 23, 2001, http://www.hrw.org/press/2001/06/isr0622.htm Draper's statement is quoted here from a BBC documentary on the massacres in Sabra and Shatila, broadcast in the U.K. on June 17, 2001.

23 Ibid.

24 http://www.information.uwaterloo.ca/Gazette/1994/Gazette,%20March%2016,%201994/Western%20reaches%20agreement%20with%20Palestinians

25 For a good overview of Hanoch Levine's production and status, see Glenda Abramson, *Drama and Ideology in Modern Israel* (Cambridge: Cambridge University Press, 1998), Chapter 10.

26 Sidra Dekoven Ezrahi, "Revisioning the Past: The Changing Legacy of the Holocaust in Hebrew Literature," *Salmagundi: A Quarterly of the Humanities and Social Science*s, vol. 19 (Fall-Winter 1985), pp. 267.268. The lines spoken and sung by Lahav in this scene are from the Program Notes of "The Patriot" and were excised from the play by the board of censors.

27 David K. Shipler, *op. cit.*, pp. 469-470.

28 James E. Young, *Writing and Rewriting the Holocaust. Narrative and the Consequences of Interpretation* (Bloomington & Indianapolis: Indiana University Press, 1988). The chapter I will be quoting from is entitled "When Soldier Poets Remember the Holocaust: Anti-War Poetry in Israel."

29 Ibid., p. 140.

30 http://www.fpp.co.uk/online/01/11/Palestine_boy4.html

31 http://www.fpp.co.uk/online/01/11/Palestine_boy3.html

32 In another photograph taken of the same boy by another Reuters photographer, the child appears to be throwing stones at Israeli soldiers. This image is presently accessible at the following websites: http://www.politicsnow.co.il/realpic.html, http://www.israelinsider.com/channels/diplomacy/articles/dip_0025.htm and http://www.honestreporting.com/articles/critiques/The_Sympathy_Photo.asp

33 http://www.ukar.org/mutato01.shtml

34 This work is presented on the following web site: http://www.dottycommies.com/holocaust10.html The artist, Alan Schechner, served in the Israeli army from 1981-1983 with active duty both in the Occupied Territories and Lebanon. The work described here is both a "stand alone" project in itself, and also used in "Dialog," a collaboration between Israel artist Alan Schechner and Palestinian artist Rana Bishara.

35 Unfortunately, France 2 would not authorize my reprinting here of three images from the video film recorded by Talal Abu Rahma, a Palestinian cameraman working for France 2, at the Netzarim Junction in Gaza City on September 30, 2000, as Jamal al-Dura attempted to shield his son Mohammed from the ongoing gunfire. Readers interested in seeing these images can access them on a number of websites, such as: http://www.kadado.com/gallery/bulletinboard/mohammed_al_durrah.htm#pictures,

36 Susanne Goldenberg, "Making of a Martyr," *The Guardian*, October 3, 2000. In this article, the cameraman is cited as follows: "Of course [the Israelis] saw the father," says Talal Abu-Rama, the cameraman who watched the horror unfold. "They were aiming at the boy, and that is what surprised me, yes, because they were shooting at him, not only one time, but many times." http://www.guardian.co.uk/israel/Story/0,2763,376639,00.html

37 "General Yom-Tov Samia, then the head of the IDF's Southern Command, which operated in Gaza, said, 'It could very much be – this is an estimation – that a soldier in our position, who has a very narrow field of vision, saw somebody hiding behind a cement block in the direction from which he was being fired at, and he shot in that direction.'" James Fallows, "Who Shot Mohammed al-Dura?" *The Atlantic Monthly*, June 2003, at http://www.theatlantic.com/issues/2003/06/fallows.htm

38 This is a conclusion reached in a German TV documentary, *Drei Kugeln und ein totes Kind (Three Bullets and a Dead Child)*, by Esther Schapira. This documentary is discussed by Ellis Shuman in "German TV: Mohammed a-Dura likely killed by Palestinian gunfire," at http://www.israelinsider.com/channels/diplomacy/article/dip_0182.htm

39 Fallows, op. cit.

40 Gérard Huber, *Contre-expertise d'une mise en scène* (Paris: Raphael, 2003). See also: an interview with Gérard Huber by *Primo Europe* at http://www.primo-europe.org/dossier1-interview.php David Kupelian, "Probe: Famous 'martyrdom' of Palestinian boy 'staged,'" *WorldNetDaily*, April 26, 2003, http://www.worldnetdaily.com/news/article.asp?ARTICLE_ID=32137

41 Helen Schary Motro, "Tragedy or Exploitation?" *The Jerusalem Post*, 22 February 2001; reprinted by *The Jewish Journal*, March 2, 2001, and posted on its website at http://www.jewishjournal.com/home/preview.php?id=6555

42 Amina Elbendary, "Nation unto what?" *Al-Ahram Weekly Online*, March 21-27, 2002, at http://weekly.ahram.org.eg/2002/578/cu1.htm

43　Kupelian, op. cit.
44　Fallows, op. cit.
45　Quoted in "Dossier *Contre-expertise d'une mise en scene* de Gérard Huber aux Editions Raphaël," by *Primo Europe* at http://www.primo-europe.org/dossier1-faits.php and also cited by Jacques Tarnero in "L'obsession de Catherine Nay," Désinfos, June 16, 2002, at http://www.desinfos.com/tarnero020616.html
46　"Bases for Coexistence" (1997), in Edward W. Saïd, *The End of the Peace Process*, revised edition (London: Granta, 2002), pp. 207-208; originally published in *Al-Hayat*, November 5, 1997.
47　"At the Rendezvous of Victory" (February 25, 2003), in *Culture and Resistance. Conversations with Edward W. Saïd*, interviews by David Barsamian (London: Pluto Press, 2003), pp. 179-180.

A CONCLUDING NOTE

According to Matti-Juhani Karila, the Finnish documentary writer and producer, the photograph of the child with raised hands has a life of its own and continues to become a part of new stories.[1]

Whether factual or interpretive issues are at stake, or it is a question of uses of the image in any number of contexts, new and unexpected perspectives invariably turn up, requiring us to expand our sense of the repertory of stories told by or about the photograph. In the present book, every effort has been made to respect the inexhaustible qualities of this image, and to open the way for further reflection, rather than to give a misleading impression that all questions raised by the picture have now been settled once and for all.

In October 2003, after the research for this book was completed and the above chapters written, I learned from the U.S. Holocaust Memorial Museum that they had a related artifact in their collection: a lead plate used for printing copies of the photograph of the boy with raised hands. It is one of a group of thirty such plates, bearing images of the Nazi persecution of Jews. These photographic plates had been found in a second-hand bookstore, possibly in Munich, "at the end of the war" by a Kovno survivor and photographer named George Kadish (originally Tsvi Kadushin), who in 1991 gave the plates to the Museum via Raye Farr, then director of the Museum's Permanent Exhibition.

The lead photographic plate, on which the image itself measures 14.9 x 9.8 cm. Courtesy of the USHMM.

How and when a copy of the photograph was made available to whoever made the lead plate, is a mystery, considering that only four copies of the photograph are known to have been printed in connection with the *Stroop Report* – a document available only to an inner circle of the SS elite. And equally perplexing are such questions as: what was the plate used for and by whom? And through what channels and to what public was the picture disseminated via the photographic plate, in the final years of the Second World War?

This note of uncertainty seems a fitting way to conclude the present study, in order to emphasize the point that although a good deal of research has now been done on the photograph, new questions will continue to emerge about one of the most haunting images we have.

NOTE

1 Numerous personal communications in 2002 and 2003. My debt to Matti-Juhani Karila for this entire project is incalculable.

BIBLIOGRAPHY

Adler, Stanislaw. *In the Warsaw Ghetto 1940-1943. An Account of a Witness*. Trans. from the Polish by Sara Chmielewska Philip. Jerusalem: Yad Vashem, 1982.

Ainsztein, Rubin. *The Warsaw Ghetto Revolt*. New York: Holocaust Library, 1979.

Akta w sprawie likwidacji getta w Warszawie at Instytut Pamięci Narodowej, Komisji ścigania Zbrodni przeciwko Narodowi Polskiemu, Biuro Udostępniania i Archiwizacji Dokumentów.

Arendt, Hannah. *Eichmann in Jerusalem. A Report on the Banality of Evil*. New York: Penguin, 1994; orig. pub. 1963.

Bak, Samuel. *Landscapes of Jewish Experience*. Essay and commentary by Lawrence L. Langer. Boston: Pucker Gallery, 1997.

Bak, Samuel. *Painted in Words: A Memoir*. Indiana University Press, 2001.

Barthes, Roland. "Rhetoric of the Image" (1964) in *Classic Essays on Photography*, ed. Alan Trachtenberg. New Haven: Leete's Island Books, 1980.

Barthes, Roland. *La chambre claire. Note sur la photographie*. Paris: Editions de l'Étoile, Gallimard, Seuil, 1980.

Bauer, Yehuda. *Rethinking the Holocaust*. New Haven: Yale University Press, 2001.

Berg, Mary. *Warsaw Ghetto. A Diary*. Trans. Norbert Guterman. Edited by S. L. Shneiderman. New York: L. B. Fischer, 1945.

Berger, John. "Understanding a photograph" (1974) in *Classic Essays on Photography*, ed. Alan Trachtenberg. New Haven: Leete's Island Books, 1980.

Bergman, Ingmar. *Persona*. Copenhagen: Det Schønbergske Forlag, 1967.

Biagi, Enzo. "Tsvi Nussbaum: un bambino dalle braccia alzate," in *Noi c'eravamo*. Milan: Rizzoli, 1990; pp. 101-105.

Borges, Jorge Luis. "Deutsches Requiem," in *Collected Fictions*. Trans. Andrew Hurley. New York: Viking, 1998; pp. 229-234.

Borwicz, Michel. *L'Insurrection du ghetto of Varsovie*. Paris: René Julliard, 1966.

Borzykowski, Tuvia. *Between Tumbling Walls*. Trans. from the Yiddish by Mendel Kohansky. Tel Aviv: Hakibbutz Publishing House, 1972.

Burgin, Victor. "Looking at Photographs." *Screen Education*, vol. 24 (Autumn 1977), pp. 17-24.

Cole, Tim. *Selling the Holocaust. From Auschwitz to Schindler. How History is Bought, Packaged and Sold*. New York: Routledge, 1999.

Dawidowicz, Lucy S. *The War Against the Jews: 1933-1945*. London: Penguin, 1990; orig. pub. 1975.

Ebert, Roger. "Persona." *Chicago Sun-Times*, January 7, 2001.

Eichmann, Adolf. "I transported them… to the butcher." Eichmann's Story Part I. *Life Magazine*, vol. 49, No. 22 (November 28, 1960), pp. 19-25, 101-112.

Eliach, Yaffa. *Hasidic Tales of the Holocaust*. New York: Oxford University Press, 1982.

Epstein, Eric Joseph and Philip Rosen. *Dictionary of the Holocaust. Biography, Geography and Terminology*. Westport, Conn.: Greenwood Press, 1997.

Ezrahi, Sidra Dekoven. "Revisioning the Past: The Changing Legacy of the Holocaust in Hebrew Literature," *Salmagundi* (Fall 1985-Winter 1986), pp. 245-270.

Finkelstone, Joseph. "'Ghetto boy' lives here." *Jewish Chronicle*, August 11, 1978, pp. 1-2.

Fishkoff, Sue. "The Holocaust in one photograph." *Jerusalem Post*, April 18, 1993.

Frankl, Viktor E. *Man's Search for Meaning: An Introduction to Logotherapy*. Trans. Ilse Lasch. New York: Washington Square Press, 1963; orig. publ. 1959 under title *From Death-Camp to Existentialism*.

German Crimes in Poland. New York: Howard Fertig, 1982; orig. pub. in Polish 1946-1947.

Gilbert, G. M. *Nuremberg Diary*. London: Eyre & Spottiswoode, 1948.

Gilbert, Martin. *Final Journey. The Fate of the Jews in Nazi Europe*. London: George Allen & Unwin, 1979.

Gillis-Carlebach, Miriam. "Jewish Mothers and Their Children During the Holocaust: Changing Tasks of the Motherly Role," pp. 230-247 in *Remembering for the Future. The Holocaust in an Age of Genocide*, ed. John K. Roth and Elisabeth Maxwell. Houndmills: Palgrave, 2001.

Goldberg, Vicki. *The Power of Photography. How Photographs Changed Our Lives*. New York: Abbeville Press, 1991.

Grupinska, Anka et al. *Warsaw Ghetto*. Warsaw: Parma Press, 2002.

Grynberg, Michal (ed.). *Words to Outlive Us. Voices from the Warsaw Ghetto*. Trans. Philip Boehm. New York: Metropolitan Books, 2002. Orig. pub. in Poland in 1988.

Gutman, Yisrael. *The Jews of Warsaw, 1939-1943. Ghetto, Underground, Revolt*. Trans. from the Hebrew by Ina Friedman. Sussex: Harvester Press, 1982.

Hartman, Geoffrey H. "The Book of Destruction," in *Probing the Limits of Representation. Nazism and the 'Final Solution,'* ed. Saul Friedlander. Cambridge: Harvard University Press, 1992; pp. 318-334.

Hever, Hannan. "An Extra Pair of Eyes: Hebrew Poetry under Occupation," *Tikkun* vol. 2, No. 2 (1987), pp. 84-87, 122-126.

Heydecker, Joe J. and Johannes Leeb. *Der Nürnberger Prozeß*, vols. 1 and 2. Köln: Kiepenheuer & Witsch, 1985.

Heydecker, Joe J. *Das Waschauer Getto. Foto-Dokumente eines deutschen Soldaten aus dem Jahr 1941*. Munich: Deutscher Taschenbuch Verlag, 1987; orig. pub. 1983.

Heydecker, Joe J. *Where Is Thy Brother Abel? Documentary Photographs of the Warsaw Ghetto*. Sao Paolo: Atlantis, 1981.

Hilberg, Raul. *Perpetrators, Victims, Bystanders. The Jewish Catastrophe 1933-1945*. New York: HarperCollins, 1992.

Hilberg, Raul. *The Politics of Memory. The Journey of a Holocaust Historian*. Chicago: Ivan R. Dee, 1996.

Hilberg, Raul. *Sources of Holocaust Research*. Chicago: Ivan R. Dee, 2001.

Hirsch, Marianne. "Nazi Photographs in Post-Holocaust Art: Gender as an Idiom of Memorialization," in *Crimes of War: Guilt and Denial*, ed. Omer Bartov, Atina Grossmann, Molly Noble. New York: The New Press, 2002; pp. 100-120.

Hirsch, Marianne. "Projected Memory: Holocaust Photographs in Personal and Public Fantasy," in *Acts of Memory. Cultural Recall in the Present*, ed. Mieke Bal, Jonathan Crewe, Leo Spitzer. Hanover: University Press of New England, 1999; reprinted in *Ways of Reading: An Anthology for Writers*, ed. David Bartholomae & Anthony Petrosky. New York: Bedford/St. Martin, 2002.

Hirsch, Marianne. "Surviving Images: Holocaust Photographs and the Work of Postmemory," pp. 215-246 in *Visual Culture and the Holocaust*, ed. Barbie Zelizer. London: The Athlone Press, 2001.

Hirsch, Marianne. "The Day Time Stopped," *The Chronicle of Higher Education*, January 25, 2002. http://chronicle.com/free/v48/120/20b01101.htm

Hoess, Rudolf. *Commandant of Auschwitz. The Autobiography of Rudolf Hoess.* Trans. Constantine FitzGibbon. Cleveland and New York: World Publishing Company, 1959.

Huber, Gérard. *Contre expertise d'une mise en scène.* Paris: Raphael, 2003.

Jensen, Nils Aage. *Holocaust. Nazismens folkedrab.* Copenhagen: Gyldendal, 1999.

Kaleske, Karl. *Final Interrogation Report*, November 1, 1945. Headquarters, United States Forces European Theater, Military Intelligence Service Center.

Karila, Matti-Juhani (writer/producer). *A Boy from Warsaw: Tsvi Nussbaum.* Helsinki: MTV,1990. 50 min. documentary.

Keller, Ulrich (ed.). *The Warsaw Ghetto in Photographs.* New York: Dover, 1984.

Knightley, Phillip. *The First Casualty. The War Correspondent as Hero, Propagandist, and Myth Maker from the Crimea to Vietnam.* London: André Deutsch, 1975.

Knoll, Erwin. "The Uses of the Holocaust." *Progressive* July 1993, vol. 57, issue 10, pp. 15-16.

Kogon, Eugen, Adalbert Rückerl, et al. *Nationalsozialistische Massentötungen durch Giftgas. Eine Dokumentation.* Frankfurt am Main: S. Fischer Verlag, 1983.

Konrad, Franz. *Aussage von KONRAD Franz, betreffend seine vergangene Betaetigung in dem Warschauer Ghetto.* 2. Januar 1946. Counter Intelligence Corps, Salzburg Detachment, United States Forces Austria.

Korczak, Janusz. *Warsaw Ghetto Memoirs.* Trans. from the Polish by E. P. Kulawiec. Washington, D.C.: University Press of America, 1979.

Korwin, Yala. *To Tell the Story. Poems of the Holocaust.* New York: Holocaust Library, 1987.

Kossoy, Edward. "The Boy from the Ghetto." *Jerusalem Post*, Sept. 1, 1978, p. 5.

Kossoy, Edward. "Stop the Hoax." Unpublished letter to the editor of the *Jerusalem Post*, dated April 22, 1993.

Krakowski, Anna Feigenbaum. *Comme des chiens abandonnés. Chronique de Varsovie 1939-1943.* Documents rassemblés par le professeur Bernard Mark. Paris: Librairie Acadmémique Perrin, 1964.

Kunicka-Wyrzykowska, Magdalena. "Raport Stroopa: Historia Dokumentu Zbrodni," *Główna Komisja Badania Zbrodni Hitlerowskich w Polsce Miedzynarodowa Sesja Naukowa, Hitlerowskie ludobójstwo w Polsce i Europie 1939-1945,* 14-17 kwietnia 1983, 17 pp.

Kurzman, Dan. *The Bravest Battle. The Twenty-eight Days of the Warsaw Ghetto Uprising.* New York: Putnam's Sons, 1976.

Kushner, Tony. *The Holocaust and the Liberal Imagination: A Social and Cultural History.* Oxford: Blackwell, 1994.

Langer, Lawrence L. *Preempting the Holocaust.* New Haven: Yale University Press, 1998.

Lanzmann, Claude. *Shoah.* Paris: Fayard, 1985.

Laqueur, Walter. *The Holocaust Encyclopedia.* New Haven: Yale University Press, 2001.

LeMarec, *Les photos truqueées.* Un siècle de propagande par l'image. Paris: Editions Atlas, 1985.

Levi, Primo. *If This Is a Man* and *The Truce.* Trans. Stuart Wolf. London: Penguin, 1986; orig. pub. in Italian 1958 and 1963.

Levi, Primo. *The Drowned and the Saved.* Trans. Raymond Rosenthal. London: Penguin, 1988; orig. pub. in Italian 1986.

Levi, Primo. *Moments of Reprieve*. Trans. Ruth Feldman. London: Penguin, 2002; orig. pub. in Italian 1981/1985.

Levin, Judith and Daniel Uziel. "Ordinary Men, Extraordinary Photos." http://www.yadvashem.org/about_holocaust/studies/ordinary/levein_uziel–full.html

Lewin, Abraham. *A Cup of Tears. A Diary of the Warsaw Ghetto*. Edited by Antony Polonsky. Trans. Christopher Hutton. Oxford: Basil Blackwell, 1989.

Lustiger, Arno (ed.). *The Black Book of Polish Jewry. An Account of the Martyrdom of Polish Jewry under the Nazi Occupation.* Bodenheim: Frankfurter Buchgesellschaft Syndikat, 1995. Orig. pub. 1943.

Maclean, French L. *The Ghetto Men. The SS Destruction of the Jewish Warsaw Ghetto April-May 1943.* Atglen, PA: Schiffer Military History, 2001.

Margolick, David. "Rockland Physician Thinks He Is the Boy in Holocaust Photo Taken in Warsaw." *New York Times*, May 28, 1982, pp. B1, B8.

Mark, Ber. *Uprising in the Warsaw Ghetto*. New York: Schocken, 1976.

Michaels, Lloyd (ed.) *Ingmar Bergman's Persona*. New York: Cambridge University Press, 2000.

Mieke Bal, Jonathan Crew, Leo Spitzer (eds.). *Acts of Memory. Cultural Recall in the Present*. Hanover: University Press of New England, 1999.

Milton, Sybil. "The Camera as Weapon: Documentary Photography and the Holocaust." *Simon Wiesenthal Center Annual* 1. http://motic.wiesenthal.com/resources/books/annual1/chap03.html

Milton, Sybil. "Photographs of the Warsaw Ghetto." *Simon Wiesenthal Center Annual* 3. http://motic.wiesenthal.com/resources/books/annual3/chap15.html

Moczarski, Kazimierz. *Conversations with an Executioner*. Edited by Mariana Fitzpatrick. Englewood: Prentice-Hall, 1981; orig. pub. in Polish, 1977.

Nærå, Lica Weis. *Leon Flygter*. Aarhus: Husets Forlag, 1980.

Polonsky, Antony (ed.). *'My Brother's Keeper?' Recent Polish Debates on the Holocaust*. London and New York: Routledge, 1990.

Poteranski, Waclaw. *The Warsaw Ghetto. On the 30th Anniversary of the Armed Uprising of 1943*. Warsaw: Interpress, 1973.

Rapaport, Herman. *Is There Truth in Art?* Ithaca: Cornell University Press, 1997.

Raphael, Frederic. *The Glittering Prizes*. London: Allen Lane/Penguin Books, 1976.

Raskin, Richard. *Nuit et Brouillard by Alain Resnais. On the Making, Reception and Functions of a Major Documentary Film*. Aarhus: Aarhus University Press, 1987.

Ringelblum, Emmanuel. *Notes from the Warsaw Ghetto. The Journal of Emmanuel Ringelblum*. Edited and translated by Jacob Sloan. New York: McGraw-Hill, 1958.

Robin, Marie Monique. *100 Historic Photos of the 20th Century*. Köln: Evergreen/Taschen Verlag, 1999.

Roland, Charles G. *Courage Under Siege. Starvation, Disease and Death in the Warsaw Ghetto*. New York: Oxford University Press, 1992.

Rotem, Simha [Kazik]. *Memoirs of a Warsaw Ghetto Fighter*. New Haven: Yale University Press, 1994.

Rousseau, Jean-Jacques. "Discours sur l'origine et les fondements de l'inégalité parmi les hommes" (1754-1755). http://un2sg4.unige.ch/athena/rousseau/jjr_ineg.html

Rymkiewicz, Jaroslaw M. *Umschlagplatz: La dernière gare*, trans. from the Polish by Véronique Patte. Paris: Robert Laffont, 1989.

Rymkiewicz, Jaroslaw M. *The Final Station: Umschlagplatz,* trans. from the Polish by Nina Taylor. New York: Farrar, Strauss, Giroux, 1994.

Saïd, Edward W. *The End of the Peace Process*. 2nd edition. London: Granta Books, 2002.

Saïd, Edward W. *Culture and Resistance. Interviews with David Barsamian*. London: Pluto Press, 2003.

Sakowska, Ruta et al. *The Warsaw Ghetto*. Warsaw: Drukarnia Naukowo-Techniczna, n.d.

Schoenberner, Gerhard. *Jødestjernen. Jødeforfølgelsen i Europa fra 1933 til 1945.* Trans. from the German by Henning Albrechtsen. Copenhagen: Samlerens Forlag, 1979; orig. pub. in German, 1960.

Schoenberner, Gerhard. *The Yellow Star. Persecution of the Jewis in Europe 1933-1945.* Trans. from the German by Susan Sweet. London: Corgi, 1978; orig. pub. in German, 1960.

Schwan, Heribert and Helgard Heindrichs. *Der SS-Mann. Josef Blösche – Leben und Sterben eines Mörders*. Munich: Droemer Knaur, 2003.

Shipler, David K. *Arab and Jew. Wounded Spirits in a Promised Land* (revised edition). Harmondsworth: Penguin, 2002; orig. pub. 1986.

Shlaim, Avi. *The Iron Wall. Israel and the Arab World.* London: Penguin, 2000.

Shulman, Abraham. *The Case of Hotel Polski*. New York: Holocaust Library, 1982.

Sontag, Susan. *On Photography*. London: Penguin, n.d.; orig. pub. 1977.

Stepan, Peter (ed.). *Photos that Changed the World. The 20th Century.* Munich, London, New York: Prestel, 2000.

Stránski, Matij. *Varsavské ghetto ve fotografiích* (2001). Slezská University, Department of Photographic Studies. http://216.239.37.100/search?q=cache:5taghvQQaPgJ:itf.fpf.slu.cz/studenti/stransky.rtf+stransky+kunicka&hl=en&ie=UTF-8

[Stroop, Jürgen.] *La bataille du ghetto de Varsovie vue et racontée par les Allemands.* Introduction and translation by David Knout. Paris: Éditions du Centre [de documentation juive contemporaine], 1946.

Stroop, Jürgen. *The Report of Jürgen Stroop Concerning the Uprising in the Ghetto of Warsaw and the Liquidation of the Jewish Residential Area*. Introduction and notes by B. Mark. Warsaw: Jewish Historical Institute, 1958.

Stroop, Jürgen. *The Stroop Report. The Jewish Quarter of Warsaw Is No More!* Trans. from the German and annotated by Sybil Milton. Introduction by Andrzej Wirth. New York: Pantheon, 1979 and London: Secker & Warburg, 1980.

Surkes, Sue. "Poles trade in tragedy." *The Sunday Correspondent*, October 3, 1990.

Timerman, Jacobo. *The Longest War. Israel in Lebanon*. Trans. Miguel Acoca. New York: Vintage, 1982.

Trial of the Major War Criminals before the International Military Tribunal. Nuremberg 14 November 1945 – 1 October 1946. Vol. 26. Nuremberg, 1947.

Unsigned, untitled. *Jewish Chronicle*, July 28, 1978, p. 32.

Unsigned. "Frightened little boy whose photo symbolized Nazi terror is alive and well," *The Long Island Jewish Week,* May 9, 1982, pp. 1, 33.

Vogt, Judith. *Billedet som politisk våben*. Copenhagen: C.A. Reitzels Forlag/Oslo: J.W. Cappelens Forlag, 1988.

Weber, Mark. "Le petit garçon de Varsovie." Trans. Jean-François Beaulieu. http://www.codoh.com/inter/intwgboy.html

Wiesel, Elie. *One Generation After*. New York: Schocken, 1982; orig. pub. 1970, esp. pp. 49-50.

Wiesel, Elie. Speech at the Bundestag, Berlin, on January 27, 2000. The Day of Remembrance for the Victims of the Holocaust. http://www.gainfo.org/SFPT/Amnesia/German_Parliament_President_Holocaust_Remembrance_Day_Speech_27Jan2001.htm

Wulf, Josef. *Das dritte Reich und seine Vollstrecker. Die Liquidations von 500 000 Juden im Ghetto Warschau*. Berlin: Arani, 1961.

Yahil, Leni. *The Holocaust. The Fate of European Jewry*. New York: Oxford University Press, 1990.

Young, James E. *Writing and Rewriting the Holocaust. Narrative and the Consequences of Interpretation*. Bloomington: Indiana University Press, 1988.

Zand, Nicole. "Keeping sane amid madness of the Warsaw ghetto." *The Guardian*, October 8, 1989.

Zelizer, Barbie. *Remembering to Forget. Holocaust Memory Through the Camera's Eye*. Chicago: University of Chicago Press, 1998.

Zuckerman, Yitzhak ("Antek"). *A Surplus of Memory. Chronicle of the Warsaw Ghetto Uprising*. Translated and edited by Barbara Harshav. Berkeley: University of California Press, 1993.

PICTURE AND OTHER CREDITS

Grateful acknowledgment is made for the following:

All images from and of the Warsaw specimen of the *Stroop Report* (on the front cover and fold-out flap of this book and on pp. 13-15, 20, 29-30, 40-50, 73-74, 82, 93-94, 96-97) as well as the photos on p. 16 and the photos of Jürgen Stroop on p. 28: Biuro Udostępniania i Archiwizacji Dokumentów, Instytutu Pamięci Narodowej (Institute of National Remembrance) – Komisji ścigania Zbrodni przeciwko Narodowi Polskiemu.

Photo of Buchenwald survivors behind barbed wire (p. 17): © MARGARET BOURKE-WHITE/Time Life Pictures/Getty Images.

Photo of a ghetto child (p. 18): Krakow Photographic Society.

Photo by Heinrich Jöst (p. 18): © Günther Schwarberg, Hamburg.

Photo by Joe Heydecker (p. 19): *Das Warschauer Ghetto.* © 1983, 1999 Deutscher Taschenbuch Verlag, München.

Title page of NARA specimen of *Stroop Report* (p. 30): National Archives and Records Administration.

Photo of Robert H. Jackson at the podium during the Nuremberg War Trials (p. 33): © The Robert H. Jackson Center for Justice, photo by Raymond D'Addario.

Two photographs (pp. 49-50) from the NARA specimen of the *Stroop Report*: National Archive and Records Administration.

"Staff Evidence Analysis" (pp. 61-62): National Archive and Records Administration.

Article (p. 84) appearing in *The Jewish Chronicle* on July 28, 1978: © *The Jewish Chronicle*.

Photo of Tsvi Nussbaum taken in 1945 (p. 90): Dr. Tsvi Nussbaum.

Photos of Levi and Chana Zeilinwarger (pp. 92-93): Avraham Zeilinwarger.

Cover of the Danish edition of *Der gelbe Stern – Jødestjernen –* and of the English edition – *The Yellow Star* (both on p. 106): © Samlerens Forlag and Corgi Press, respectively, and with the permission of Gerhard Schoenberner.

Photo of Frederic Raphael (p. 107): Frederic Raphael.

23 stills and dialogue from *The Glittering Prizes* (pp. 109-111): © BBC, producer Mark Shivas and author Frederic Raphael.

Photo of Yala Korwin (p. 115): Yala Korwin and photographer Gaston Dubois.

Yala Korwin's poem, "The Little Boy With His Hands Up" and the accompanying drawing (pp. 116-117): Yala Korwin and the United States Holocaust Memorial Museum.

57 stills from Mitko Panov's film *With Raised Hands* (pp. 120-126): Mitko Panov.

Photo of Samuel Bak (p. 131): photo by Cary Wolinsky, used with the permission of Pucker Galleries.

Reproductions of 25 paintings by Samuel Bak (pp. 132-147): provided by Pucker Galleries in Boston and reproduced with permission of Samuel Bak and Pucker Galleries.

Cartoon by António Antunes (p. 163): © António Antunes.

Photo from *HaPatriot* (p. 165): The Israel Goor Theatre Archives and Museum, Jerusalem.

Photo of Palestinian boy arrested by Israeli soldiers (p. 167): Scanpix/Reuters/Evelyn Hockstein.

Photos from Alan Schechner's "The Legacy of Abused Children: From Warsaw to Palestine" (p. 168): © Alan Schechner.

Lead photographic plate (p. 177) courtesy of USHMM.

The Autobiography of Rudolf Höss, from which I have quoted extensively on pp. 76-78, was published in 1959 by the World Publishing Company. My attempts to reach the publisher, in order to request permission to cite the relatively long passages in question, were unsuccessful and I gather that the company no longer exists.

Every attempt has been made to obtain the authorization of all parties owning the rights to material appearing in this book. However, any party who feels that his or her permission was required but not given to reproduce any image or text included in this book is asked to contact Aarhus University Press.

ACKNOWLEDGMENTS

Particularly at the start of this project when help was needed most, Matti-Juhani Karila – former head of the documentary section at MTV in Helsinki, Finland, and writer/producer of *Tsvi Nussbaum: A Boy in Warsaw* (1990) – generously shared with me his extensive files on the well-known photograph and gave some excellent advice. His expertise, help and support were invaluable.

The Staff at the Institute of National Remembrance in Warsaw – Instytut Pamięci Narodowej, Komisji ścigania Zbrodni przeciwko Narodowi Polskiemu, Biuro Udostępniania i Archiwizacji Dokumentów – was exceptionally helpful in providing access to the documents I needed to examine and for supplying all of the images from the *Stroop Report* as well as permission to use them in this book; I am particularly thankful to Michalina Wysocka and Michal Matyasik for their tireless support, and to the photographic department for their excellent work.

In connection with the works of art presented in Chapter 5, I am deeply indebted to a number of people who kindly granted interviews and/or authorized the reproduction of these works in the present book. My warmest thanks go out to novelist and screenwriter Frederic Raphael, actor Tom Conti and producer Mark Shivas, as well as to Paul Richmond and Justine Avery at the BBC (*The Glittering Prizes*, 1976); to poet Yala Korwin, and to Stuart Bender at the USHMM (*The Little Boy With His Hands Up*, 1982); to screenwriter/director Mitko Panov (*With Raised Hands*, 1985); and to artist Samuel Bak and to Bernie and Sue Pucker at the Pucker Gallery in Boston (*25 paintings*, 1995-present).

I am grateful to Tsvi Nussbaum for a memorable interview in January 2003 and for providing photographs; to political cartoonist António Moreira Antunes for sending a copy of his 1982 cartoon and authorizing its reproduction here; to artist Alan Schechner, for providing images from his work and permission to use them; to Jeff Barak and Keith Feldman at the *Jewish Chronicle* for enabling me to reproduce a 1978 article from that newspaper; to Edward Kossoy in Geneva, for important information and articles; to Karen Ramey Burns, Forensic Anthropologist at the University of Georgia, for her help with photo comparison; to graphologist Per F. Andersen for help with handwriting comparison; to Torsten Zarwel and B. Kuhl at the Berlin and Koblenz divisions of the *Bundesarchiv* respectively, for important information about surviving specimens of the *Stroop Report*; to Avraham Zeilinwarger, Haifa, for photographs of Levi and Chana Zeilinwarger; to Zvi Oren and Deborah S. Jacobs at the Photo Archives Department, Ghetto Fighters' House (*Beit Lohamei Haghetaot*) for information about Avraham Zeilinwarger; to

Dr. Amy Schmidt and Donald L. Singer, Archivists in Modern Military Records, National Archives and Records Administration; to Ella Avital-Florsheim, Film and Photo Department, Yad Vachem; to Diana Afoumado, documentalist/historian at the *Centre de documentation juive contemporaine* in Paris; to Jan Jagielski, director of photo archives at the Jewish Historical Institute in Warsaw; to Leslie Swift, USHMM Photo Archives; to Dieter Britz, Bo Mønsted, Lone Sarauw, Jan Kjaer-Hansen, Jorge Leitao, Jing Haase, Elzbieta Snopek, Danuta Holewinska-Ladefoged and Eric Bednarski for help with translation, proofreading and/or making contacts in German, Czech, Polish or Portuguese; to Wlodzimierz Kutner, professor at the Academy of Science, Warsaw; to Liza Verlinsky and Jeppe Lilholt; to Cristina Parodi; to Magnus Berg; to Peter Fischl; to Mrs. Chani Meckler; to former Chief Rabbi of Denmark, Bent Melchior; to Eric Markussen and Uffe Østergaard at the Danish Center for Holocaust and Genocide Studies; to author Niels Aage Jensen; to Søren Giessing, Cultural Attaché at the Israeli Embassy in Copenhagen; to Jakob Elias Nielsen for help with computer graphics; to Melanie Raskin for moral support; to Adina and Ronnie Teplin for a rare copy of *The Yellow Star* and for good advice; to Gerhard Schoenberner for a number of illuminating conversations; to Günther Schwarberg at Hamburg, for permission to reprint a photograph by Heinrich Jöst; to Constanze Chory and Daniela Steiner at Deutscher Taschenbuch Verlag, München, for permission to reprint a photograph by Joe Heydecker; to Torben Madsen at Samlerens Forlag and Emma White at Transworld Publications (including Corgi Press) for permission to reproduce the cover of their respective editions of *Der gelbe Stern;* to Matej Stransky; to Judy Tergis at Tikkun Magazine; to James E. Young; to photographer Andrew Kobos; to Glenda Abramson for sending a chapter from her book, *Drama and Ideology in Modern Israel*; to Marianne Hirsh, for sending several of her articles on Nazi photography and the work of memory; to The Israel Goor Theatre Archives and Museum in Jerusalem, for providing the photo of a scene from Hanokh Levin's play, *HaPatriot*; to Helgard Heindrichs for replying to several questions; to Phillip Knightley; to Raye Farr and Suzanne Brown-Fleming at the USHMM; to Dr. Aleksander Skotnicki at the Krakow Photographic Society; to Rolland Kidder and John Barett at the Robert H. Jackson Center for Justice; to David Wingate for showing me the short film *With Raised Hands* which precipitated the writing of this book.

 Without the generous help of the Aarhus University Research Foundation, I would not have been able to examine the surviving specimens of the *Stroop Report* as well as other important documents in Warsaw and Washington. I am also grateful to my colleagues and students at the Department of Information and Media Studies for inspiration and to the technical staff for patient and friendly support. And it was a great pleasure to work with Clæs Hvidbak and Mary Waters Lund

at Aarhus University Press; their professionalism, enthusiasm and cheerfulness meant a lot to me.

Finally, I want to thank my wife, Marilyn Raskin, on whose wisdom and encouragement I have relied throughout this project.

INDEX

Abdullah, Abdullah 163
Abramson, Glenda 173
Al-Dura, Mohammed 169-171
Antunes, António Moreira 163
Arafat, Yasser 158, 159, 172
Arendt, Hannah 75-80
Armbands 11, 14
As'idah, Kamal Ali 166-167
Askaris 47, 73-75, 79
Bak, Samuel 6, 130-155, 156
Begin, Menachem 157-158
Benfes, Alexander 66
Bergman, Ingmar 106, 156
Blösche, Josef 94-98, 102-103
Borges, Jorge Luis 78-79, 80
Borwicz, Michel 64
Bourke-White, Margaret 17-18
Brandt, Karl-Georg 94, 96
Bundesarkiv 30, 65-66
Burns, Karen Ramey 90
Captions 16, 34, 38-39, 50-51, 52, 53, 67, 68
Carlson, C. E. 166
Cayrol, Jean 105, 155
Chazan, Naomi 160
Christ 72
Conti, Tom 6, 107, 109-111, 113-115
Cusian, Albert 31
Czerniakow, Adam 58
Dawidowicz, Lucy S. 5, 7, 71, 80
Deutsches Requiem 78-79, 80
Dobroszycki, Lucjan 88-89, 91-92
Draper, Morris 162
Eichmann, Adolf 55-56, 69, 75, 77-78, 155-156
Ezrahi, Sidra D. 173
Farr, Raye 177
Faurisson, Robert 85-86
Fischl, Peter 11, 22
Finkelstone, Joseph 83-85
Frank, Hans 58, 61
Frankenstein 102

Frenkel, Pawel 59
Gallagher, Paul 172
Gee, Prunella 107, 109-111
Glittering Prizes, The 6, 107-113
Goering, Hermann 34, 56
Goldberg, Vicki 18, 21, 23
Goldenberg, Susanne 174
Golden Section 20
Grimm, Arthur 31
Gutman, Yisrael (Israel) 25, 55, 64, 68
Haber, Eitan 160, 173
Harris, Clay 84-85
HeChalutz 44, 58, 74-75, 80
Heindrichs, Helgard 5, 95, 96, 102
Heydecker, Joe 19, 23
Himmler, Heinrich 5, 25-26, 27, 30, 34-35, 54, 55-56, 59, 61-63, 65-66, 72, 75, 79, 89
Hirsch, Marianne 5, 7, 18-19, 23, 69, 71-72, 80, 156
Höss, Rudolf 76-78
Huber, Gérard 174, 175
Irving, David 91-92, 101, 166
Jackson, Robert H. 32-34, 35, 56, 67
Jagielsky, Jan 32, 66-67
Jesuiter, M. 26, 29, 32, 54, 68
Jodl, Alfred 34
Jöst, Heinrich 18, 23
Kadish, George 177
Kaleske, Karl 30, 31, 32, 66
Karila, Matti-Juhani 5, 7, 88, 100-102, 177, 178
Kartuzinsky, Leo 94
King, Oona 160-161, 173
Klaustermeyer, Heinrich 94, 96, 97, 102, 103
Knightley, Phillip 31
Konrad, Franz 32, 66-67
Korwin, Yala 6, 115-119, 156
Kossoy, Edward 84, 98-99
Krüger, Friedrich Wilhelm 26, 27, 37, 51, 63, 65, 72, 79, 89

Kunicka-Wyrzykowska, Magdalene 31-32, 66
Kurzman, Dan 64-65
Lamet family 93-94
Langer, Lawrence 7, 130, 156
Levine, Hanokh 164-165
Life 17, 56, 69, 105-106, 155
Little Boy With His Hands Up, The 6, 116-119
Margolick, David 87
Mark, B 64, 103
Milton, Sybil 31, 63, 71, 96
Moczarski, Kazimierz 54, 63, 68, 72-75
Nay, Catherine 170, 175
Netanyahu, Benjamin 159, 171-172
Neyer family 67
Night and Fog 103, 105, 155
Nuremberg Tribunals 28-29, 32-34, 65, 155
Nussbaum, Tsvi 7, 87-92, 100, 101, 130, 156
Oz, Amos 159, 172
Panov, Mitko 6, 119-130, 156
Peres, Shimon 158
Petras, James 159-160
Piasecki, Henryk 82-83
Piesecka, Yadwega 82-83, 99
PK 689 31
Polish underground 59, 60
Pucker Gallery 130-147, 156
Rabin, Yitzhak 158, 173
Rapaport, Herman 5, 7, 15-16, 71, 80
Raphael, Frederic 6, 107-113
Reagan, Ronald 157-158
Resnais, Alain 103, 105, 155
Ringelblum, Emmanuel 25
Rosenthal, Joe 23
Rymkiewicz, Jaroslaw 7, 12, 23, 83
Sabra and Shatila 162-163, 173
Saïd, Edward W. 157, 170-171, 175
Samia, Yom Tov 174
Sammern-Frankenegg, Ferdinand von 35, 54, 60
Saramago, José 159
Schechner, Alan 166-168, 174

Schoenberner, Gerhard 105, 155, 156
Schwan, Heribert 5, 95, 96, 102
Schwarberg, Günther 18
Sharev, Ari 161
Sharon, Ariel 162
Shipler, David K 158, 161-162, 164, 171, 173
Shivas, Mark 107, 108
Siemontek, Artur Domb 82-83, 98, 99-100
Sontag, Susan 5, 7, 54
SS-Mann, Der 5, 102
Star of David 11, 58
Stavarowski, Golda 94
Stranski, Matij 67
Stroop, Jürgen 5, 6, 22, 25-57, 60, 61-62, 63-69, 71-80, 88, 89, 97, 160, 172
Terry, Antony 31
Time 105, 155
Timerman, Jacobo 158
Treblinka 36, 37, 58, 59, 60, 89, 95, 96, 102, 157
Tsvi Nussbaum, a Boy from Warsaw 7, 88, 101
Ulmann, Liv 106, 156
Ut, Huynh Cong (Nick) 23
Weber, Mark 100, 101
West, Charlotte 161
Wiesel, Elie 5, 7, 12, 23
Wirth, Andrzej 63, 66, 156
With Raised Hands 6, 119-130, 156
Yaalon, Moshe 161
Yarkoni, Yaffa 160, 172-173
Yellow Star, The 105-106
Young, James E. 12, 164-166, 173
Zeilinwarger family 92-93, 101
ZOB 59, 80
ZZW 59